Best wishes —
Judah Passow

Shattered Dreams
Israel and the Palestinians

# SHATTERED DREAMS

## ISRAEL AND THE PALESTINIANS

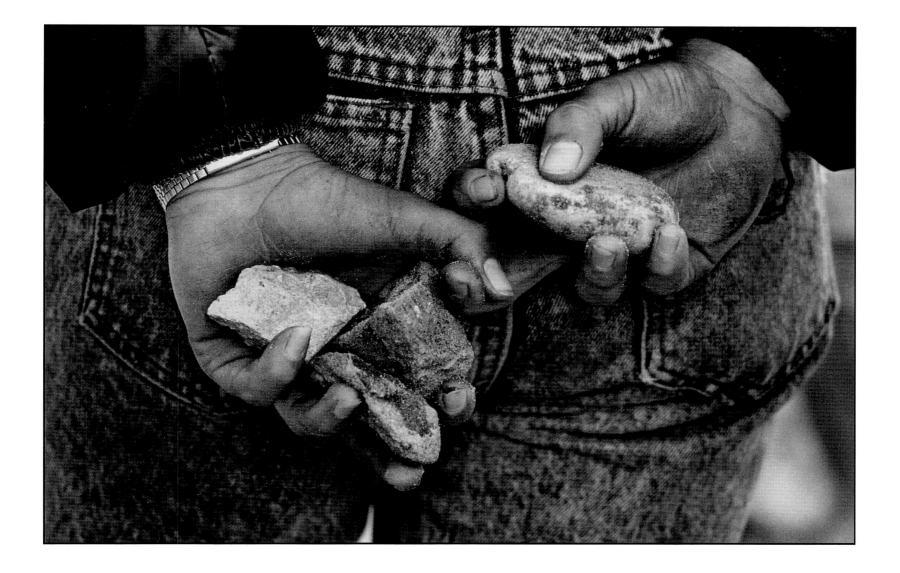

## PHOTOGRAPHS BY JUDAH PASSOW

HALBAN
LONDON

Introduction

# Fragile Bridges
## Etgar Keret

They say that one picture is worth a thousand words. But the big question is, how much are a thousand words worth? In the region I come from, not an awful lot. Here, every person you stop on the street is ready to give you not just a thousand words, but ten thousand, free of charge. And all ten thousand will say the same thing: why has this place we live in, which could so easily have been heaven, turned into hell? Each of those people you stop might have a different explanation for the situation. Some will blame the Arab countries and others the occupation, and some will explain that we can only have peace if we observe the religious commandments. But no matter who shares his solutions with you, the bottom line will always be the same. Everything could have been wonderful here if it weren't for 'them', and the 'them' they are referring to can be right-wingers, left-wingers, Arabs, settlers, secular Jews, religious Jews, Islamic fundamentalists, corrupt politicians and dozens of other guilty parties. Their names in those derogatory monologues change, but they always have the same characteristics. The 'guilty ones' are the root of all evil, the symbol of heartlessness, and they will forever be a model of wickedness, devoid of even one ounce of humanity. That's just how it is. In a place where, for six decades, violence has been erupting like a boiling geyser, the springs of compassion and empathy dried up years ago.

Any child who's laboured over a sandcastle can tell you how much harder it is to build something than to destroy it. In the Middle East, enormous efforts have been, and are still being, made to build bridges between Israelis and Palestinians. In slow, painstaking processes, people on both sides of the conflict have created social and business initiatives that try, wisely and sensitively, to intertwine the lives of the various groups who share this small piece of land. But whenever such an initiative begins to take shape, we are reminded how fragile those bridges are. One Kassam rocket or a missile launched from an unmanned aerial vehicle is enough to smash it to smithereens. And, gradually, many who once believed in those initiatives have come to see them as Sisyphean efforts doomed to failure from the outset.

Risking simplicity, I think that the difference between liberals and militants in any society is the difference between optimism and pessimism. The conflict at the heart of the debate between these two attitudes lies in the ability of both sides to imagine a better future in which neither one is forced to bury its children. Tragically, the good attempts to bridge the emotionally charged relations between these two peoples have not become etched in the collective consciousness in the same way the scars of mutual violence have. With every child who dies, whether in Jerusalem or Gaza, another fragment of the belief that still remains crumbles, belief not only in the other people, but in human nature in general. At the beginning of the second intifada, I remember travelling in a taxi that surprisingly had a 'Peace Now' sticker on the dashboard. The radio was reporting on the lynching in Ramallah in which dozens of Palestinians killed two IDF reserve soldiers and mutilated their corpses. Waiting at a red light, the driver pulled a key out of his pocket and violently began trying to scrape off the sticker. When he looked in the rearview mirror and saw me watching him from

the back seat, he said, 'That's it. I've stopped believing.'

It is not only the belief in Israeli-Palestinian relations that has shattered. In the last twelve years, belief within each group has been undermined. Rabin's assassination left Israeli society painfully wounded, creating hatred between left and right, between religious and secular. The maxim instilled in us in school, 'All Jews are responsible for one another,' has proven false. That same unjustified hatred, which, according to biblical sources, led to the destruction of the Second Temple, has erupted again in the heart of Israeli society. The harshest expression of this polarization occurred during the 2005 Gaza disengagement when settlers and soldiers became bitter enemies fighting each other with a cruelty and violence that sometimes seemed to surprise even them. And at the same time, on the other side of the border, a violent polarization has split Hamas and Fatah, threatening to tear the evolving Palestinian society to shreds.

A friend who lives in Germany once told me that Israel seems to him like a microcosm of the world, a minute piece of land that contains everything found on earth: the snowcapped Golan Mountains and not too far away, gorgeous Mediterranean beaches and the natural miracle of the Dead Sea; holy sites of the world's important religions; the most advanced westernization blended with traditional, ethnic orientalism; pork-serving restaurants and synagogues; gay pride parades and mosques – everything that nature and man have created coexisting on this single, minute piece of land. 'Sometimes I can't help thinking,' my friend said, 'that the whole country is actually a kind of controlled experiment being conducted on humans by aliens or gods. That the entire place is a Petri dish meant to teach something aboutour world and people in general.' If it really is an experiment, it would be interesting to learn the conclusions drawn by those conducting it. On the one hand, the dismal results must have thrown them into despair. But on the other, they must also have taken notice of the human miracle taking place here: despite the heavy, depressing cloud constantly hanging over us, some people on all sides of the divide still believe in a better future and beyond that, in a different kind of humanity. Even if those people are few in number, I have no doubt that their determination and faith have impressed all those scientists/ gods/aliens performing the experiment. And who knows, maybe in the end, they will even succeed in changing the results.

*Translated by Sondra Silverstone*

*Etgar Keret is one of the most popular writers among young Israelis today. He has written several collections of very short, surrealistic stories, which have won numerous prizes, been widely translated and received international acclaim. A lecturer in the Hebrew literature department at Ben-Gurion University, he has also made several films, the most recent,* Meduzot (Jellyfish) *with his wife Shira Geffen, which won the 2007 Cannes Film Festival's Camera d'Or Award for Best First Feature.*

# Peace Postponed
## Samir El-Youssef

One evening in September 1994, I am in my bedsit in London, watching Inspector Morse. The commercial break interrupts the findings of the moody detective and I switch over to BBC One. It's the News and – 'It's really happening,' I say to myself. Just like Paul on his way to Damascus, I become a convert; only I don't see God, I see Israeli troops pulling out of the city of Jericho. I see the dream of peace; I become a 'peace convert'.

Well, not exactly, but the biblical metaphor, especially in our case, is always alluring. The fact is that until that moment I was a sceptic, it was hard for me to imagine the possibility of Palestinians and Israelis existing side by side in a peaceful neighbourhood.

Scepticism is the refuge of the commitment-disabled (others might say the gutless!) but what else can you be but sceptical when the alternative is either to side with the corrupt, the tyrannical and the fanatical, or to be branded as a traitor, an agent of the CIA? Little wonder that scepticism has been the prevailing attitude among many Arabs and Palestinians. However, on the issue of achieving a peaceful neighbourhood, even the realists couldn't always help being sceptical. Yes, as the realist argument goes, war and violence are not an option when it comes to putting an end to the Palestinian-Israeli conflict. Israel is not strong enough to dictate its ultimate demands, but neither are the Palestinians weak enough to be made to vanish. The only alternative, the argument concludes, is negotiation and peaceful settlement. Fine, but the question which makes even the realists become reasonably sceptical is: Is such a realistic approach good enough grounds for a peaceful

agreement? Granted, says the sceptical-self to the realistic-self, neither side can win or lose completely. But does that make the thorny issues of Israeli settlements, the future of Jerusalem and the refugees, any easier to solve?

I hear a shy 'no' coming from the lips of the realistic-self. Hence my sceptical-self couldn't be cured even after the Palestinians and the Israelis got together – out of a sheer sense of realism – in Norway, of all places, and negotiated realistically a Scandinavian solution for the Palestine-Israel question, the Oslo Accords. Sadly, the Accords couldn't provide relief from scepticism. On the contrary, if anything they made things worse, for the two sides managed to agree only because they managed to avoid handling the big issues.

Still, one year on, on the very night I accidentally switched from Inspector Morse to the BBC News, I became a believer in peace. Was it watching the Israeli troops withdrawing from Jericho? In spite of all their obvious shortcomings, did I realise that the Oslo Accords were not merely a talk-show, that, because of Oslo, things were actually happening? That Palestinians for the first time in modern history could rule themselves, albeit on a small piece of their land? Was that a sign of the coming Palestinian statehood and sovereignty?

Not at all! The early Israeli withdrawal from Jericho didn't make me less sceptical about Oslo nor did the subsequent negotiations and treaties. Nor indeed did that notorious handshake of Arafat and Rabin: Rabin's hesitation in reaching for the outstretched hand of his foe could be read

as further testimony for the benefit of the sceptical. The failure of the Camp David talks, six years later, was not heartbreaking news for me – it was a small reward for being sceptical!

Nor was I such an ardent nationalist that the mere promise of Palestinian statehood could get me dreaming. I've never been able to reconcile myself to any kind of nationalism, especially since I have lived in London for so many years and have acquired British citizenship. One cannot be a nationalist of one country and a citizen of another unless one enjoys being a walking contradiction.

No, nationalism is not for me. Besides, the proposed Palestinian state in its most generous form – a state on the entirety of the West Bank and Gaza – if and when it comes into existence, must exclude Palestinians like me. Indeed the possibility of such a state, in itself remote, depends, among other factors, on the need to exclude Palestinians of my origin.

Within the Palestinian map I belong to the Palestinian refugee community in Lebanon, a community whose parents and grandparents came from villages and cities which are now part of Israel proper. In belonging to such a community, it is very unlikely that many of us would have developed a deep, or sincere, attachment to the West Bank or Gaza. Those who have such feelings must be nationalist Palestinians, which in practice means that they have made a career out of being established or long-serving members of the PLO. The idea, usually advanced by short-sighted or disingenuous peace advocates, that Palestinian refugees from Lebanon, Syria and Jordan could settle in the West Bank and Gaza sounds to me absurd and dangerous. Practically, it is impossible for a small, overcrowded territory with an impoverished society which has suffered decades of military occupation to be able to accommodate millions of newcomers.

Nor do I believe in the so called 'right of return', that is to say Palestinian refugees returning to what is now Israel proper. Indeed, if my dream of peace has not been encouraged by the promise of a Palestinian state, it has also never been based on the belief in the possibility of Palestinians returning to where their parents or grandparents came from. The right of return is not a solution to the refugees' plight; nor is putting an end to their suffering the genuine priority of those who keep demanding such a right.

Watching Israeli troops leaving Jericho was a sign of a different hope and one which was stronger than the expectation of the emergence of a Palestinian state – and certainly more attainable than the so-called 'right of return'. But if neither Palestinian statehood, nor the right of return gives rise to the hope I see behind the images of the Israeli withdrawal, how do these images inspire a dream of peace?

Growing up in a Palestinian refugee camp in Lebanon, I often heard my parents and their generation of neighbours, relatives and friends lamenting the past. Just like older people everywhere, my parents and their generation were susceptible to nostalgia, perhaps more so than older people elsewhere. They were the generation of Palestinians who were actually born in Palestine and were then doomed to witness and

suffer the war of 1948, which resulted in the destruction of their homes and their becoming dispossessed and refugees.

The surprising thing, however, was that when my parents, and their generation, expressed yearnings for the good but long gone past, they were not talking about their life in Palestine before 1948, they weren't lamenting the lost early life in their homeland where life was simple and the future, in spite of all the political unrest, was less unpredictable and uncertain. My parents were relatively too young to feel nostalgic about their early life in Palestine. They actually yearned, just as older people do, for their youth, for the time when they came of age and the accompanying sense of discovery. The shocking fact, for me and my generation, was that the past they regretted was their early years of exile, when their memory of defeat and dispossession was still bitterly fresh. It was the time when they had just become refugees in a barely hospitable country, relying for their daily life on aid from relief organizations, their political leadership totally subordinate to Arab regimes and impotent. This should have been considered the age of ultimate humiliation and hopelessness.

Now I understand that parents are supposed to be weird, at least in their children's eyes, but this is indulging in weirdness beyond the tolerable. How could my parents yearn for such a past? How shockingly foolish and perverse!

However, my parents and their generation were no more foolish than other older people who, in spite of their memories of political and social unrest, or even economic depression and war, cannot help feeling nostalgic. People with such a disturbing history don't usually lament the bad times. They usually think of the good times, or at least the uneventful ones when they managed to enjoy the fresh experience of life without the constant threat of war and violence. And I think this is the kind of past that my parents longed for.

My parents came of age between the mid-1950s and 1960s. In spite of the noisy Arab national rhetoric and the ranting of Gamal Abdel Nasser about defeating the Israelis and liberating Palestine, those were relatively peaceful years in comparison with later decades. Indeed in a country like Lebanon, these were also prosperous times. Generations of Lebanese, Palestinians and people from different Arab countries enjoyed the taste of modern western life without having to travel to Europe.

Yes, my parents and their generation suffered the humiliation, hardship and uncertainty of refugee life but, unlike my own generation, those of us who came of age in the 1970s and 1980s, their daily life was relatively free from the constant threat of war and violence. And it was within that life of relative security that they managed to have a taste of a good and mainly peaceful life. They were able to learn and work and hope to move away from the life of refugees to which they had been condemned. Thousands of refugees, and children of refugees, managed to gain education and qualifications that enabled them to move on and, albeit individually, enjoy the life of the middle classes in Arab societies. Yes, those were not totally peaceful times, but they were peaceful enough to make the hope of moving on achievable. And the

image of the Israeli troops withdrawing from Jericho was for me just that sign of the possibility of having a life relatively free from the threat of war and violence and of having within our grasp the hope of moving on, not only socially, but politically too.

'Dream on!' you might say.

I do, what else can I do? But at least my dream of peace is not shattered; it's only postponed.

*Samir El-Youssef's first novel in English,* The Illusion of Return, *was published in 2007 to great critical acclaim. He co-authored a collection of short stories* Gaza Blues *with Etgar Keret, which was also very favourably received and widely translated. His essays and reviews have appeared in many publications including the* Guardian, Al-Hayat, New Statesman, Nizwa, Jewish Quarterly *and the* Washington Post. *El-Youssef is also a peace campaigner and in 2005 won the Swedish PEN Tucholsky Award for promoting the cause of peace and freedom of speech in the Middle East. He was born in Rashidia refugee camp in Lebanon and has lived in London since 1990.*

# A Tough Neighbourhood
## Judah Passow

These photographs are more than simply a journalistic record of conflict and turmoil. They are the product of a very personal journey of exploration across the emotional landscape of the country in which I was born and for whose survival I once wore a uniform and fought. It's a place I keep returning to out of a sense of longing and belonging.

Every generation has its dreamers. Dreams are what drive vision and expectation. My parents' generation was driven by a vision of an egalitarian society in which hard work and cultural pride would, in time, create a model nation of social tolerance and economic achievement that would represent a triumph over the haunting experience of its people's history. Not by forgetting their tragedies, but by resolving to learn from them. This difficult and sometimes painful process has now ground to a halt. Social tolerance has sold out to religious fervour. Cultural pride has become political arrogance. The pioneer spirit has disappeared and in its place are left only shattered dreams.

My own generation – the first children born in the new state – had its dreamers too. We grew into adulthood believing that it was perfectly possible to be friends with our neighbours, that our army was a tool meant for defending our homes and not for cynically conceived political adventures, and that we had an obligation as a people to live by example in a terribly flawed world cursed with mindless cruelty. We were neither ashamed nor embarrassed to admit that, yes, in fact, we are our brother's keeper. As we approach our sixties, those of us who tried to live that dream find ourselves no less certain of those

fundamental truths, but at the same time feeling completely betrayed by those on both sides of the political divide whose only agenda is the perpetuation of fear, ignorance and hatred.

This book is an attempt to reflect on the last quarter of a century of the Israeli-Palestinian conflict. The photographs were taken over a twenty-five year period on assignments for newspapers and magazines in the United States, England, France, Germany, Italy, Switzerland and Holland. It makes no difference how you sequence the images – chronologically or randomly, the message of the conflict's relentless tragedy and ultimate futility doesn't change. Since the dates of the photographs became irrelevant to the basic narrative, what ultimately determined their order was a pattern of irony and melancholy that emerged from juxtaposing certain images with each other. This is a place where the young are robbed of their childhood and the elderly stripped of their dignity. The people here glorify their past, curse their present, and have difficulty imagining a future. It's a tough neighbourhood.

It may well take a new generation to repair the damage caused by this conflict over the past sixty years. Today's leaders, on both sides, are the generation of the desert – tired, worn out and ground down. Like Moses and all the Israelites who followed him out of Egypt, they won't be crossing the Jordan of reconciliation with all their prejudicial baggage. Israelis and Palestinians may be forced to wander around in their sad, arid, emotional wasteland until new leaders emerge, inheriting the responsibilities of their predecessors but also bringing

fresh vision and new courage in place of the fear and suspicion that characterised the past.

When Joshua's scouts returned from their reconnaissance trip across the Jordan River into the Holy Land, their report to Moses contained both good news and bad. The good news, which everyone remembers, was that 'It is a land flowing with milk and honey.' The bad news, the second half of that biblical report which no one ever quotes, was that 'It is a land that devours its inhabitants.'

Photographs

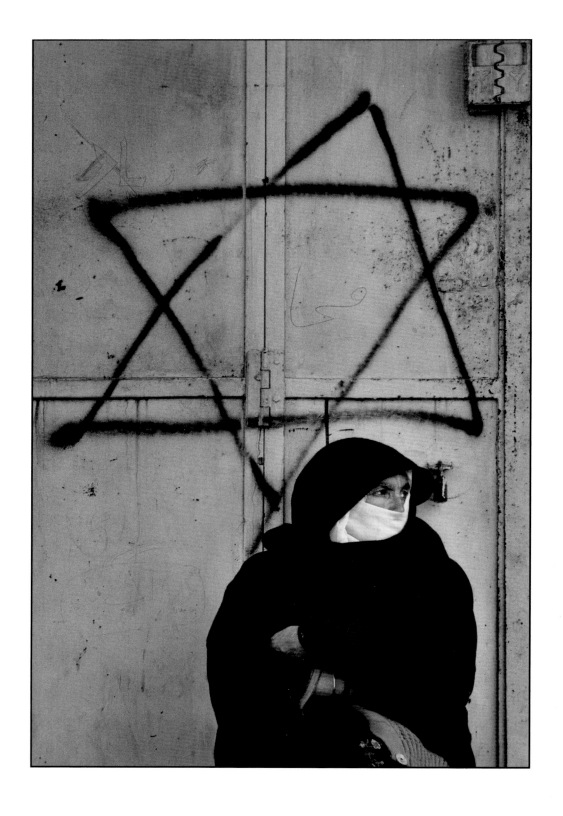

Hebron 1997

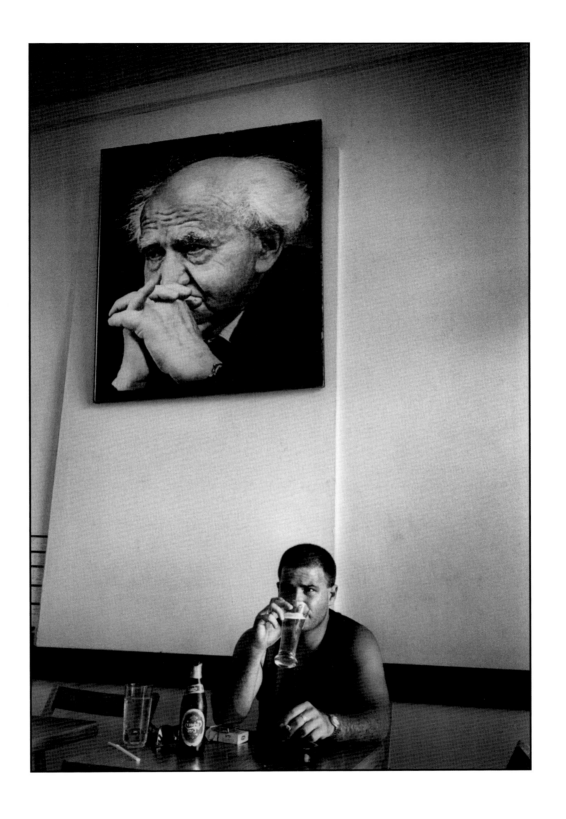

Tel Aviv 1992

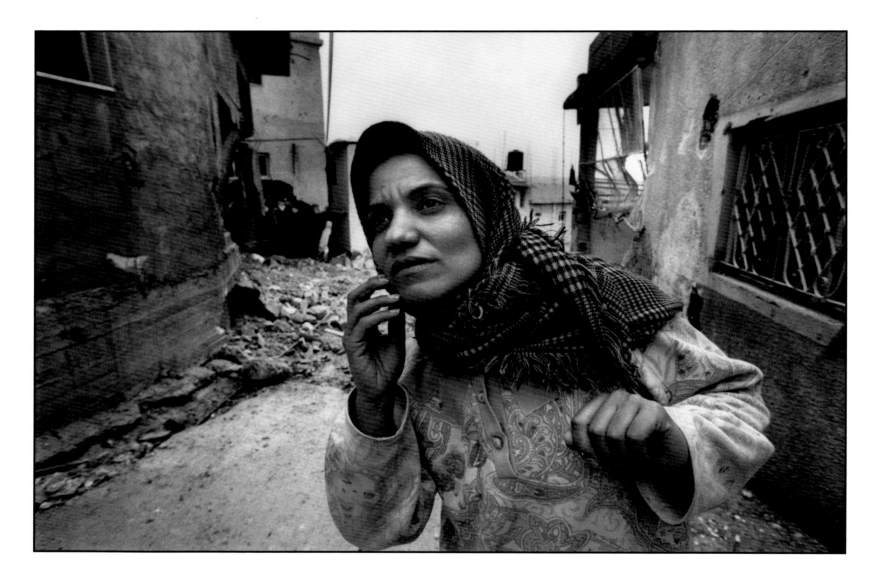

Jenin 2002

18

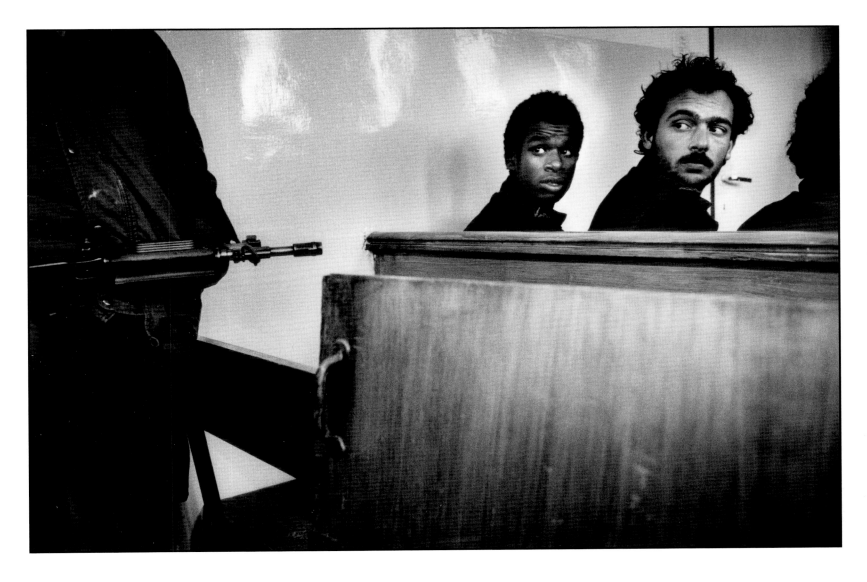

Nablus 1989

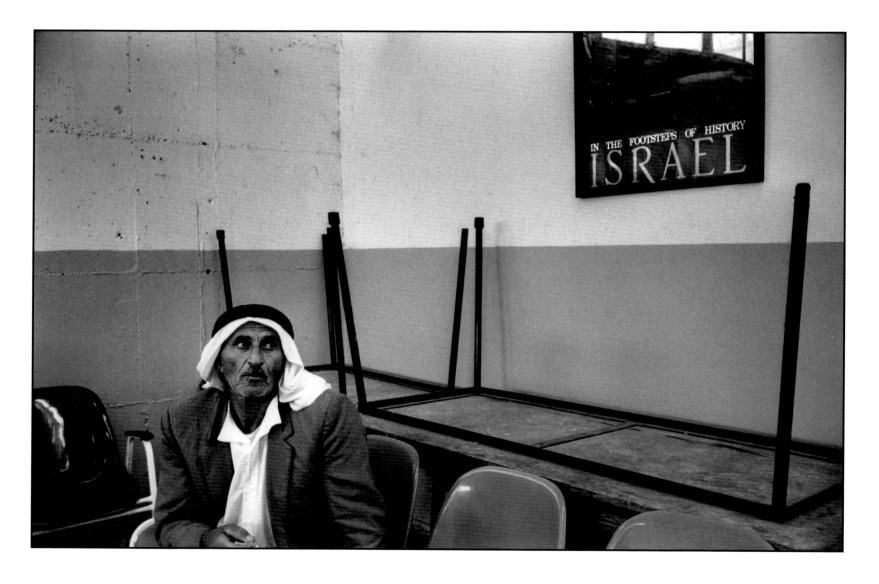

Jericho  1994

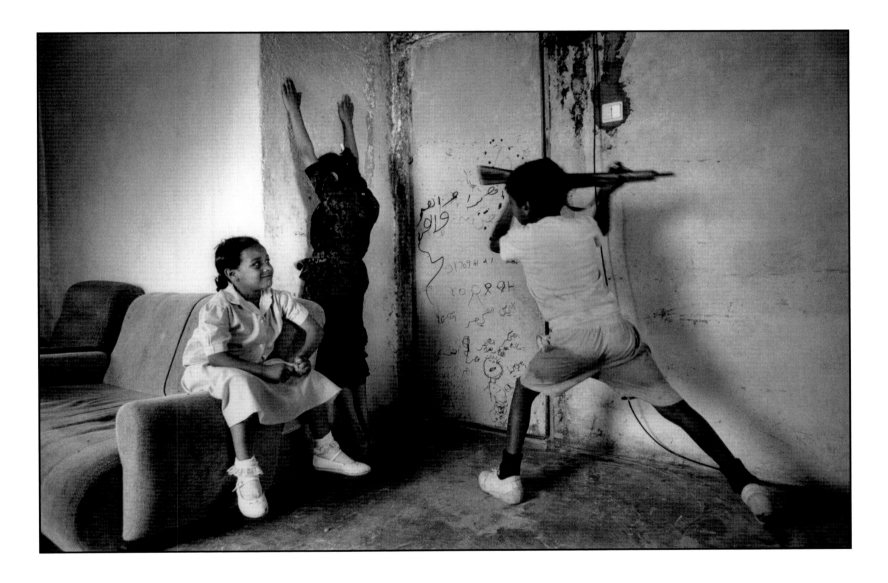

Fahme 1997

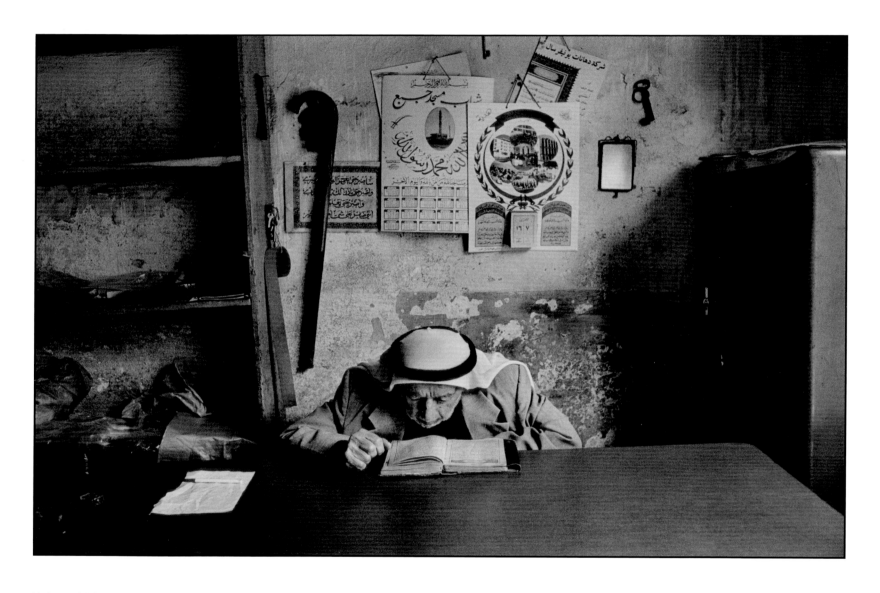

Hebron  1986

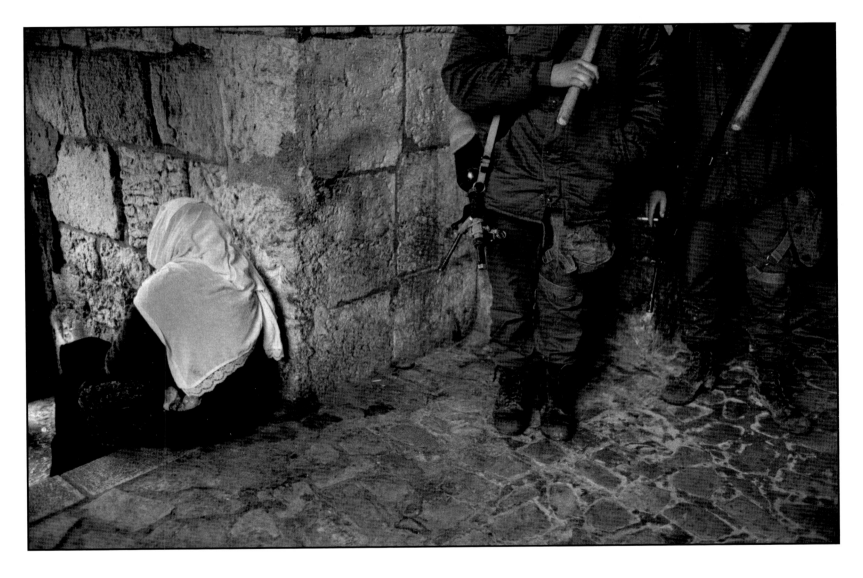

Jerusalem 1988

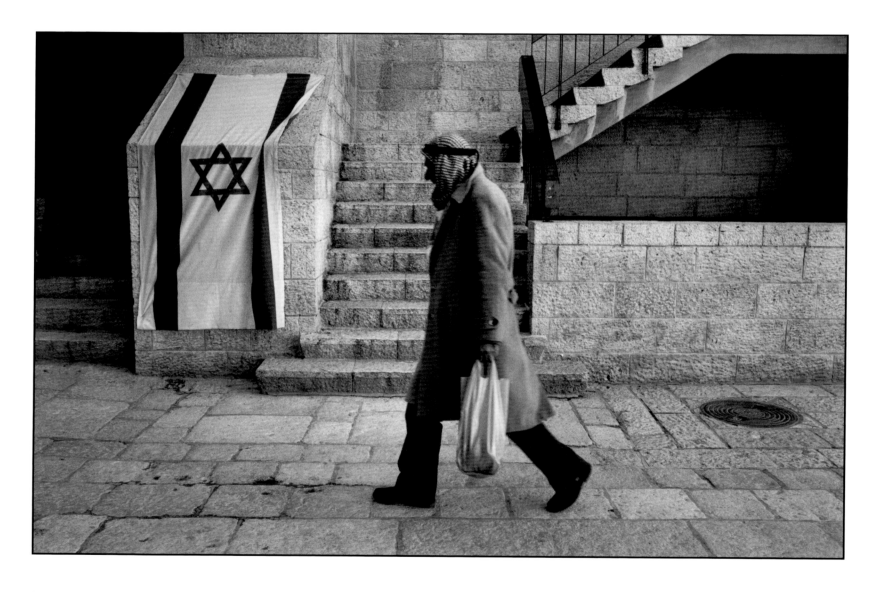

Jerusalem  2003

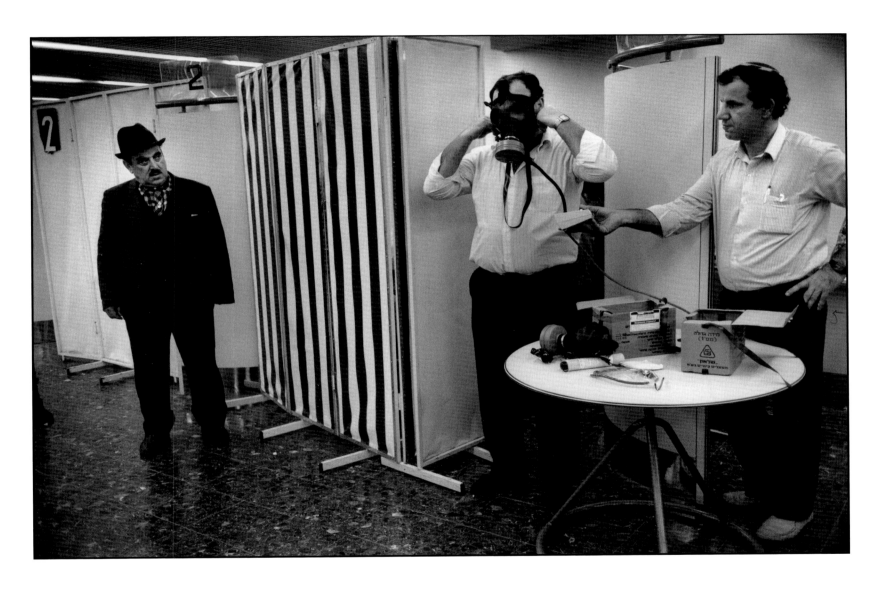

Tel Aviv 1991

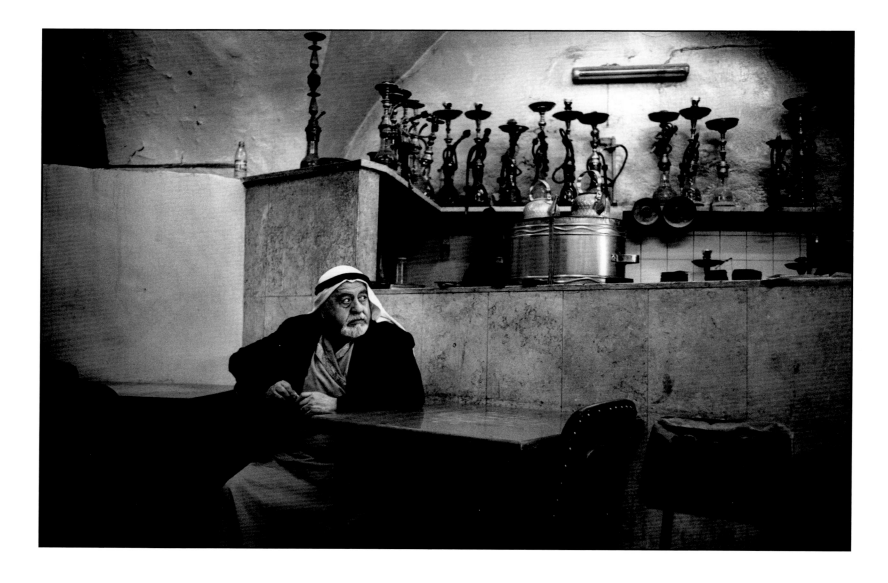

Jerusalem  1993

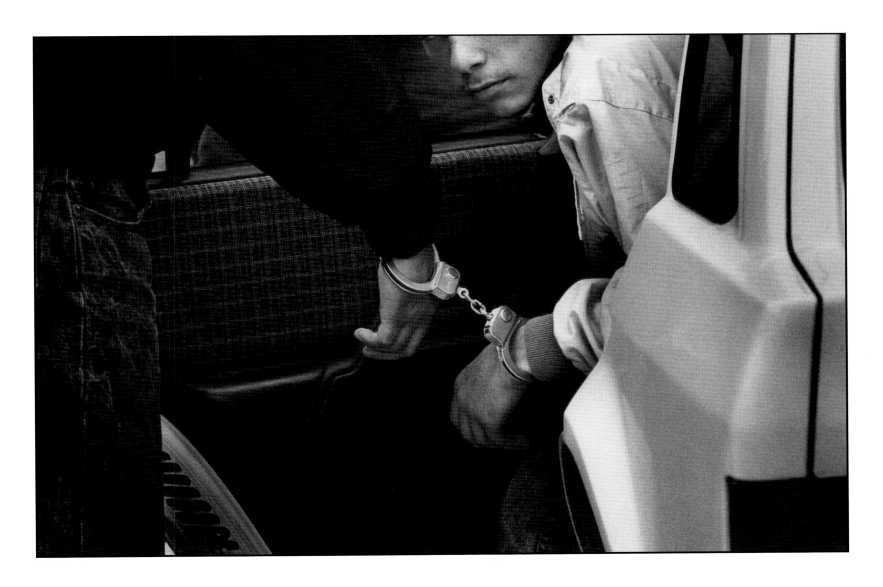

Nablus 1989

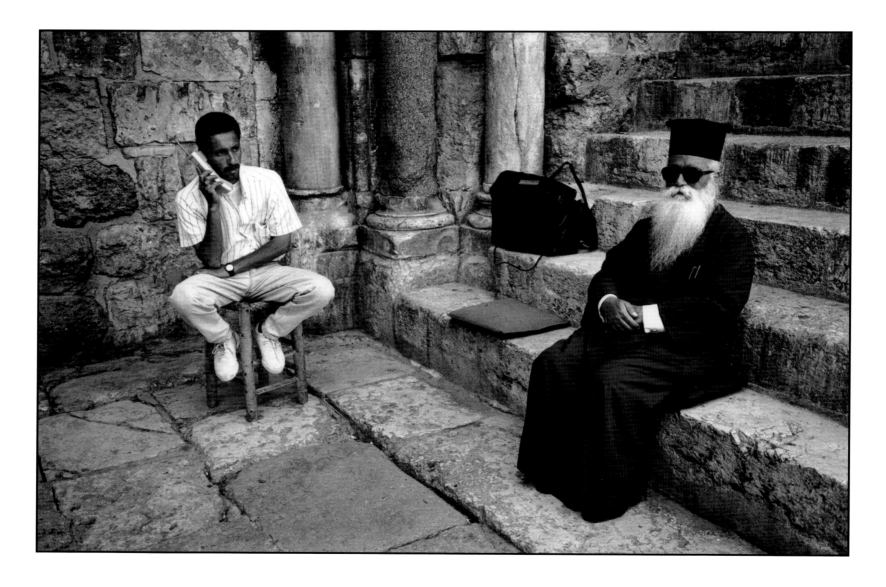

Jerusalem  1993

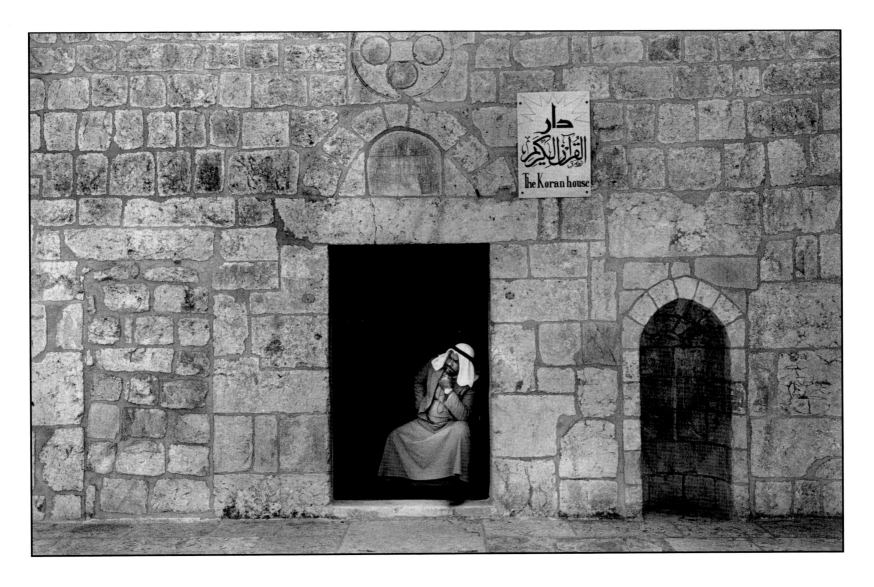

Jerusalem  1993

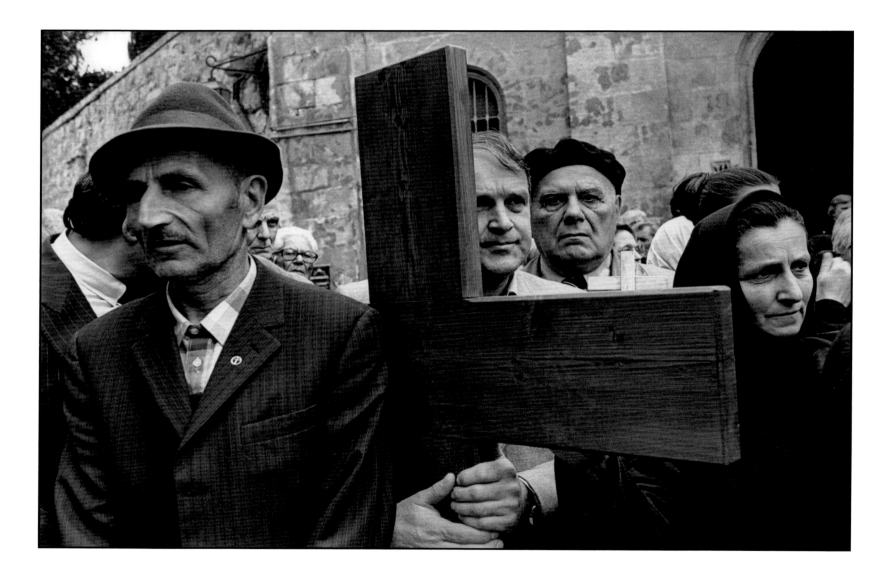

Jerusalem 1993

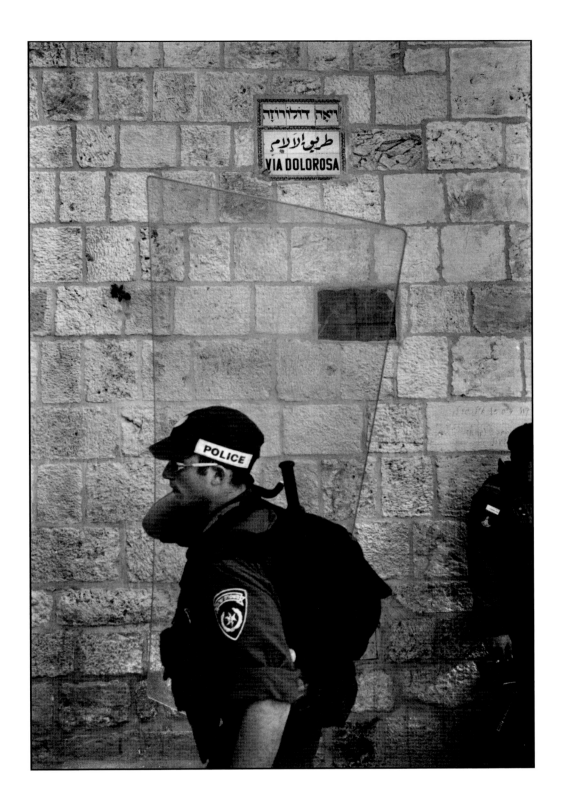

Jerusalem 2003

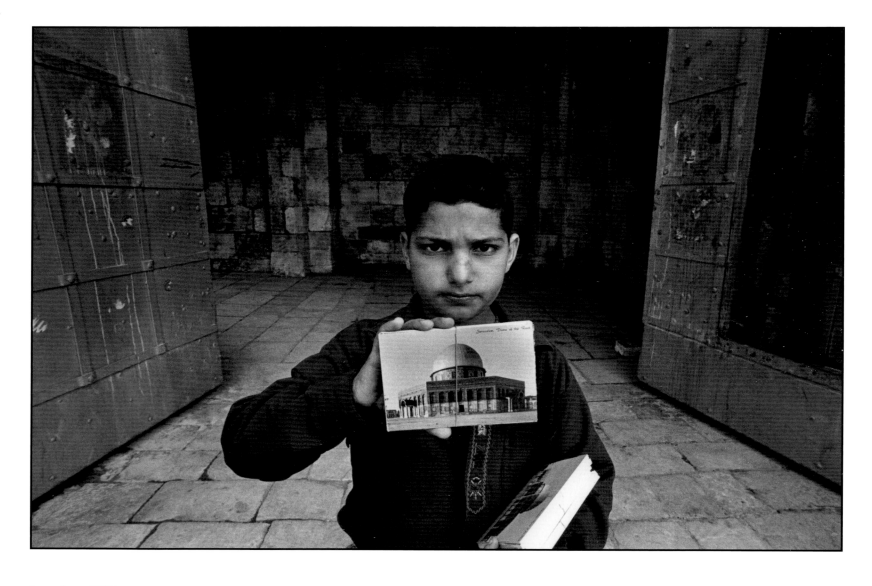

Jerusalem  1992

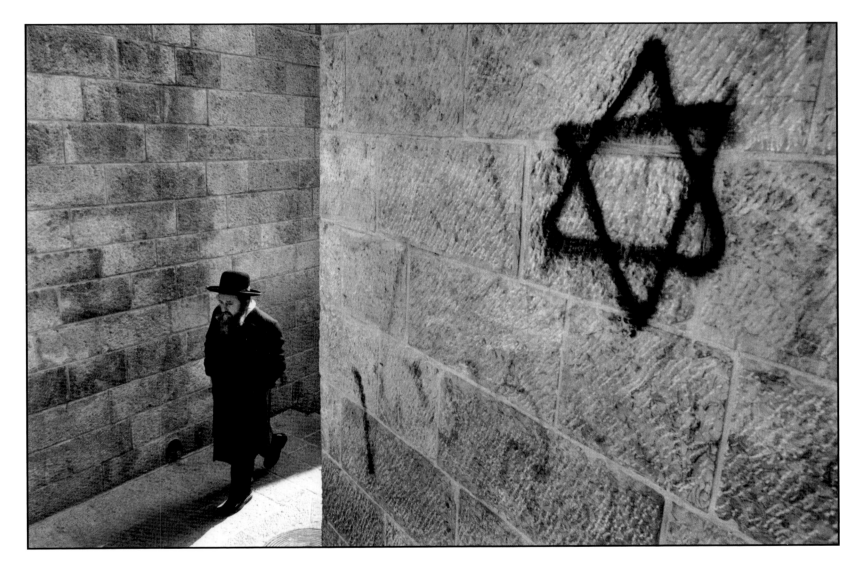

Jerusalem 2003

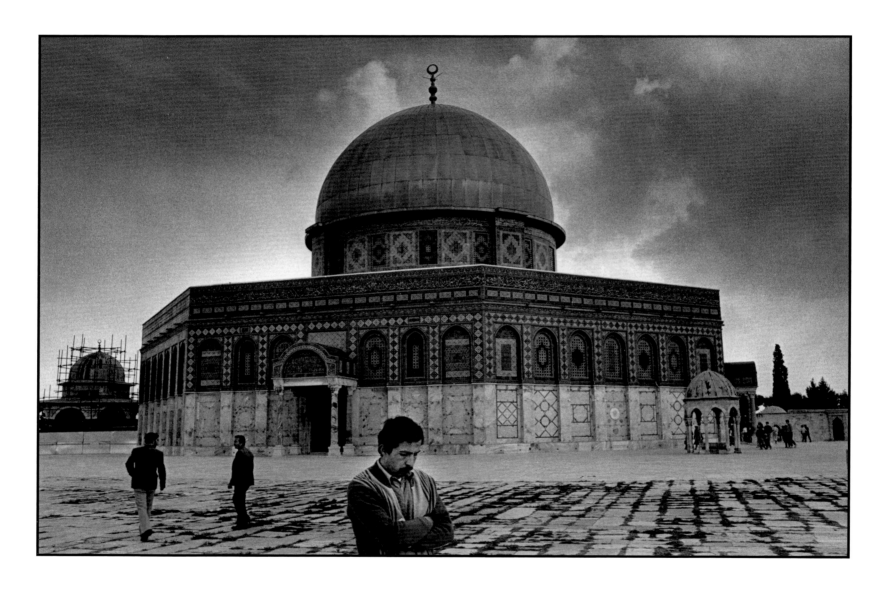

Jerusalem  1988

34

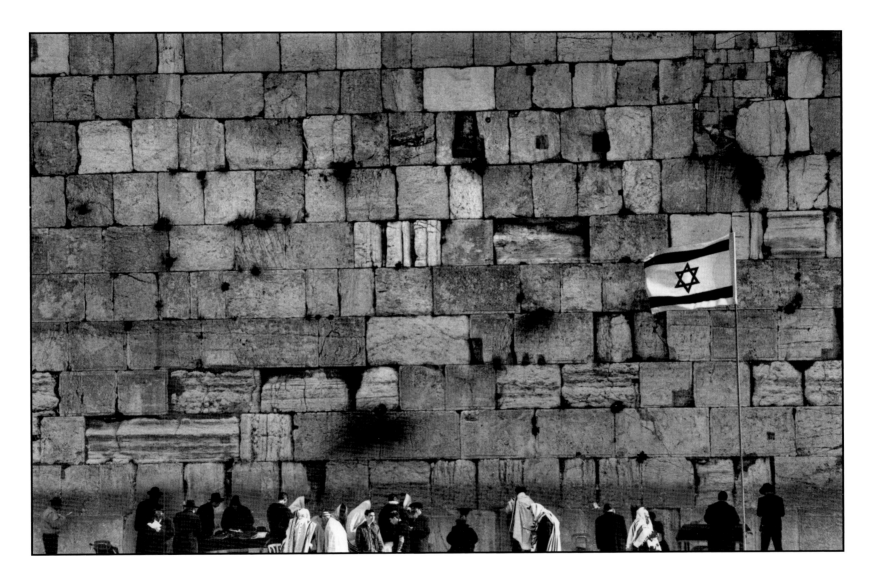

Jerusalem  2003

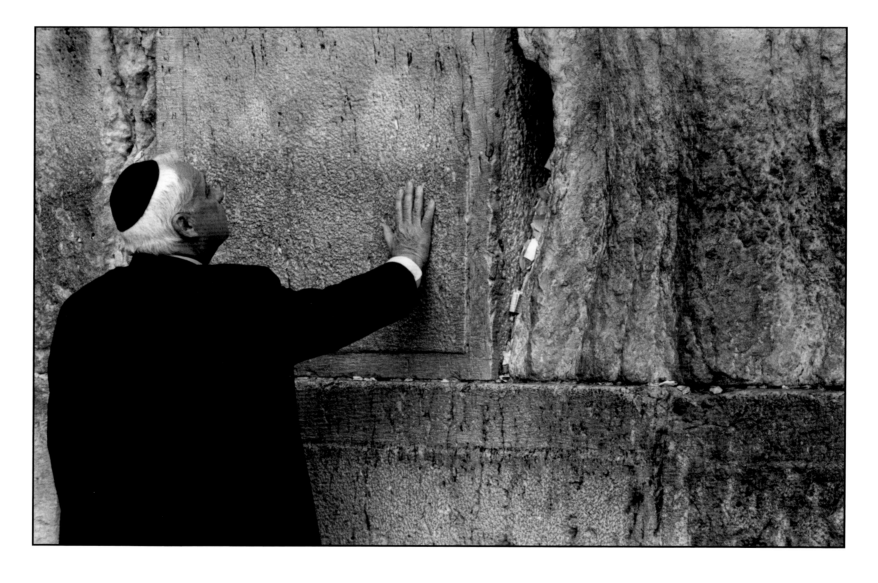

Jerusalem  2003

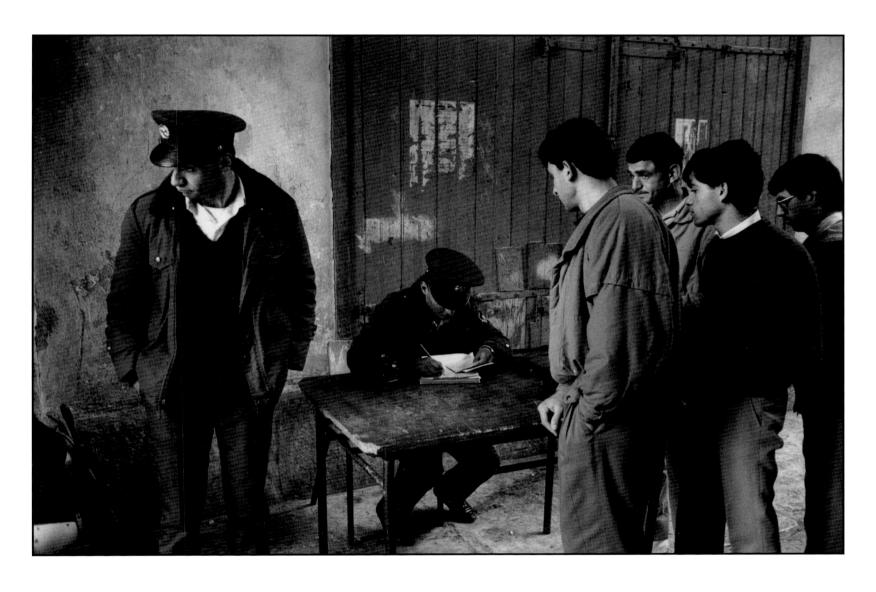

Jerusalem  2003

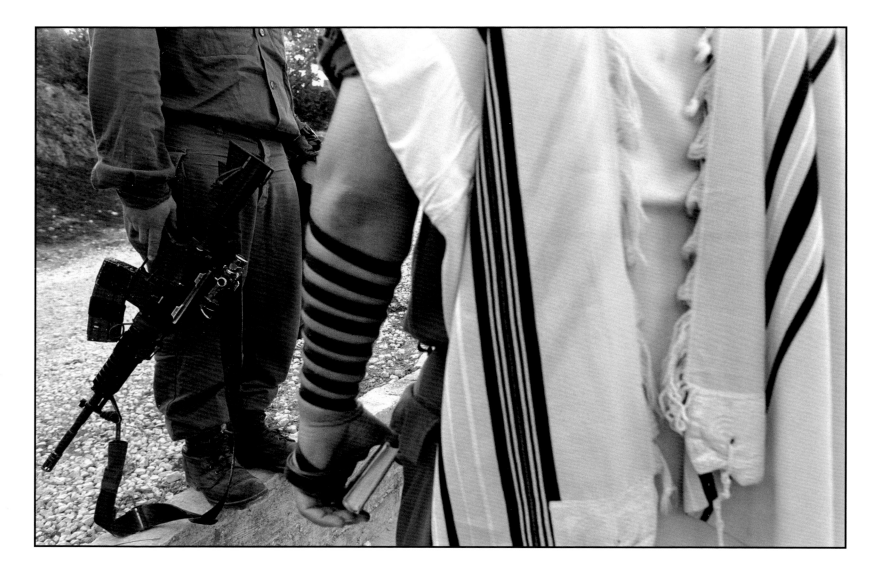

Kedumim  2003

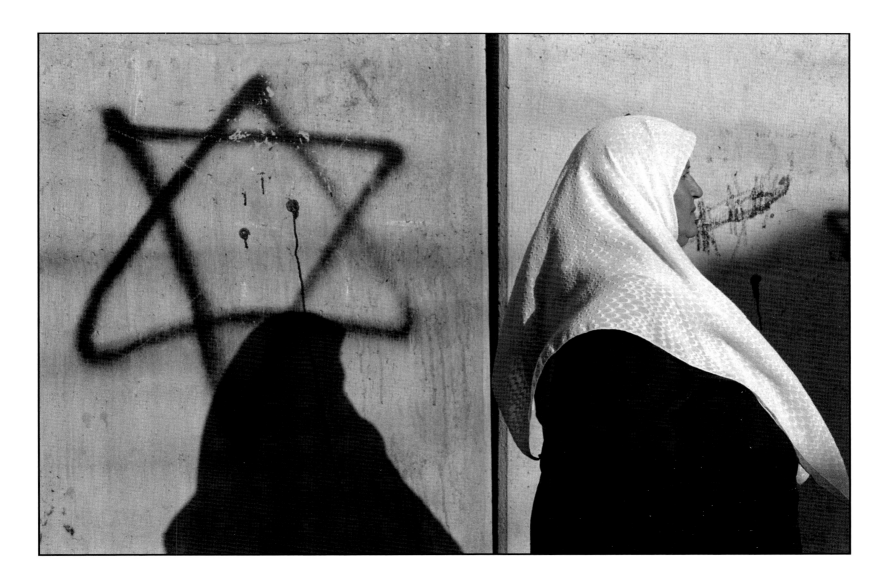

Abu Dis  2003

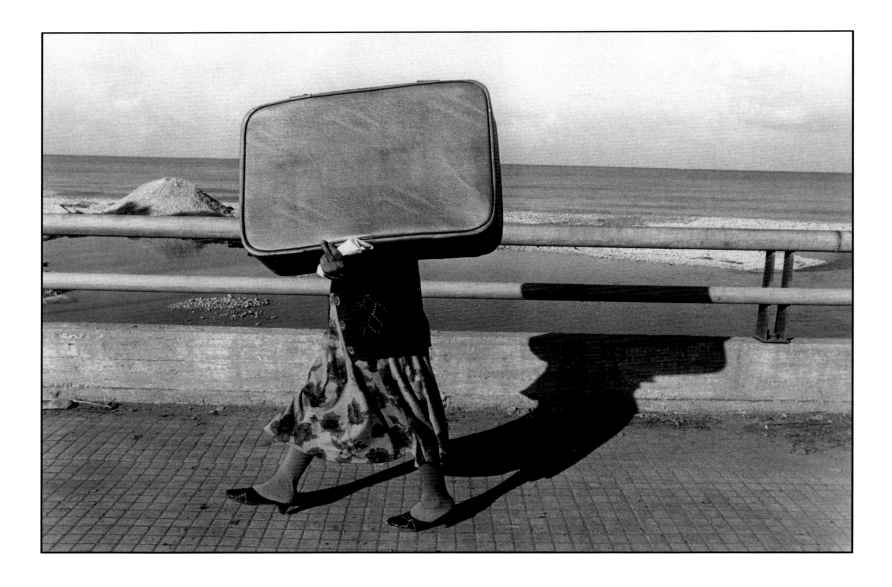

Sidon 1983

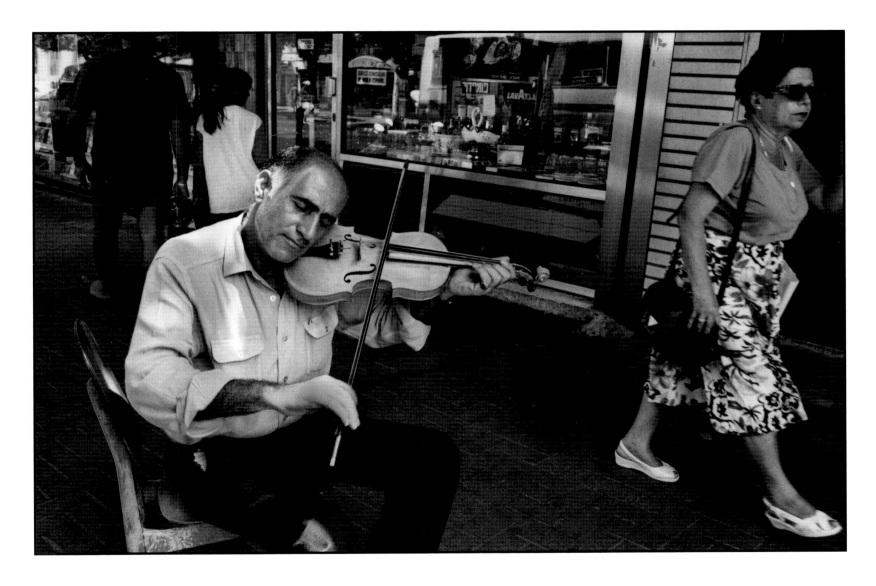

Tel Aviv  1993

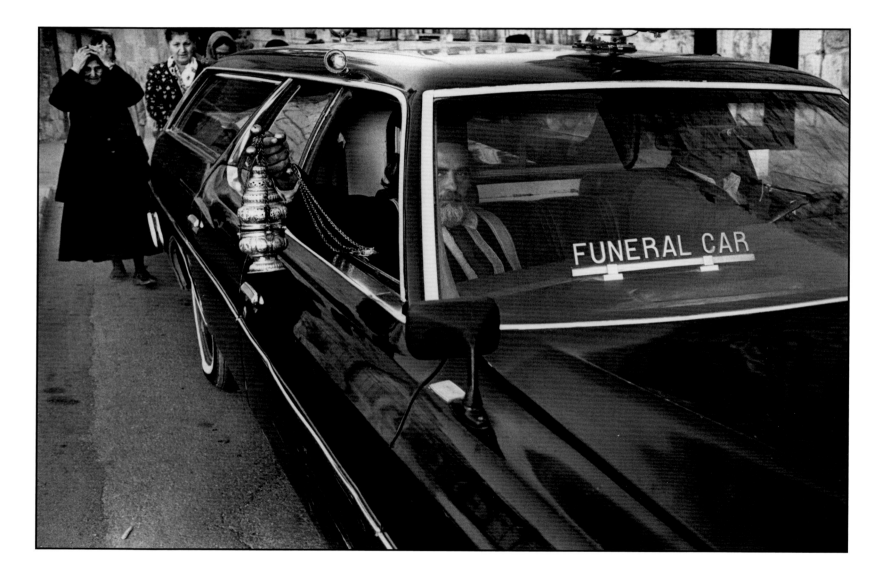

Jerusalem  1993

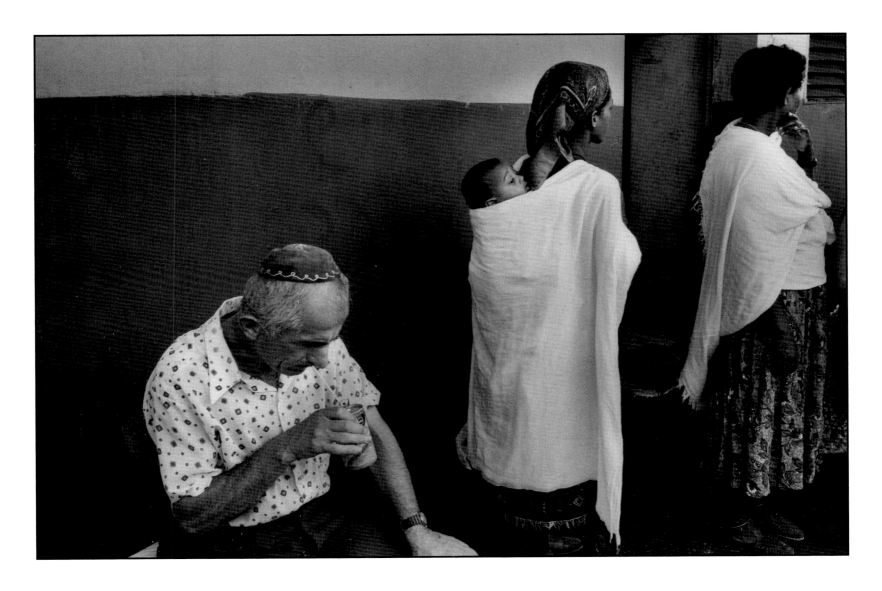

Tel Aviv 1992

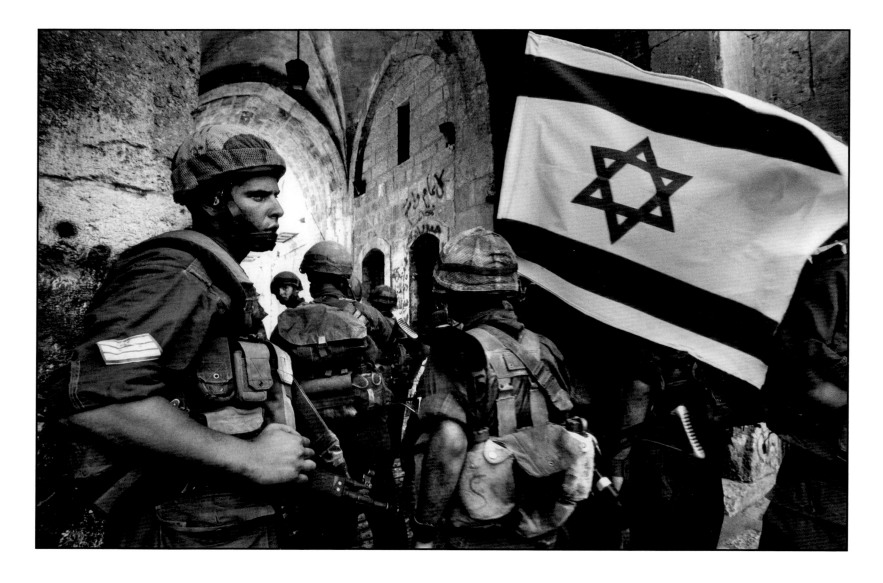

Jerusalem 1982

44

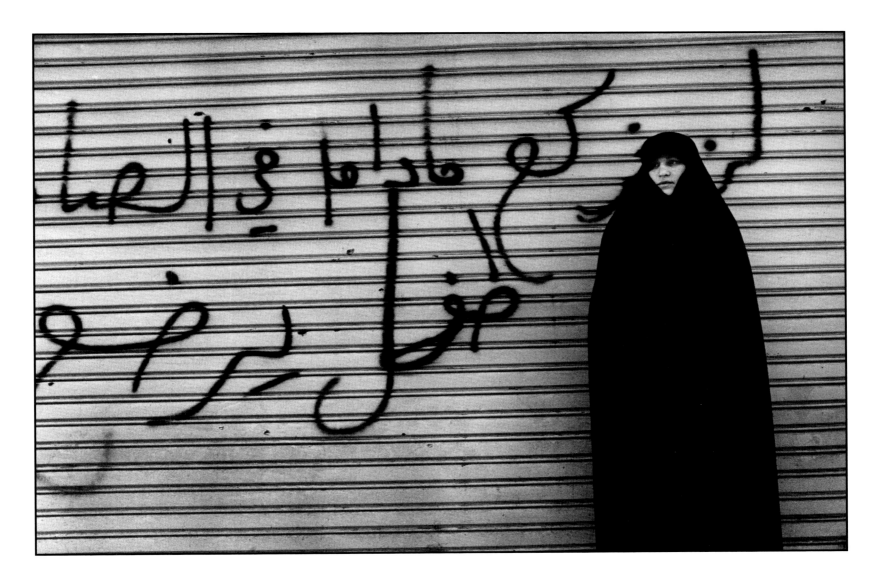

Beirut 1984

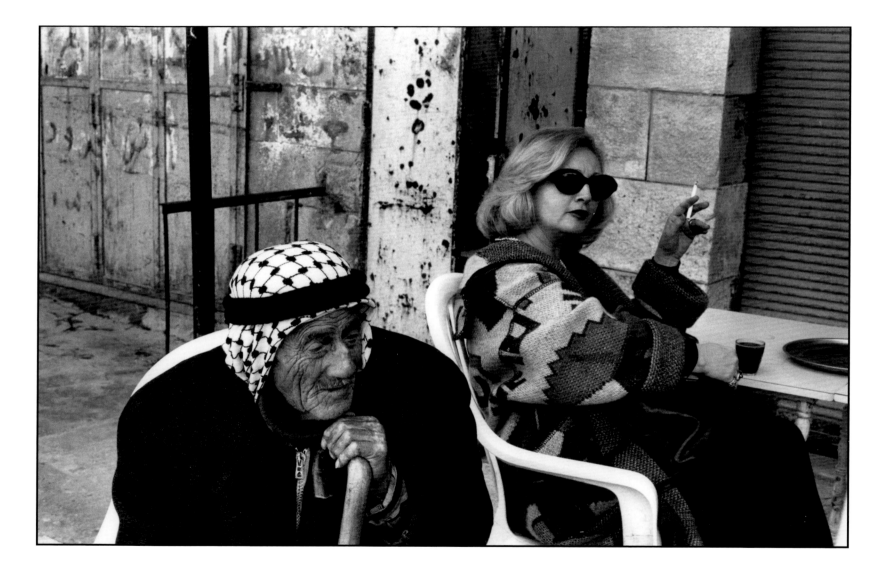

Hebron 1997

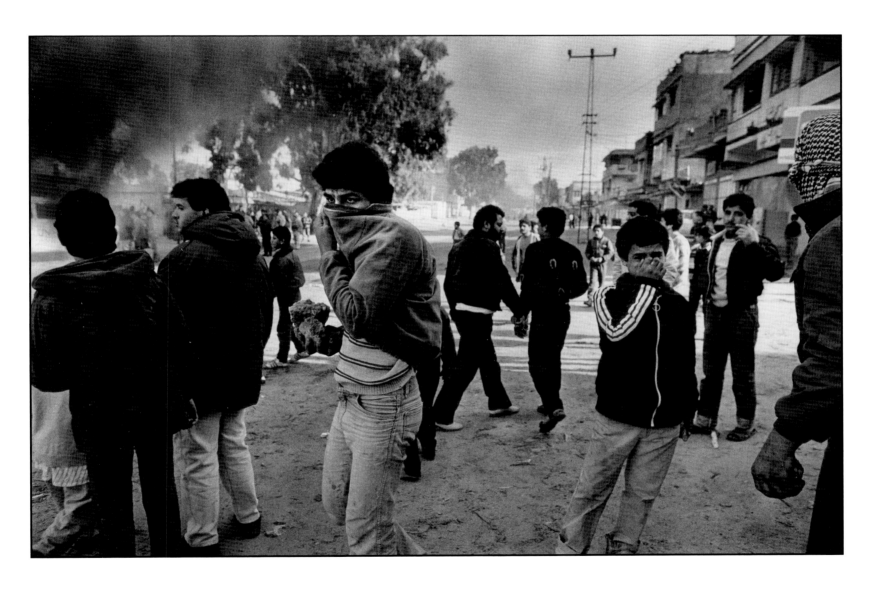

Gaza 1988

Gaza  1988

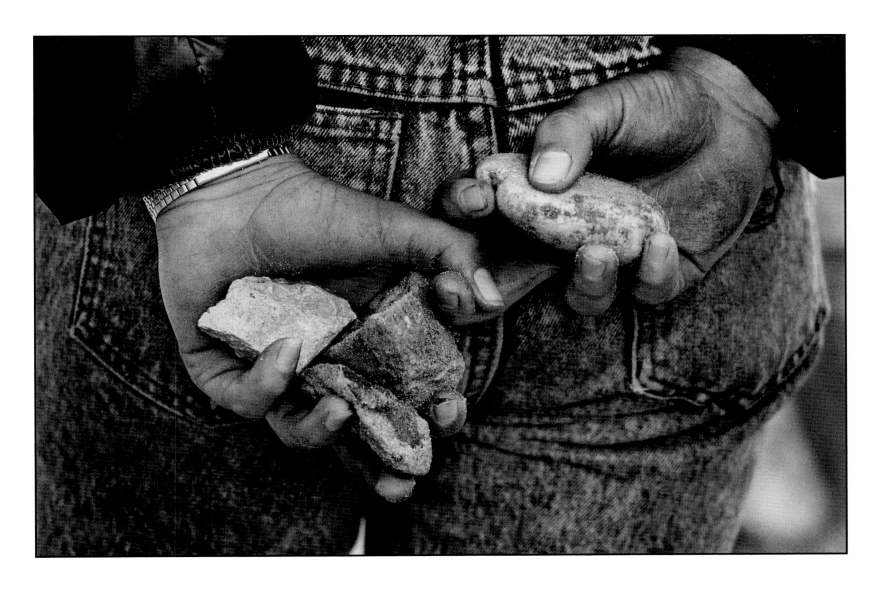

Gaza 1988

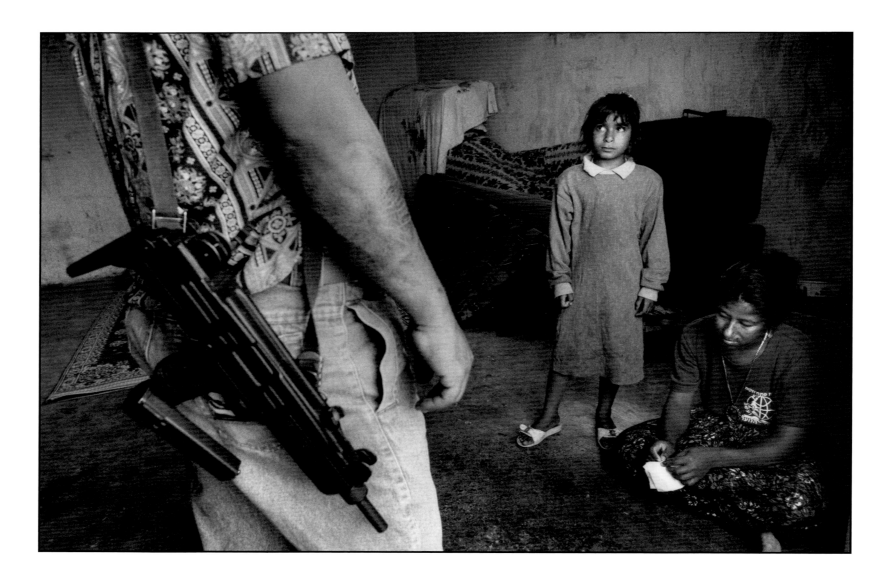

Fahme 1992

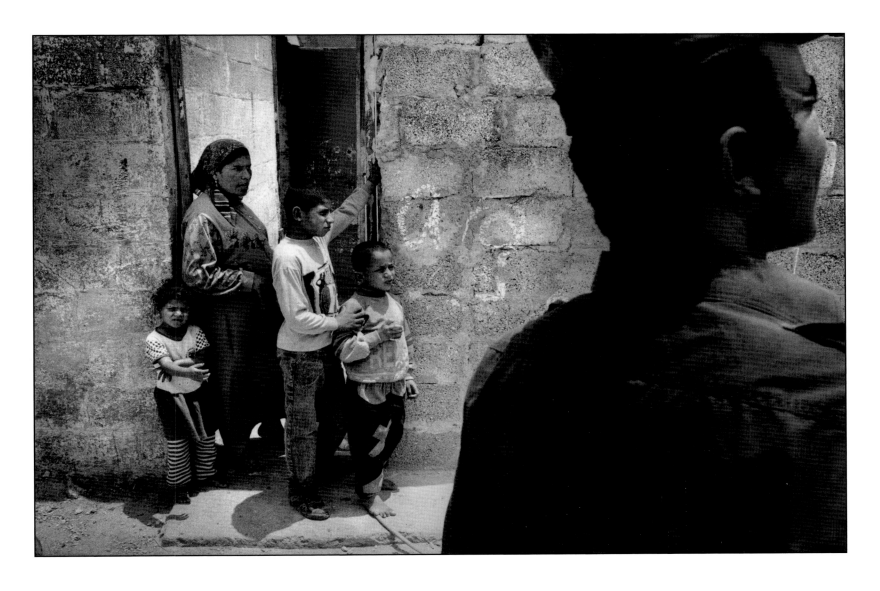

Fahme 1992

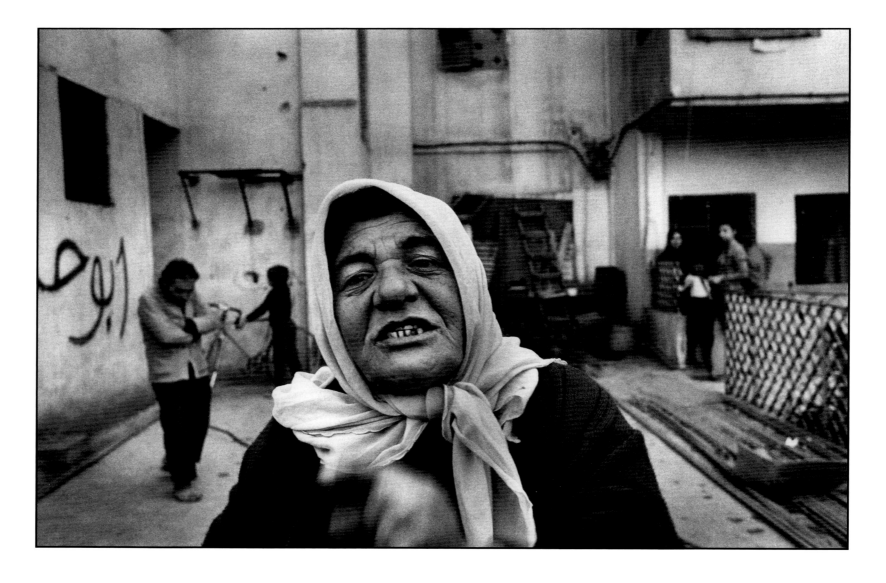

Beirut 1984

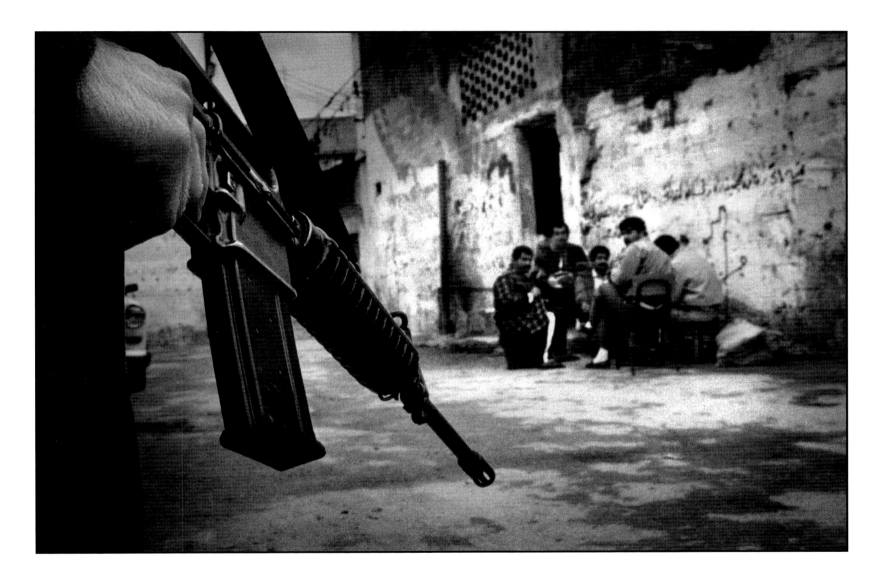

Gaza 1989

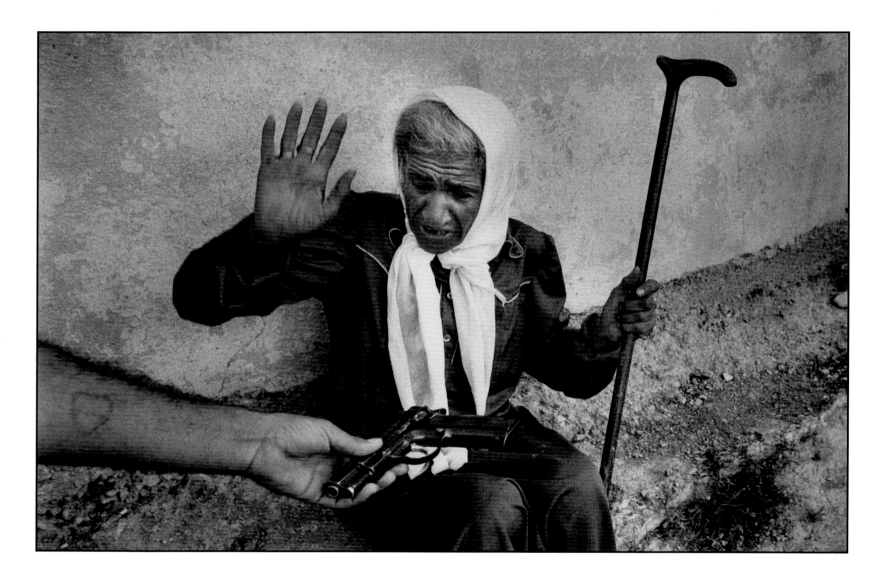

Fahme 1992

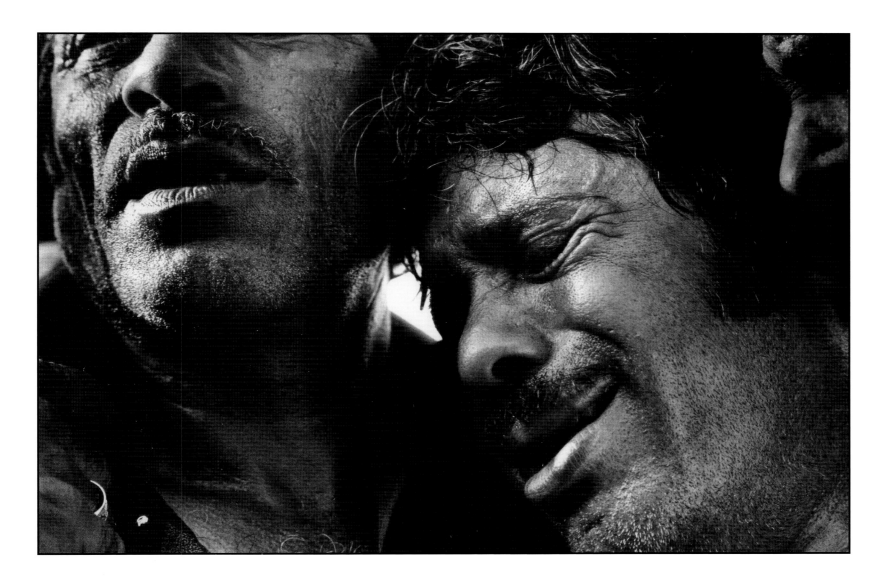

Jerusalem  1989

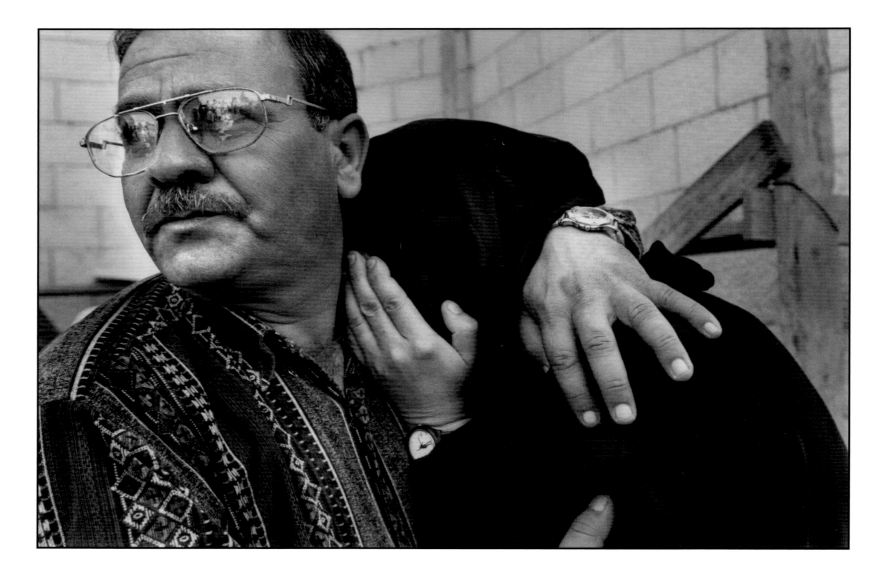

Jenin  2002

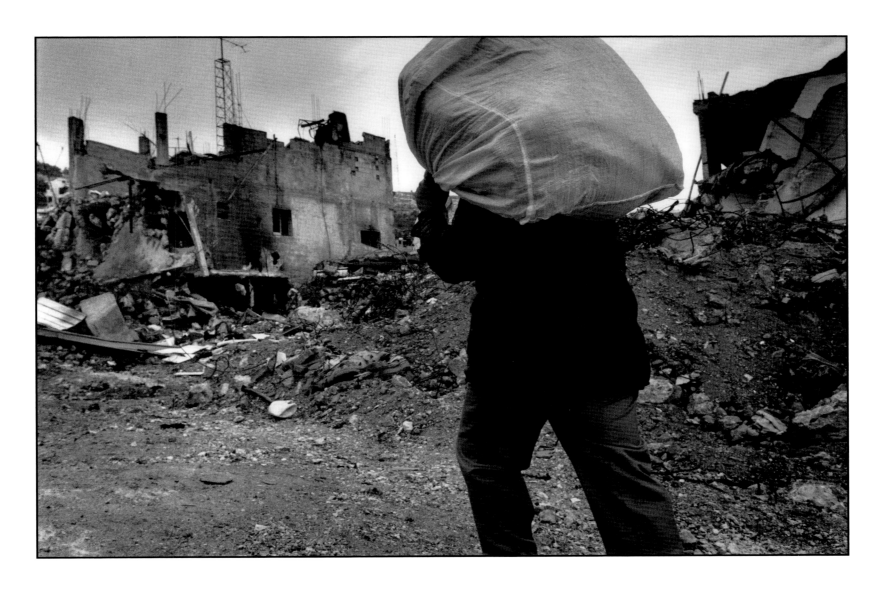

Jenin 2002

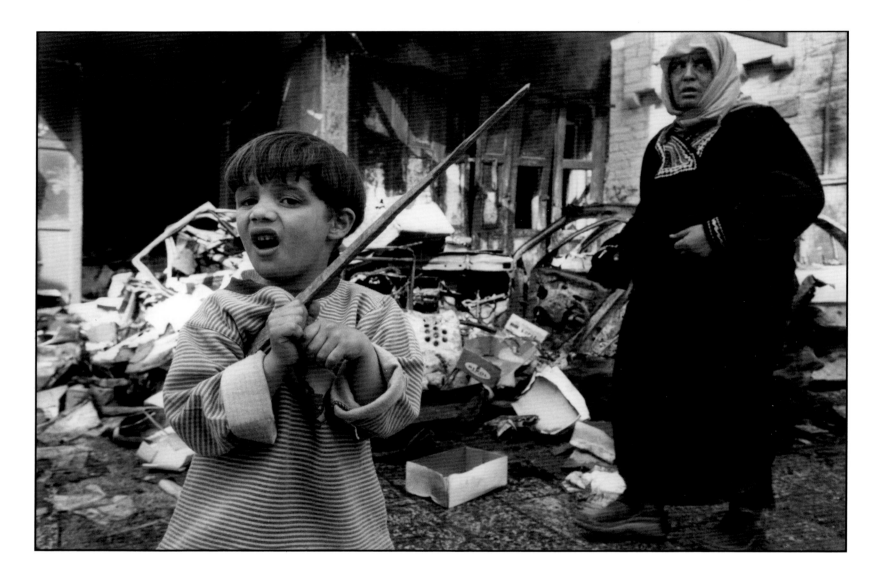

Bethlehem 2002

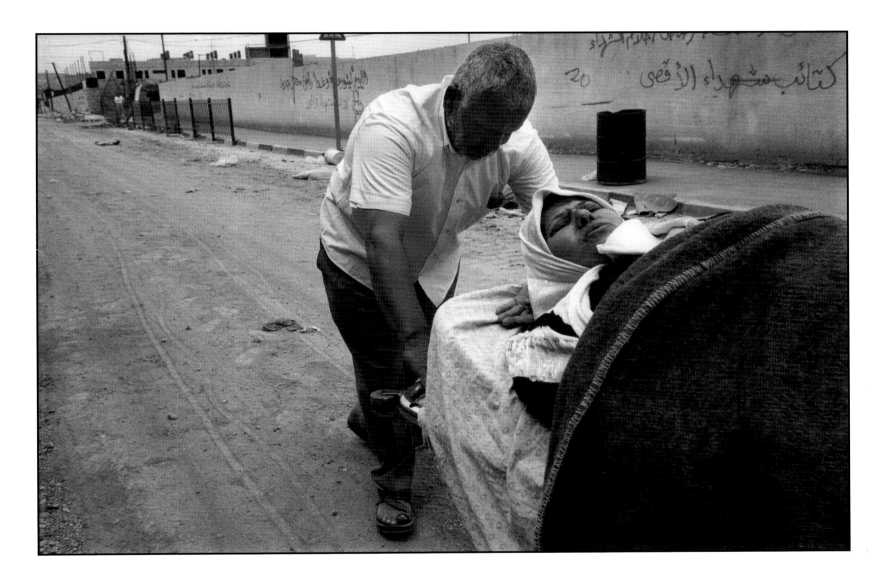

Jenin 2002

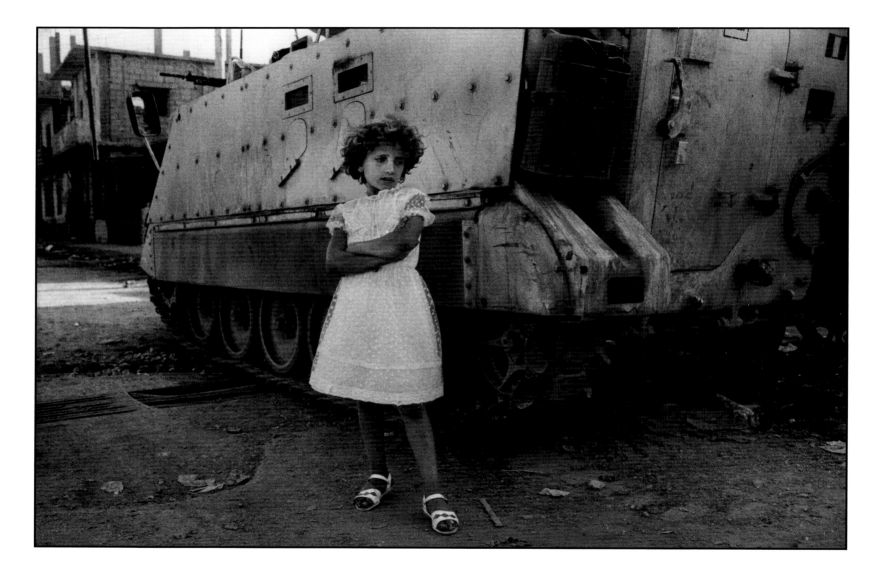

Beirut  1983

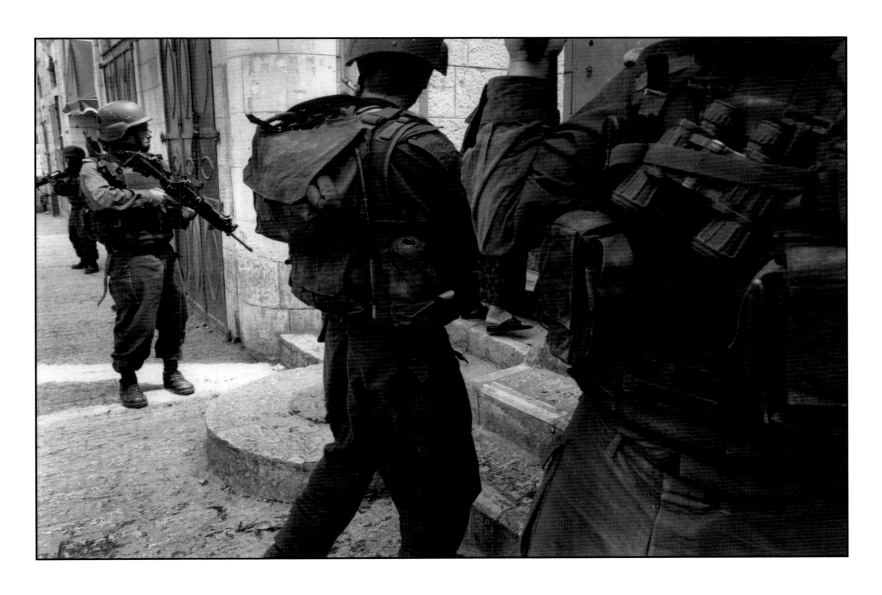

Bethlehem 2002

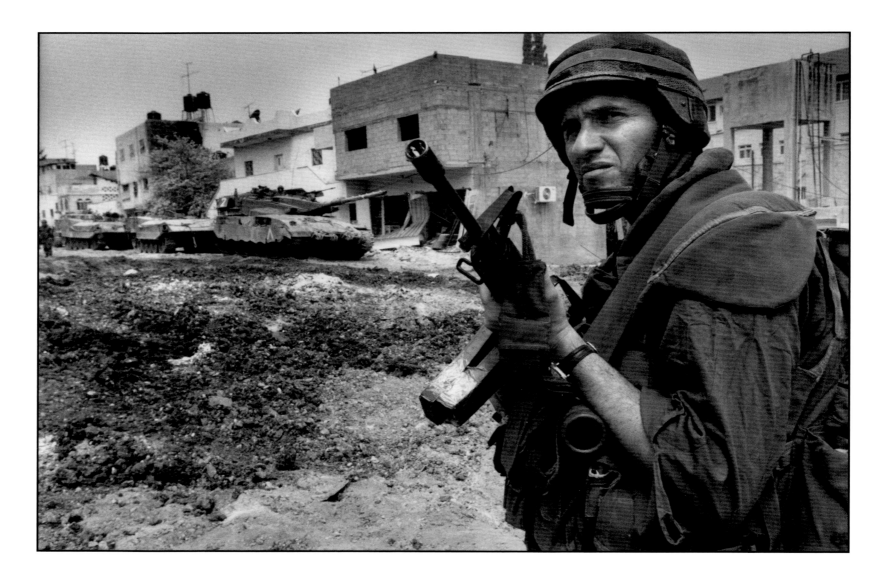

Jenin  2002

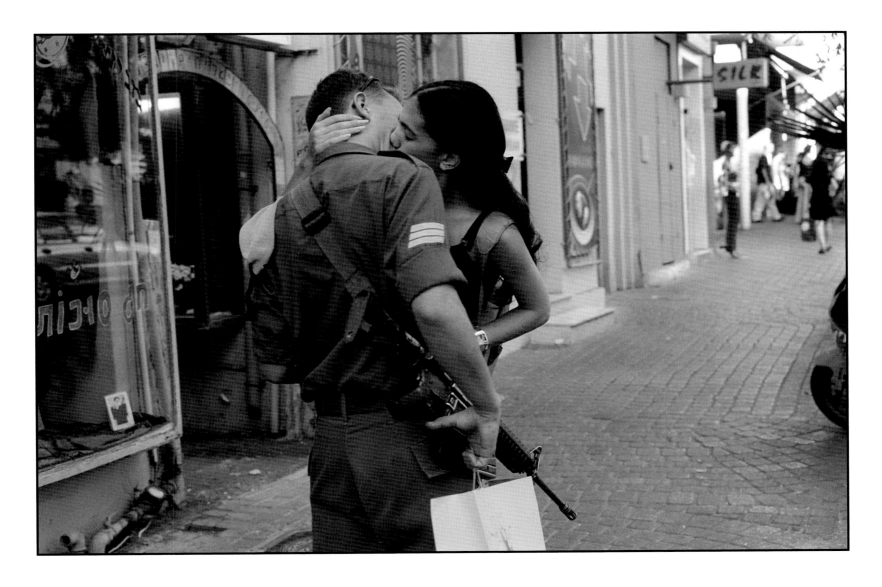

Tel Aviv  2003

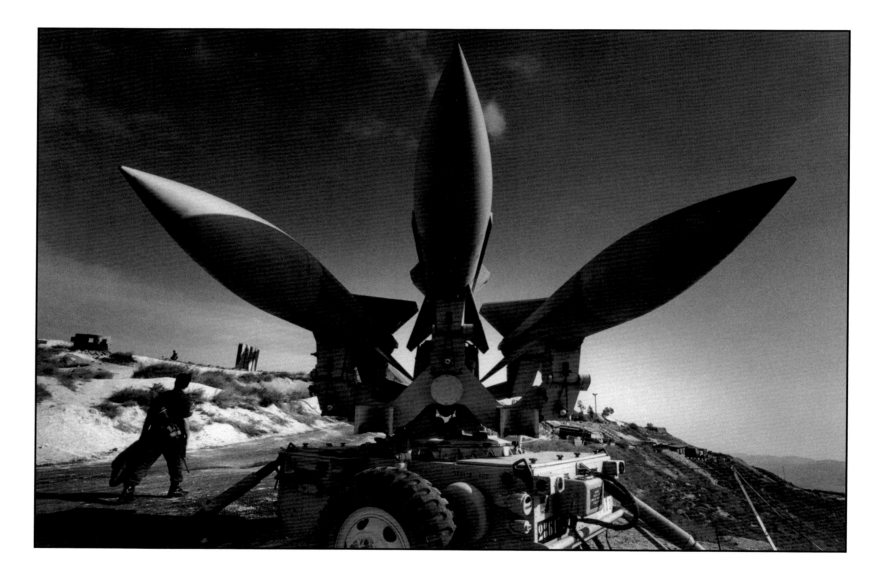

Judean Hills  1991

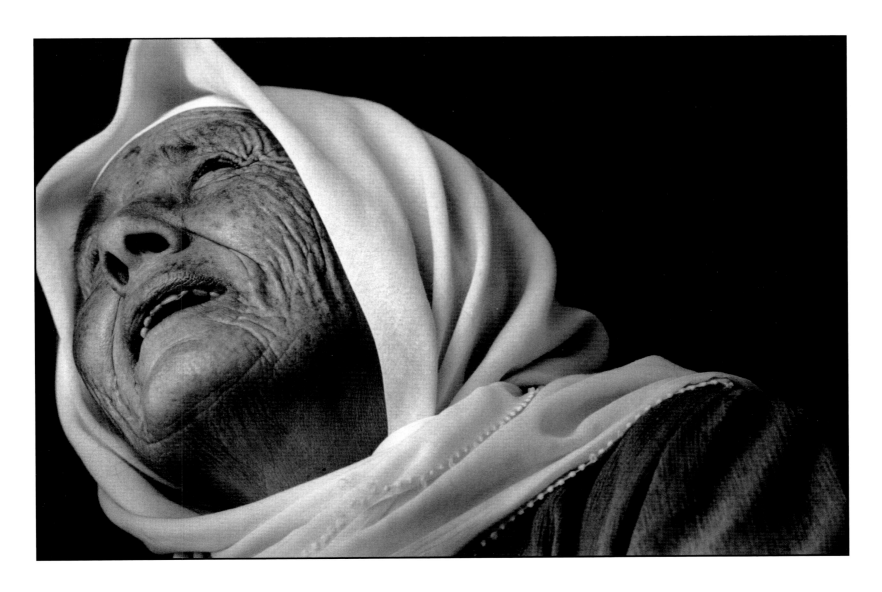

Araba 2000

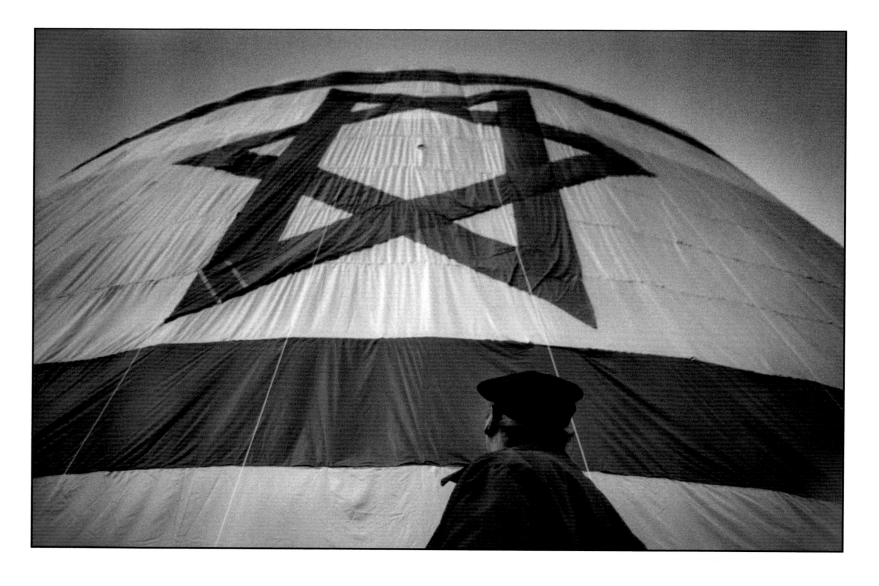

Tel Aviv 1991

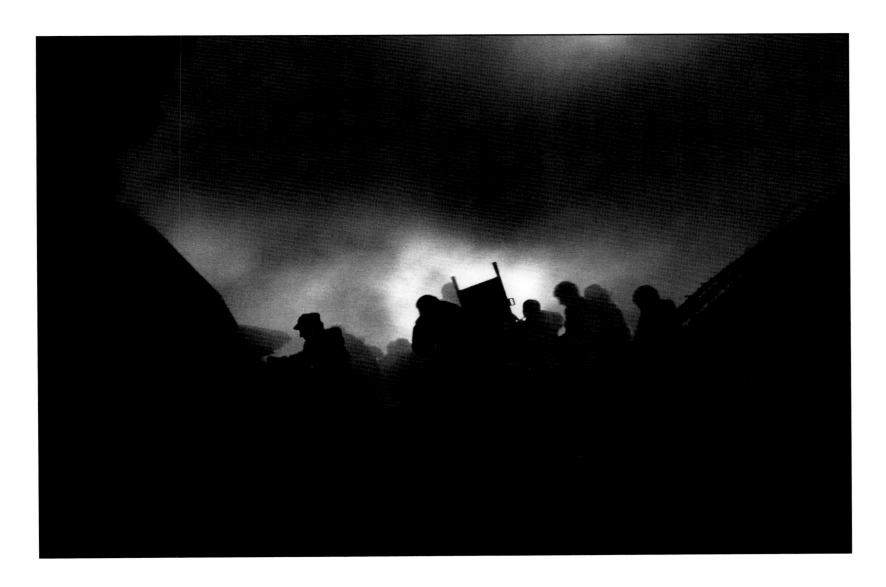

Ramat Gan 1991

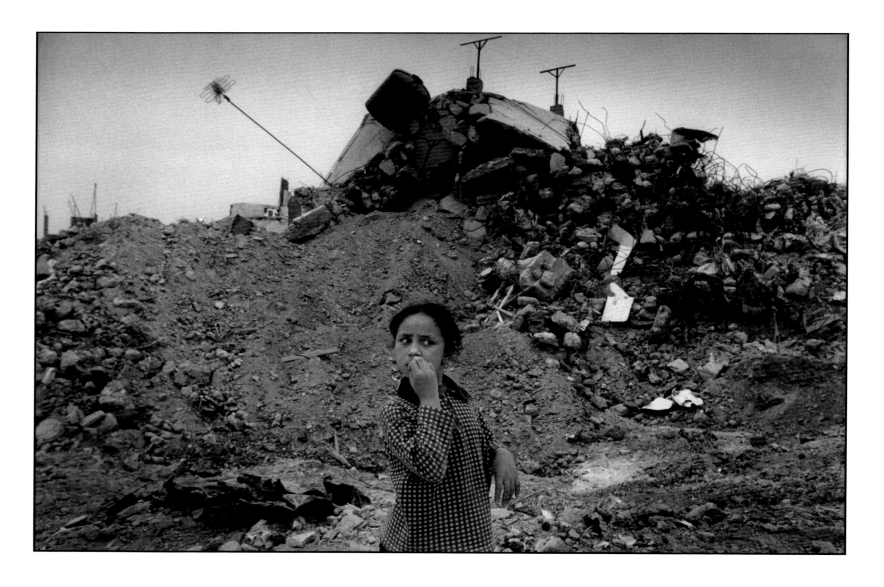

Jenin 2002

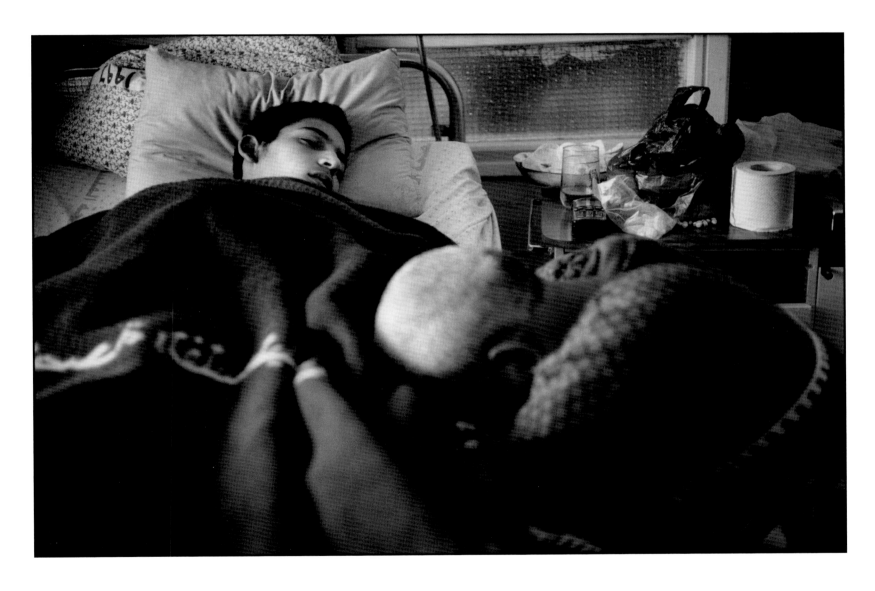

Nablus 2002

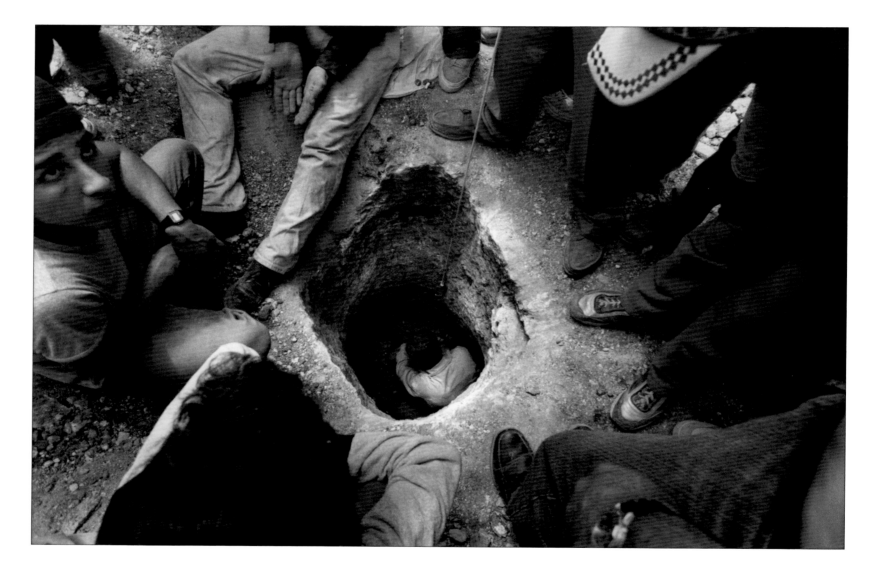

Jenin 2002

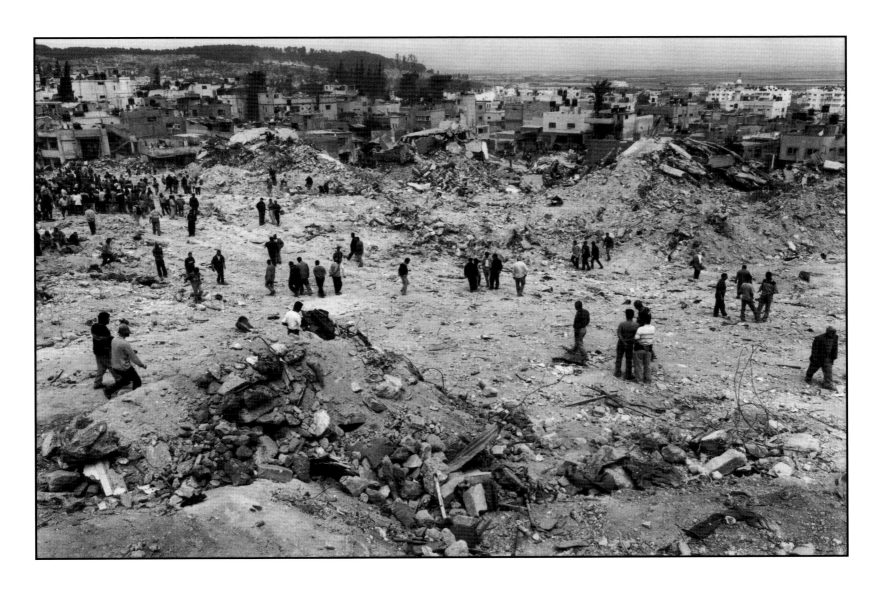

Jenin 2002

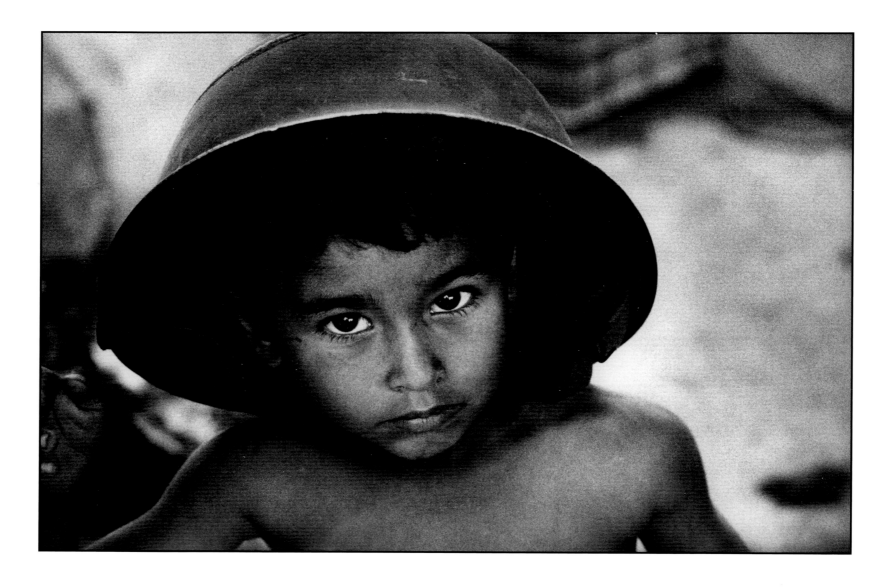

Beirut 1982

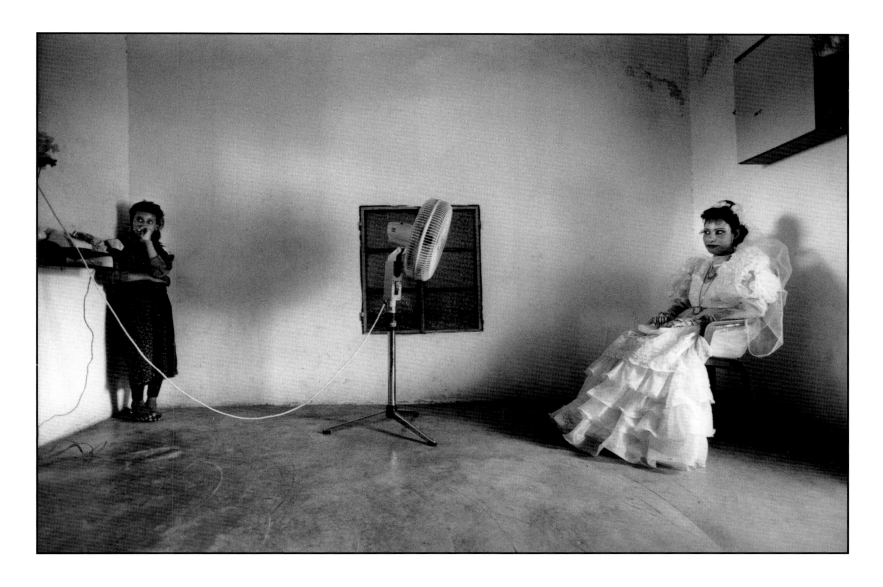

Jericho 1993

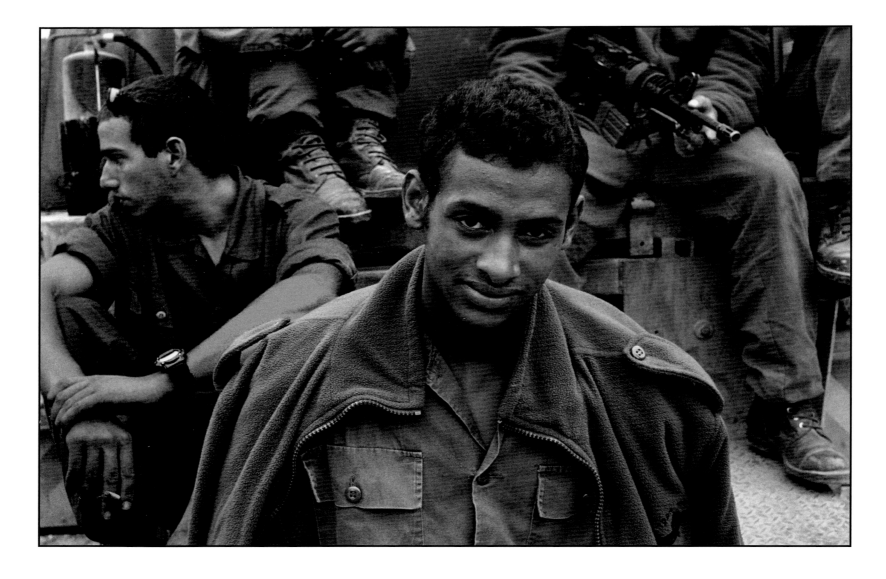

Kedumim  2003

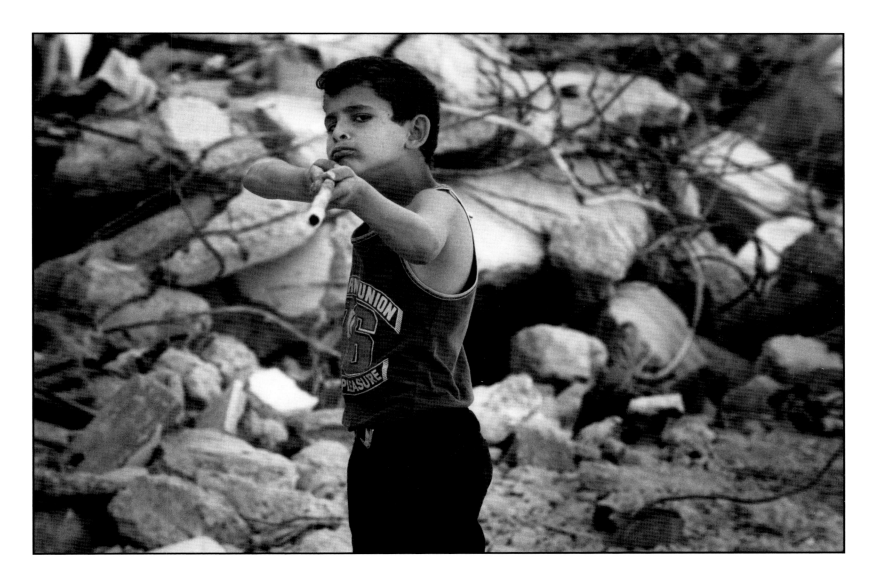

Jenin 2002

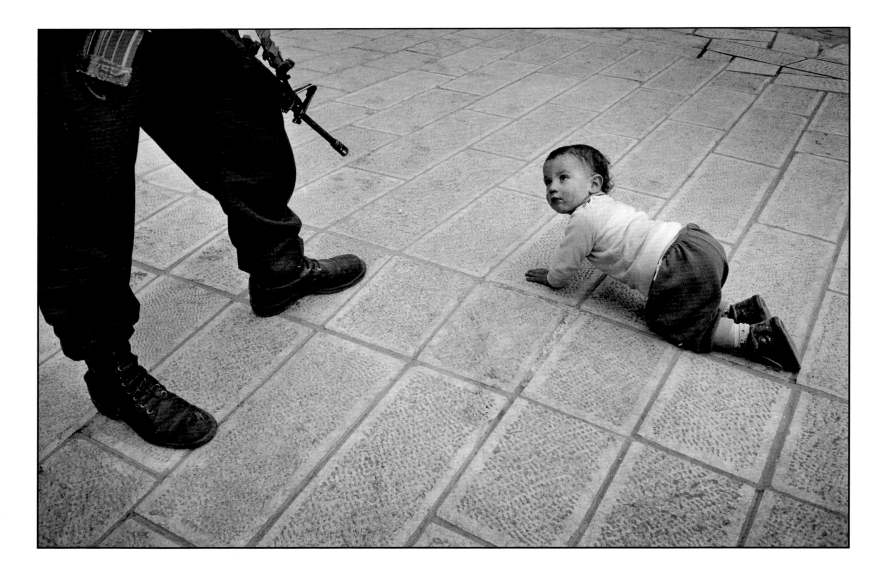

Hebron  1997

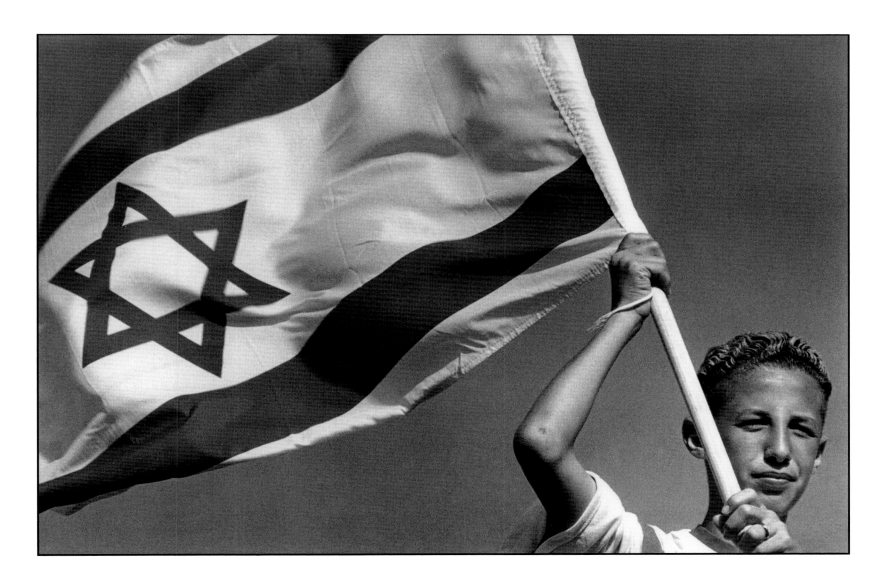

Tel Aviv  1999

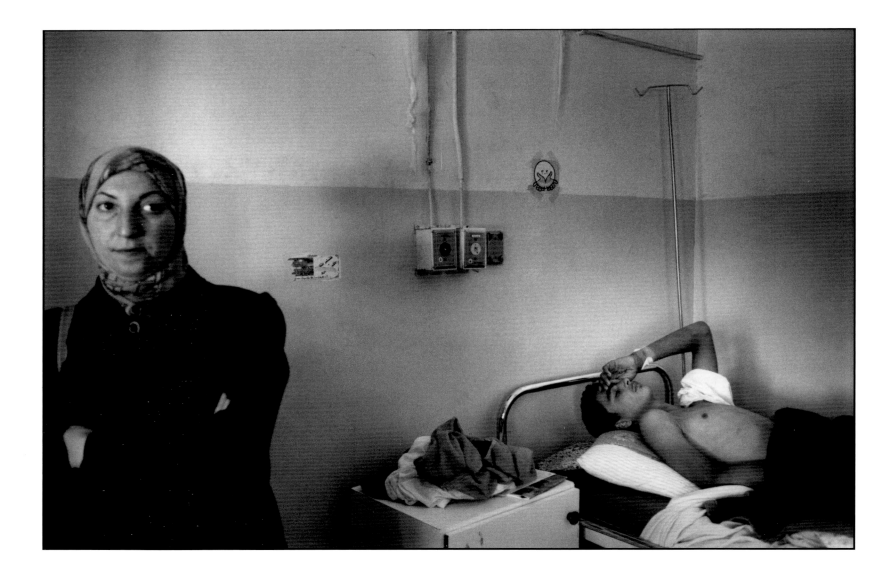

Nablus 2002

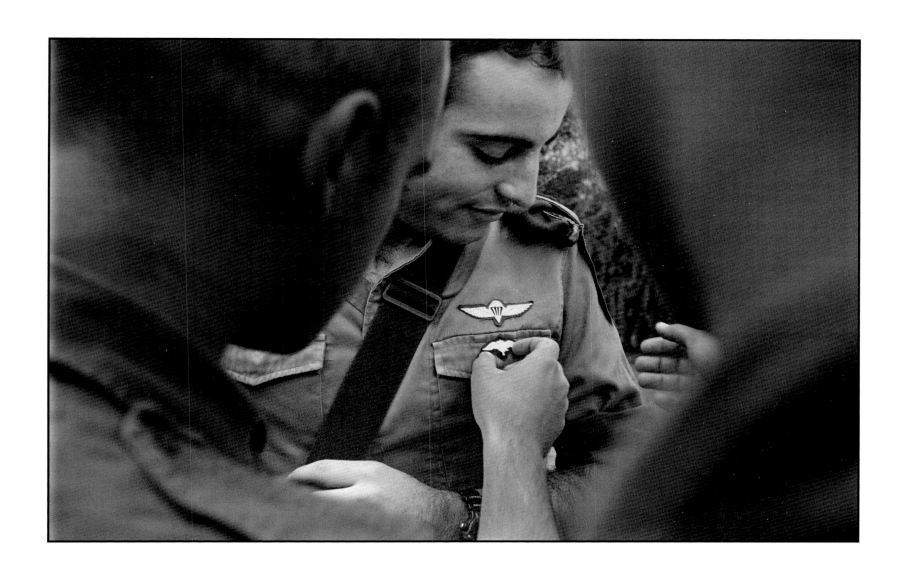

Kedumim 2003

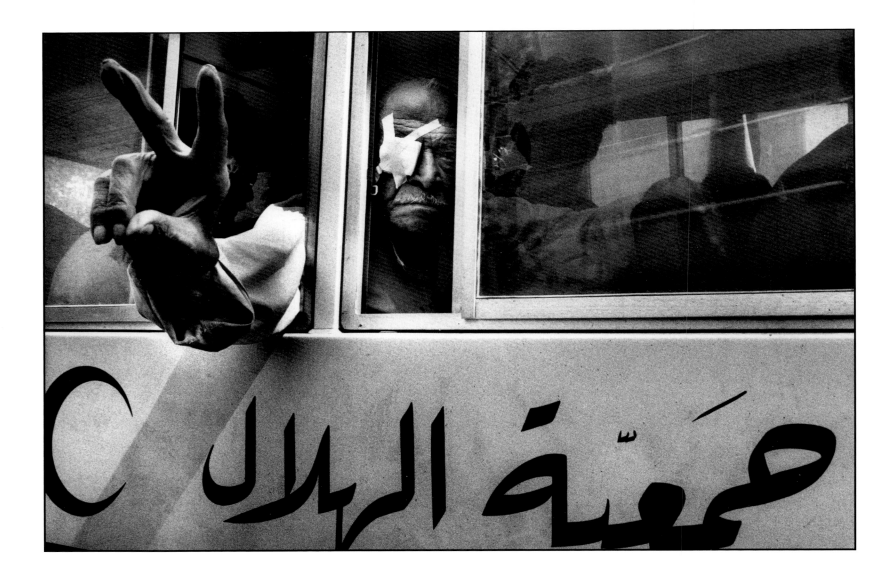

Beirut 1982

80

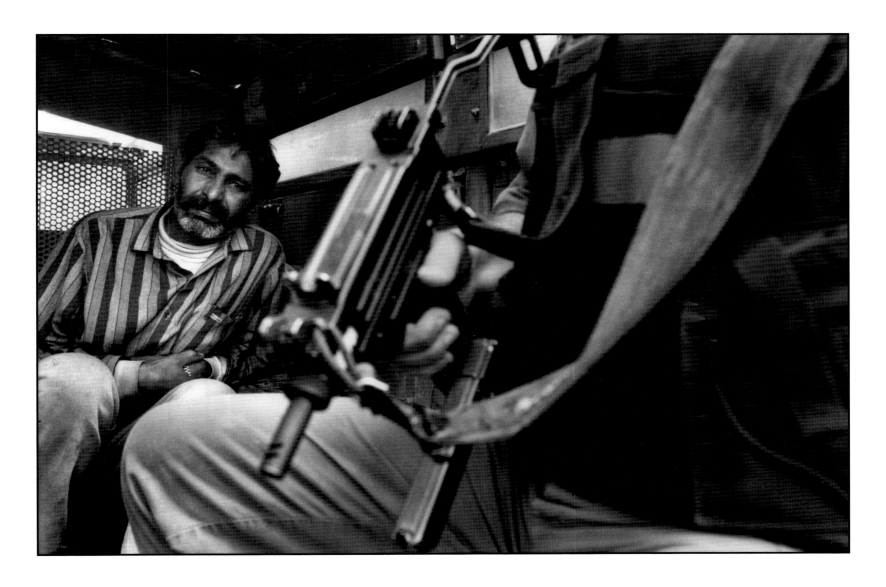

Bethlehem 2002

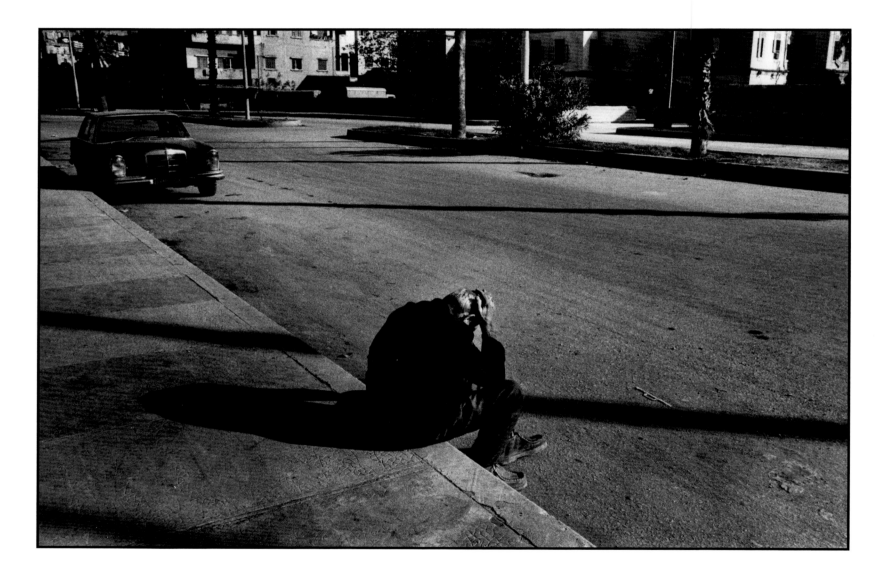

Beirut 1984

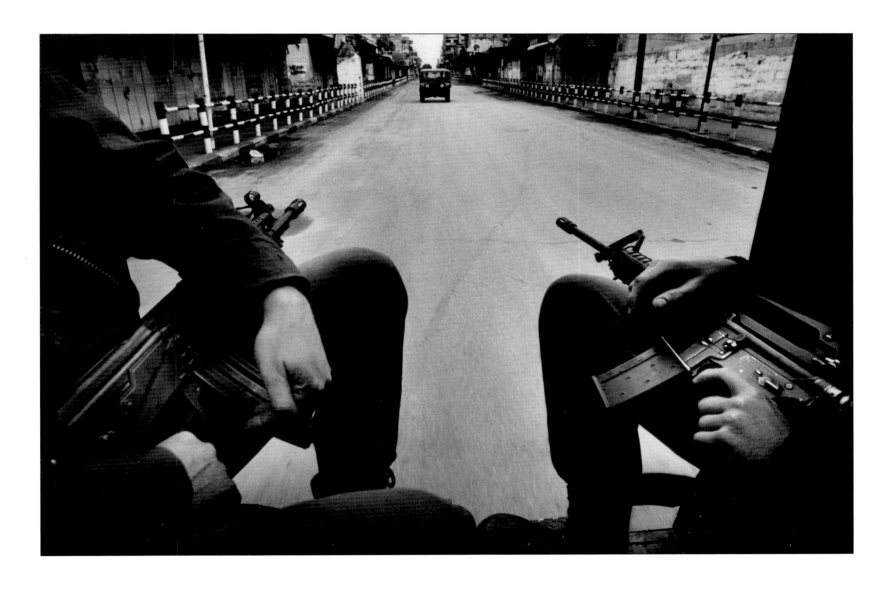

Gaza 1989

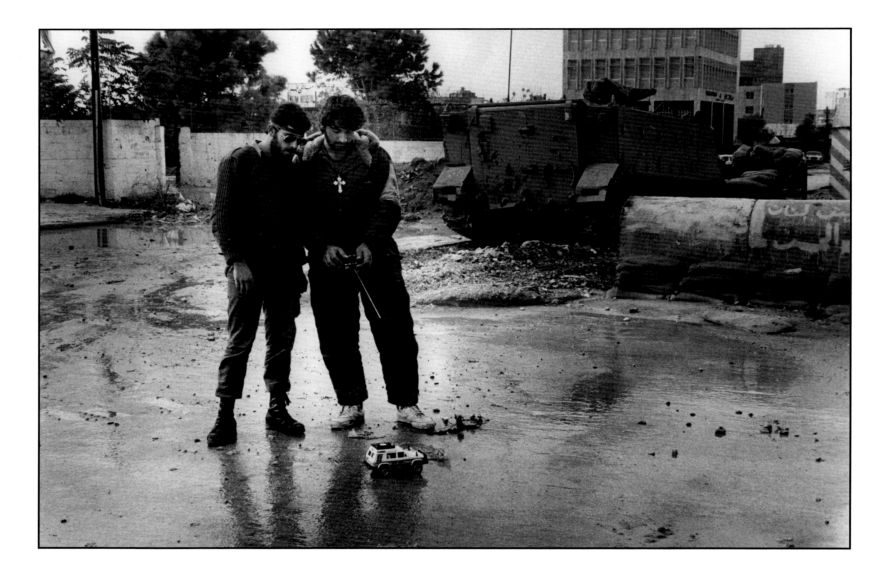

Sidon 1983

84

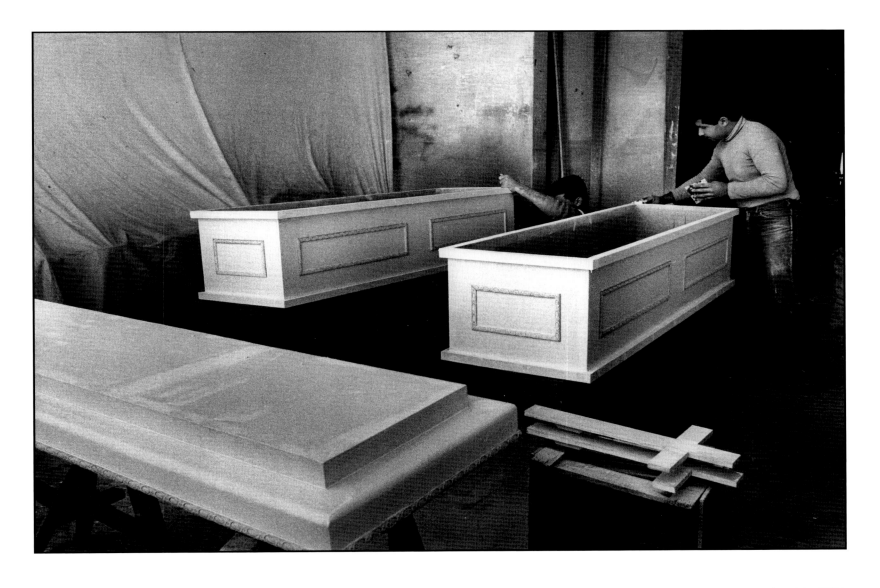

Jounieh 1984

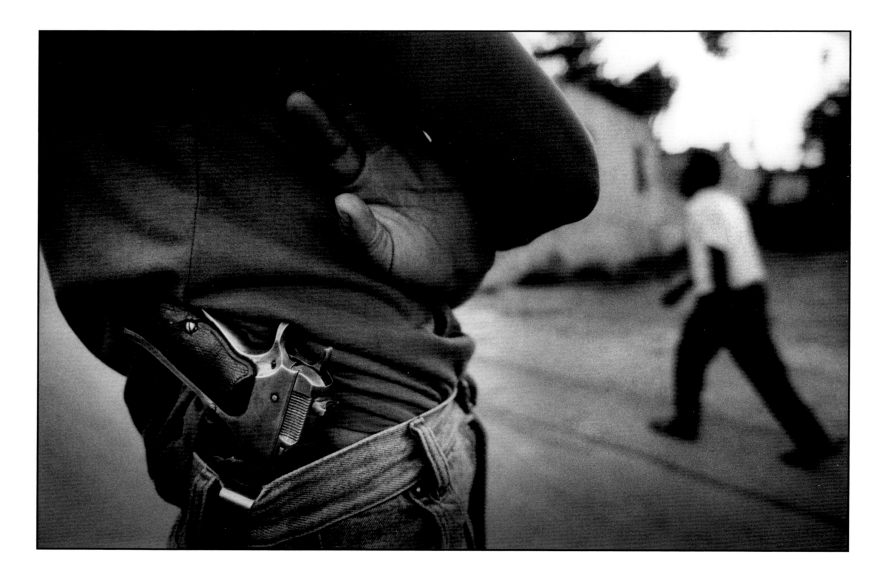

Fahme 1992

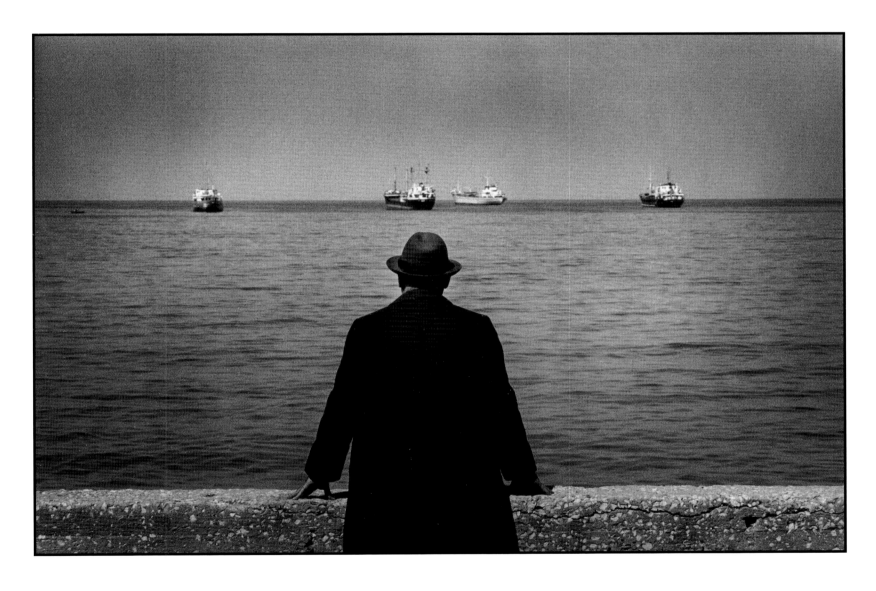

Jounieh  1984

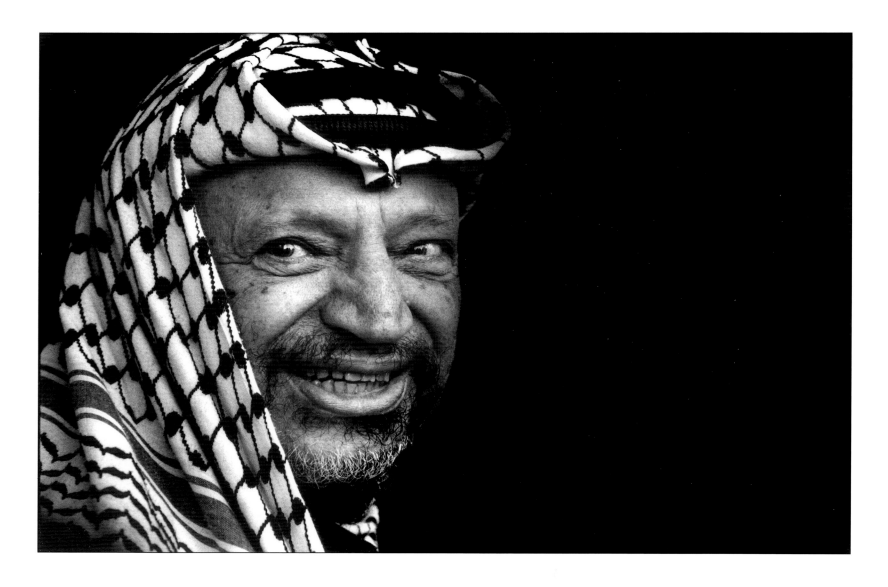

Jericho  1996

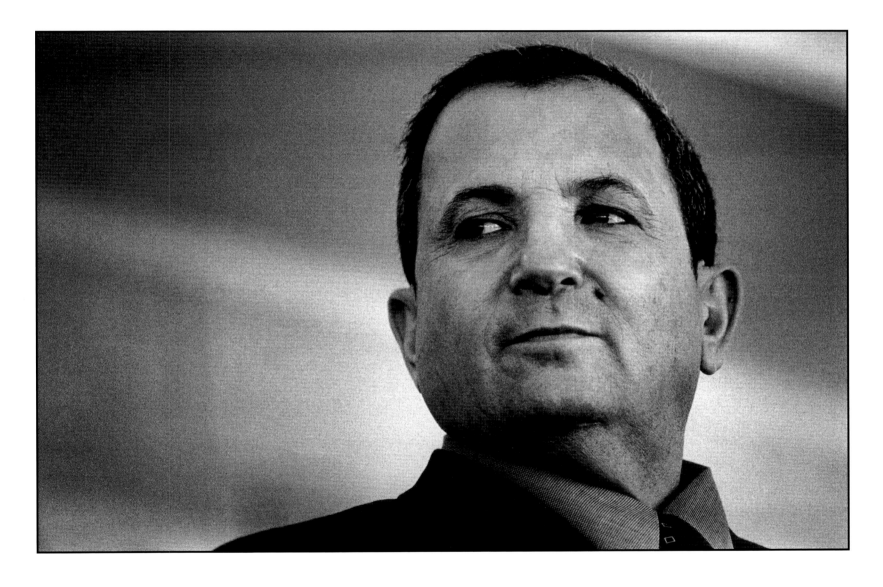

Tel Aviv 1999

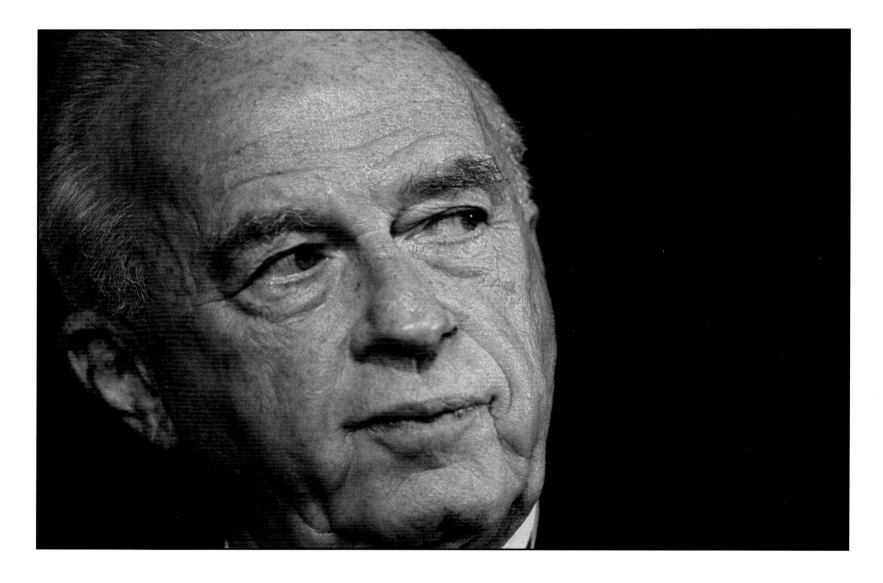

Tel Aviv  1993

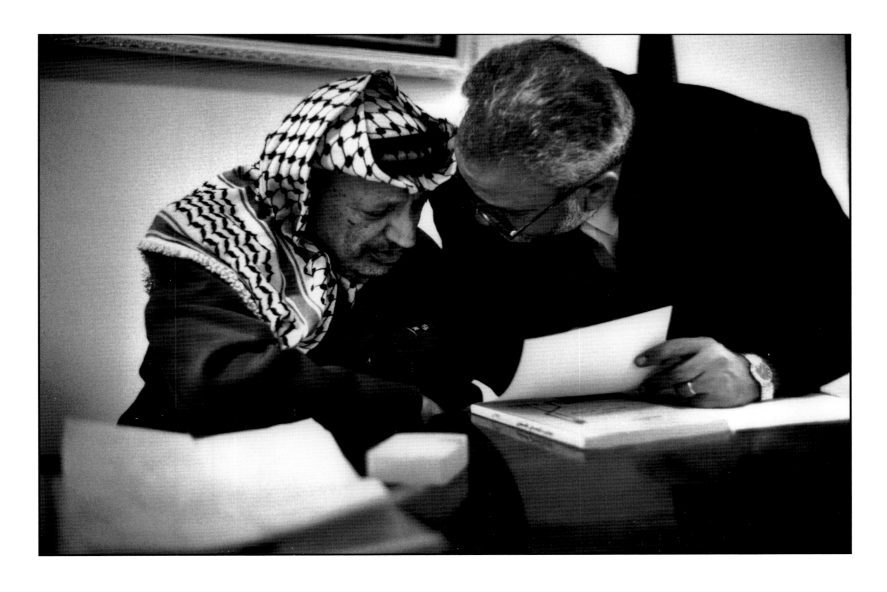

Jericho 1996

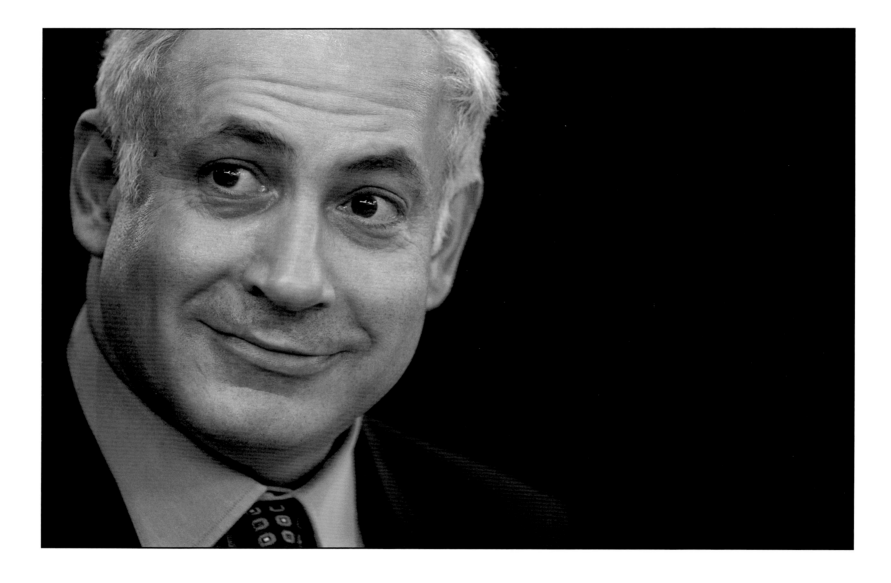

Tel Aviv 2003

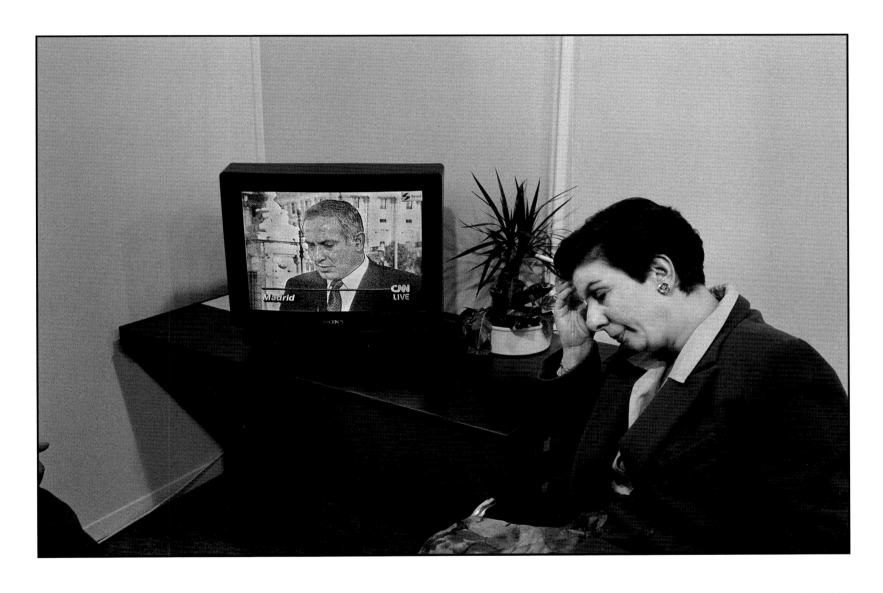

Madrid  1991

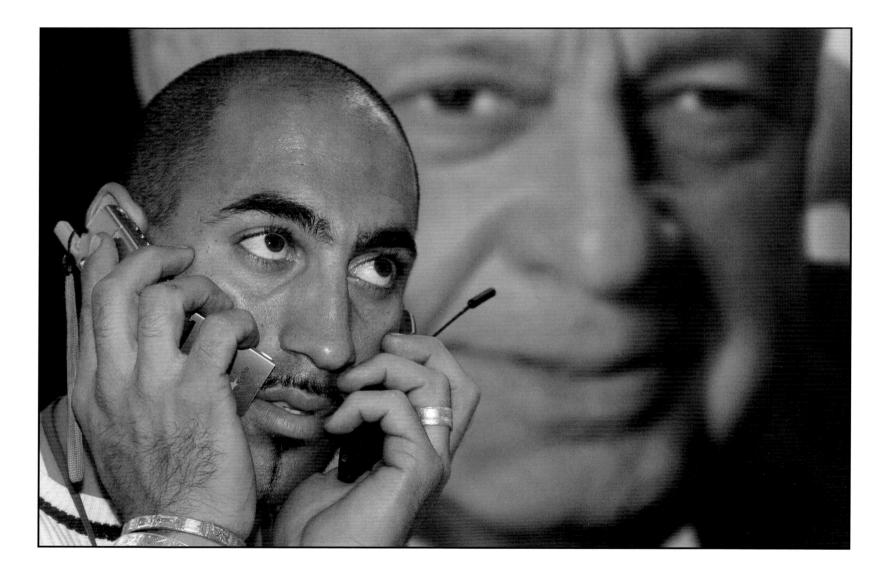

Tel Aviv 2003

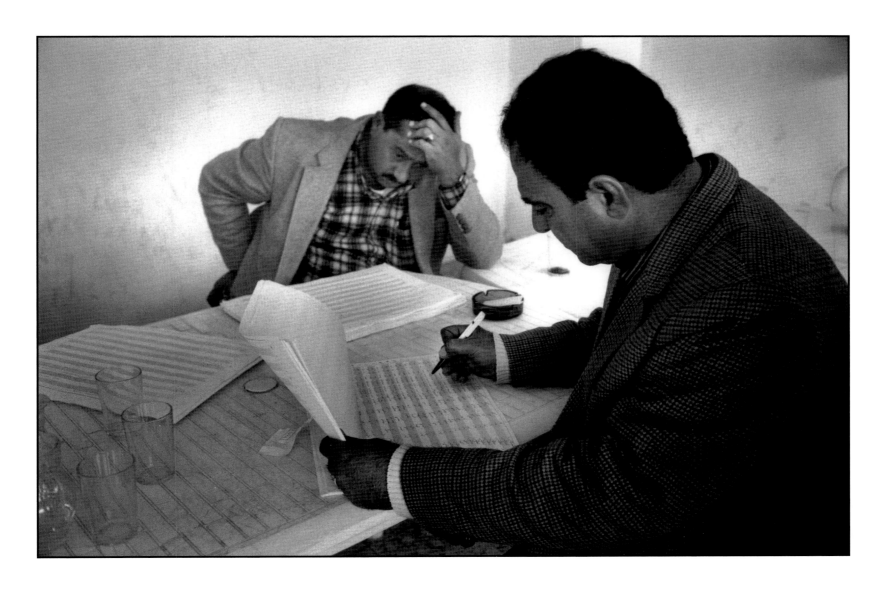

Jericho 1996

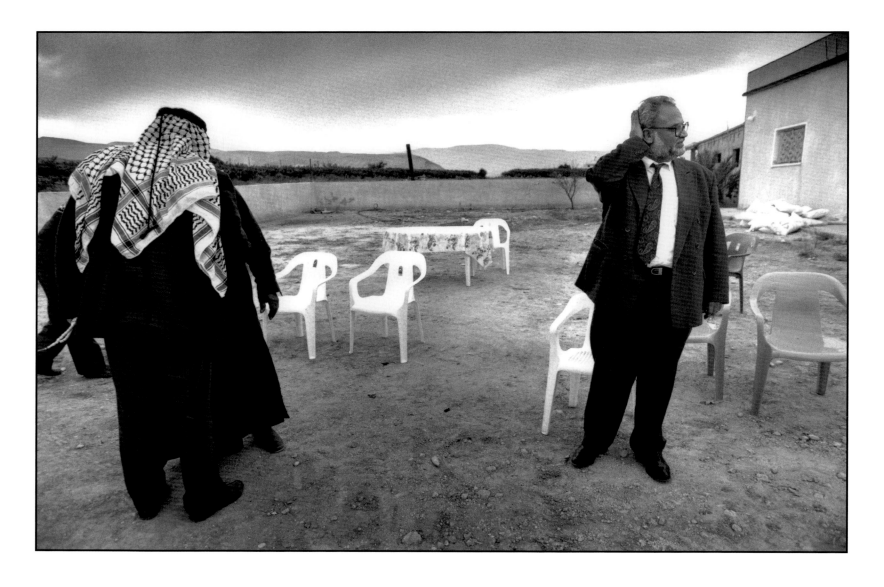

Jericho  1996

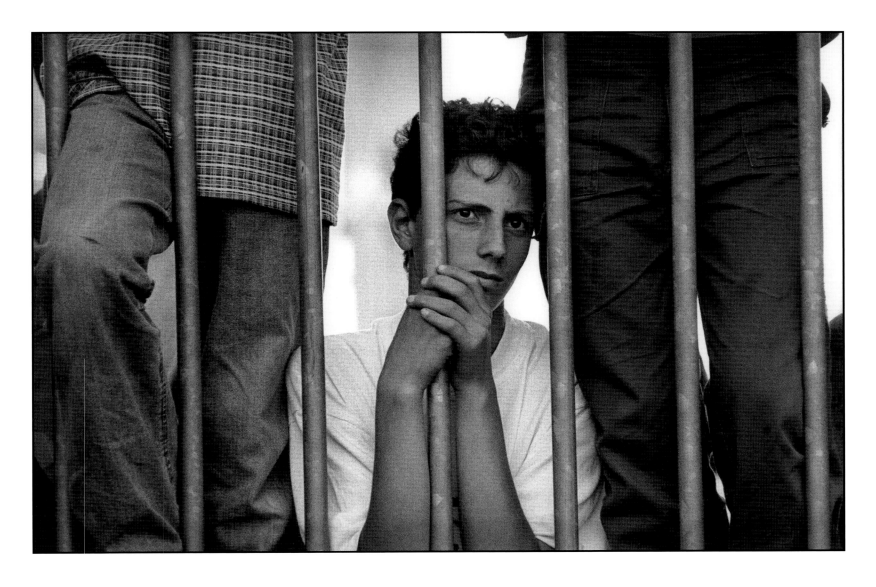

Nazareth 1999

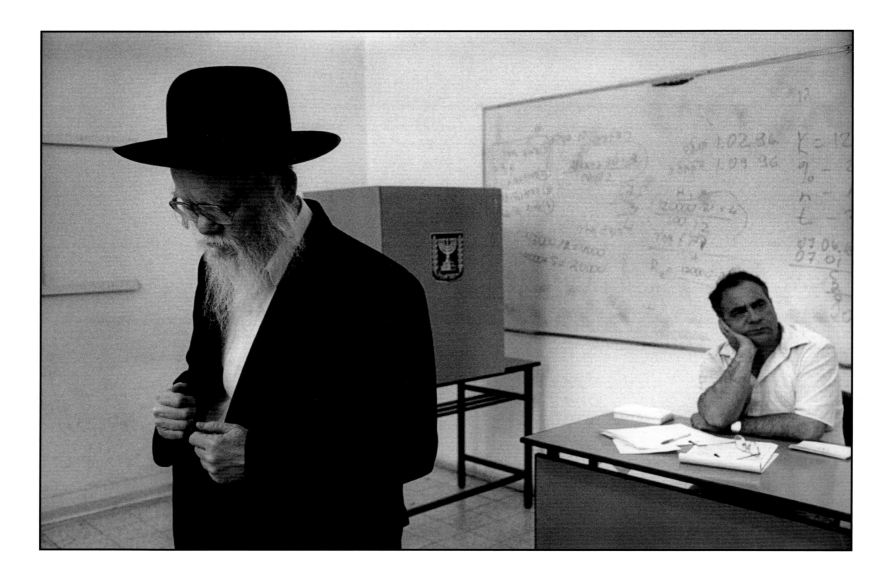

Jerusalem  1999

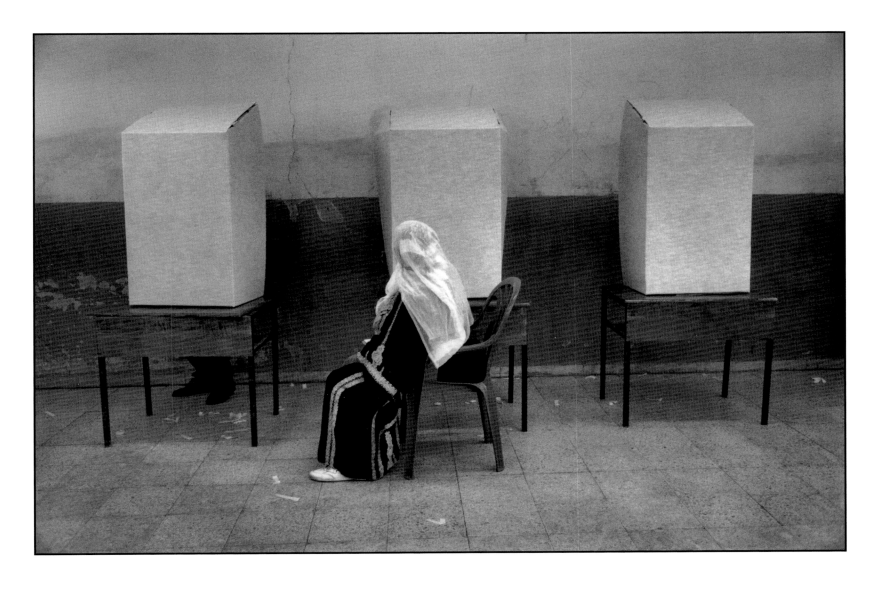

Jericho  1996

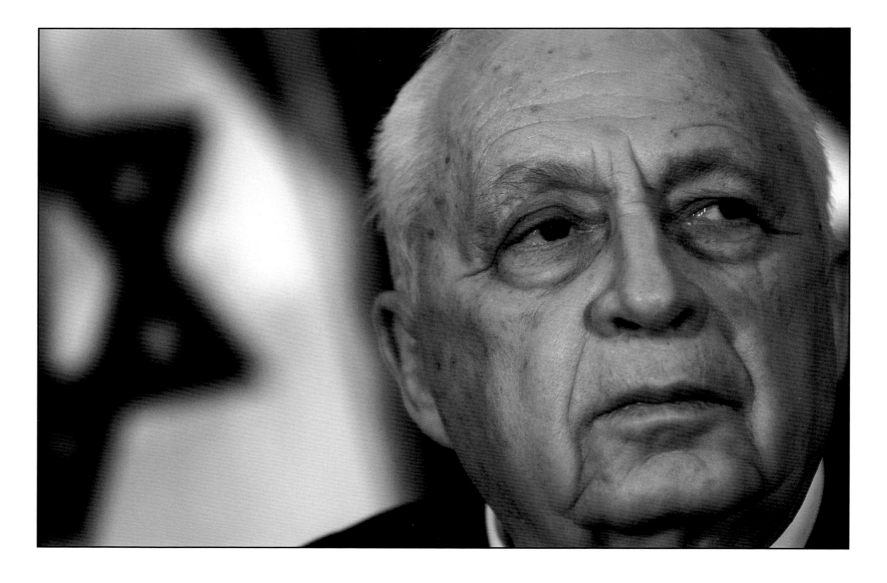

Jerusalem 2003

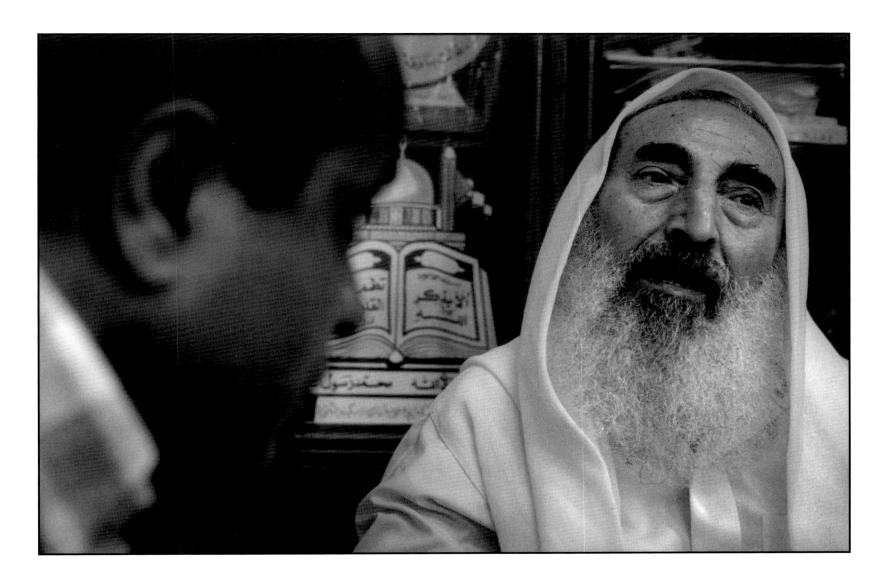

Gaza 2002

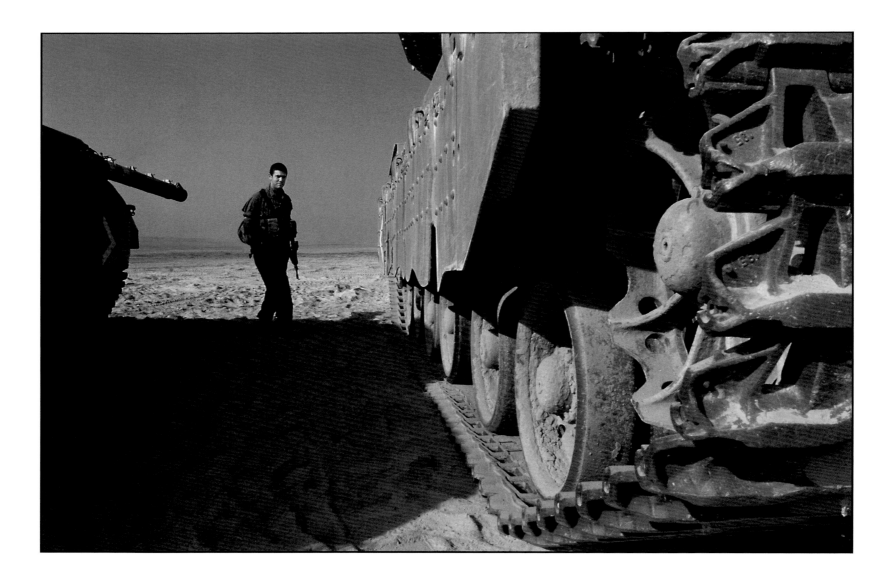

Gush Katif  2005

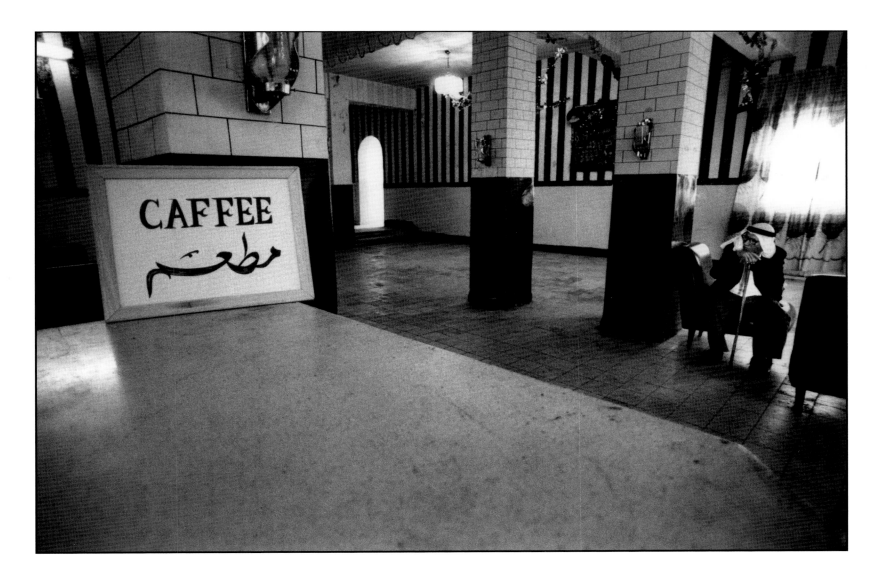

Jericho 1993

Bnei Brak  1998

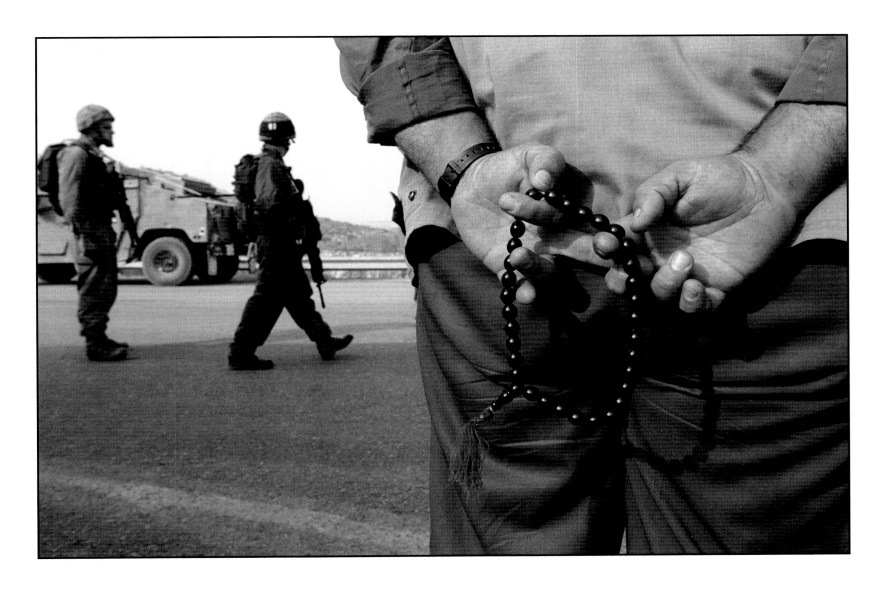

Kedumim 2003

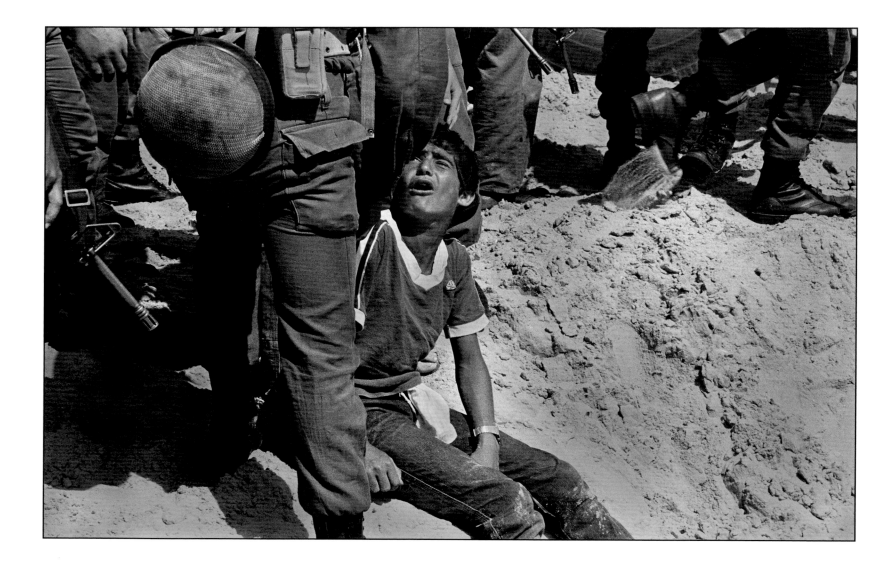

Yamit  1982

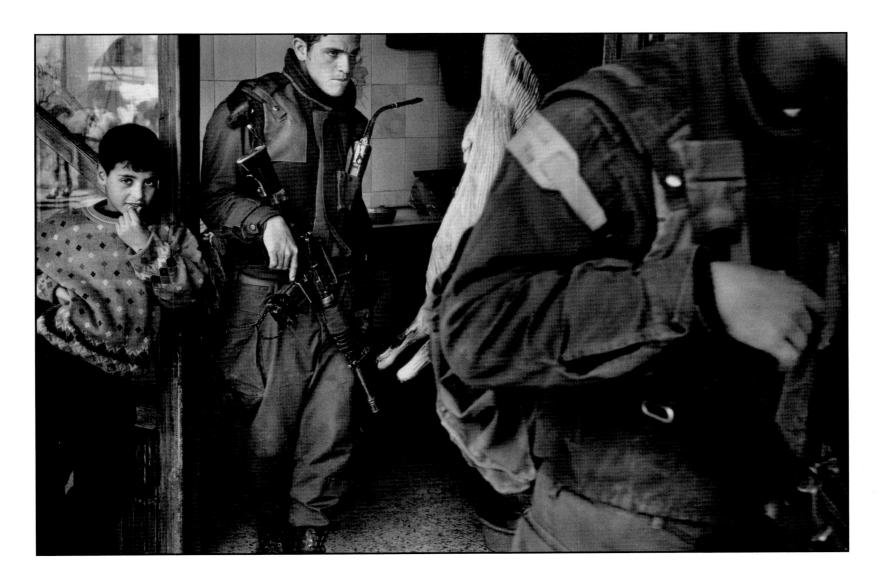

Hebron 1997

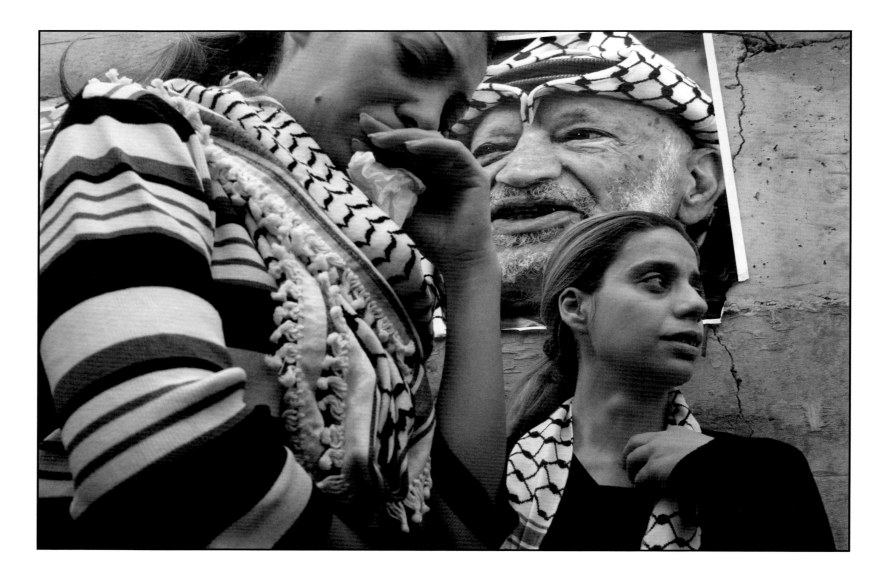

Ramallah 2004

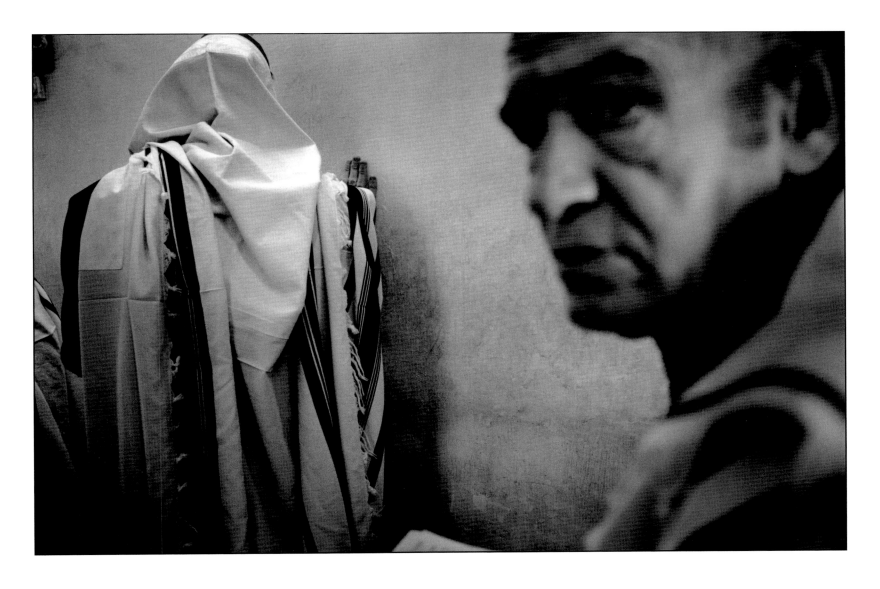

Bnei Brak  1998

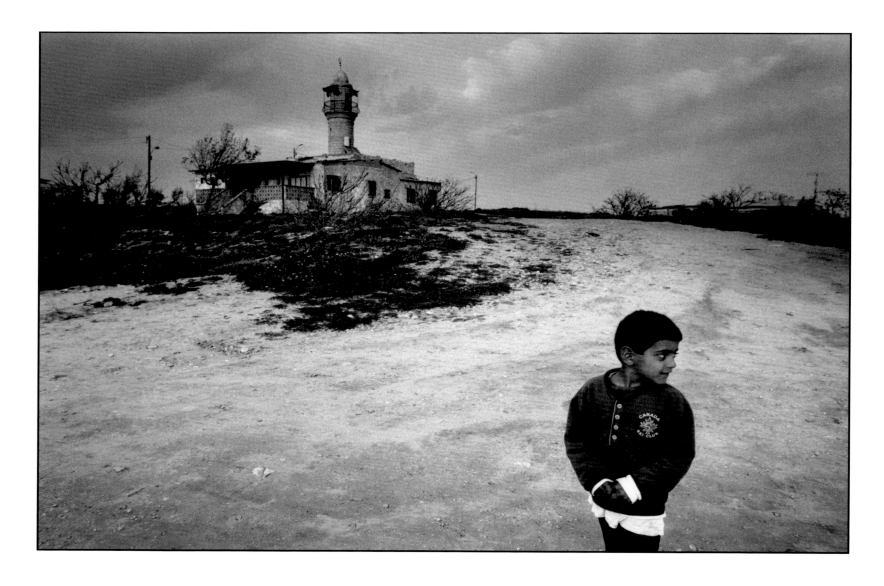

Jaffa 1994

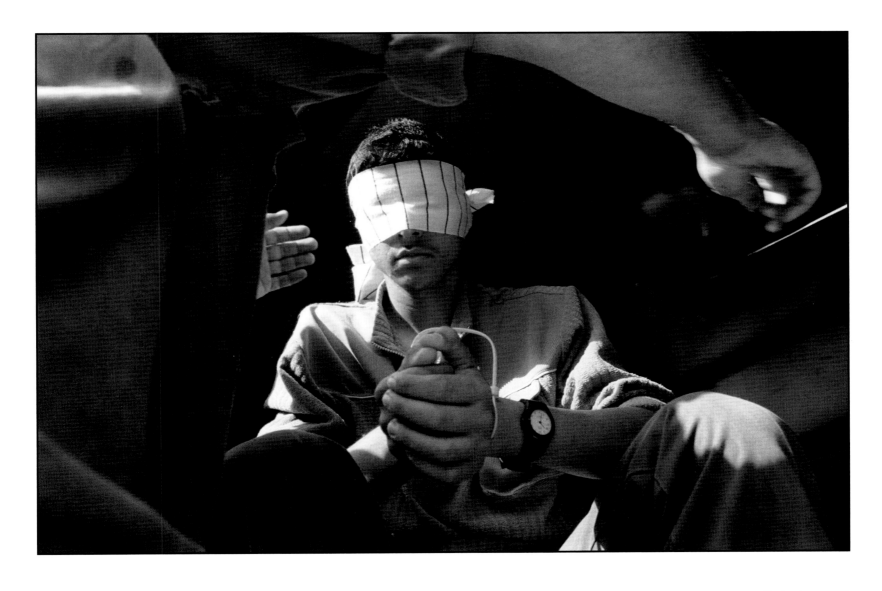

Kedumim  2003

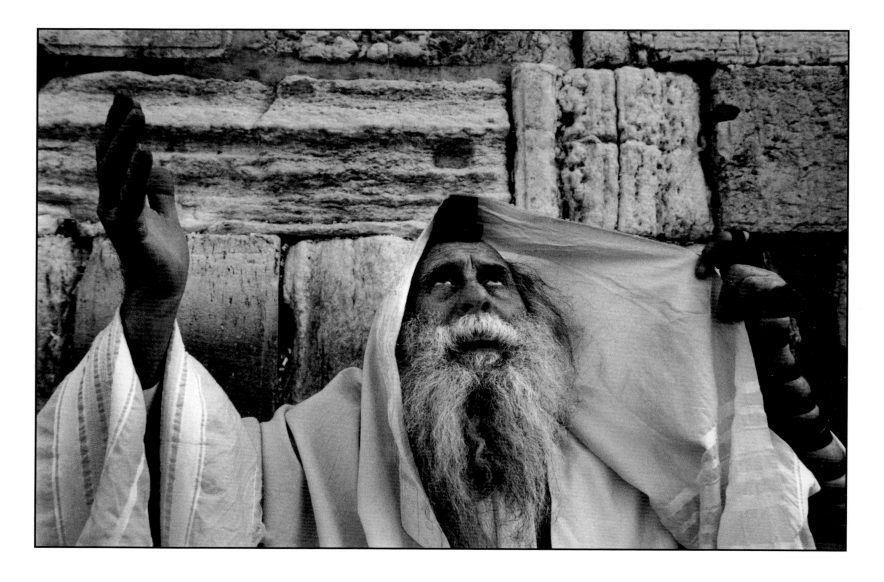

Jerusalem  1998

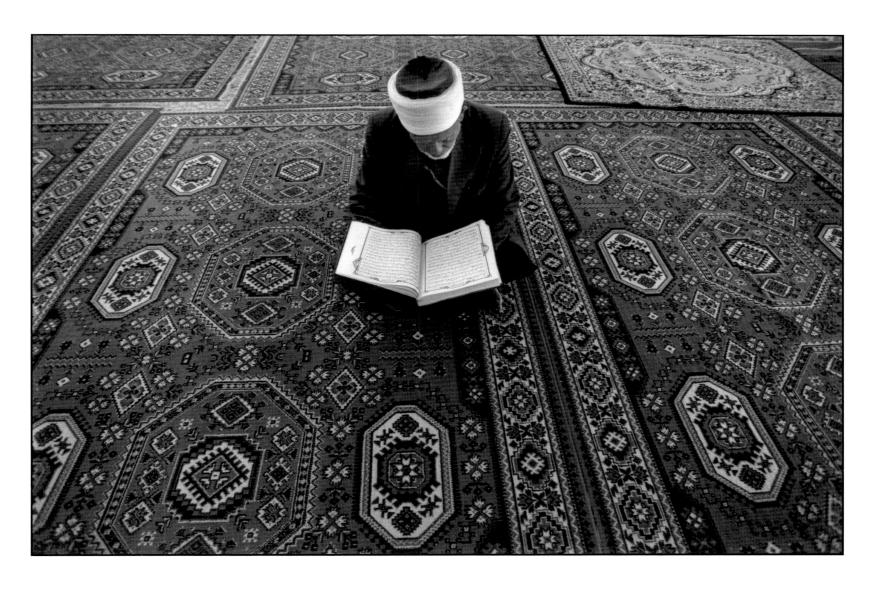

Araba 2000

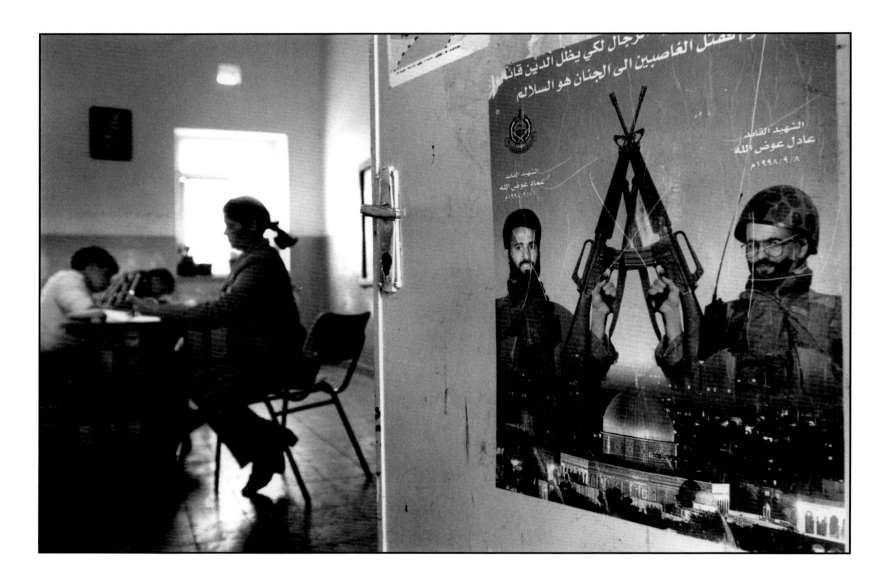

Ramallah  2001

114

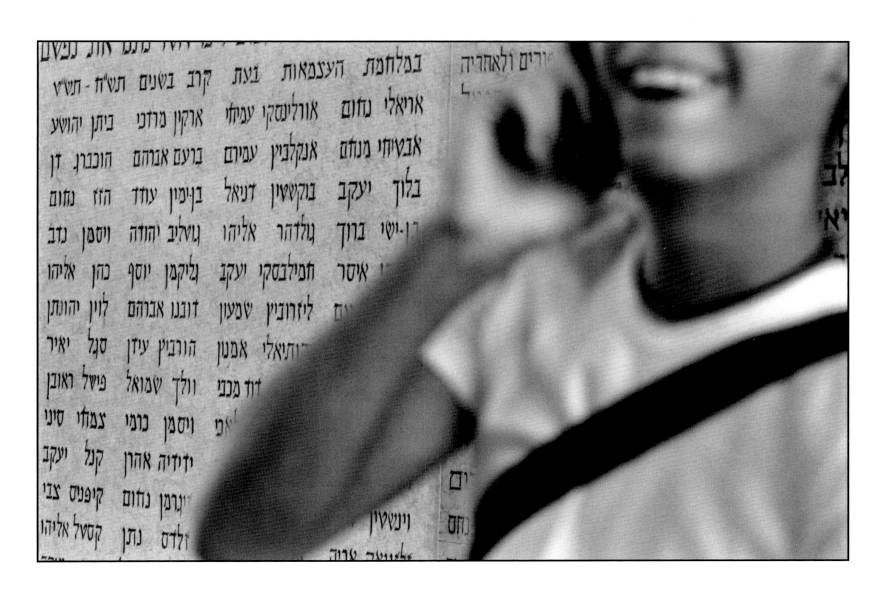

Tel Aviv  2001

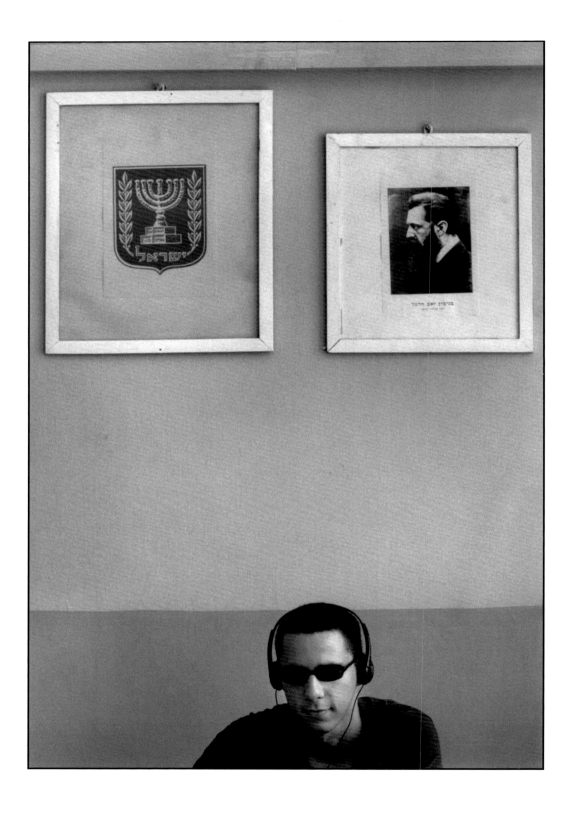

Tel Aviv 2001

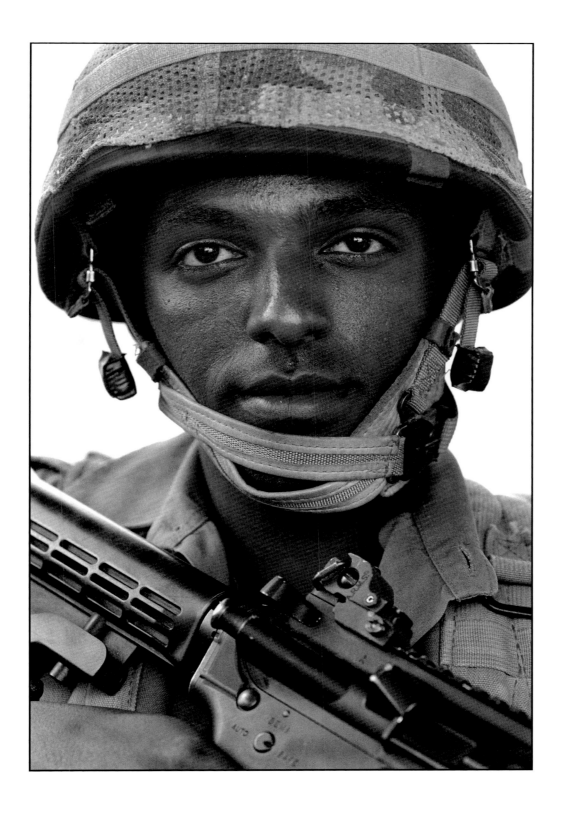

Kedumim 2003

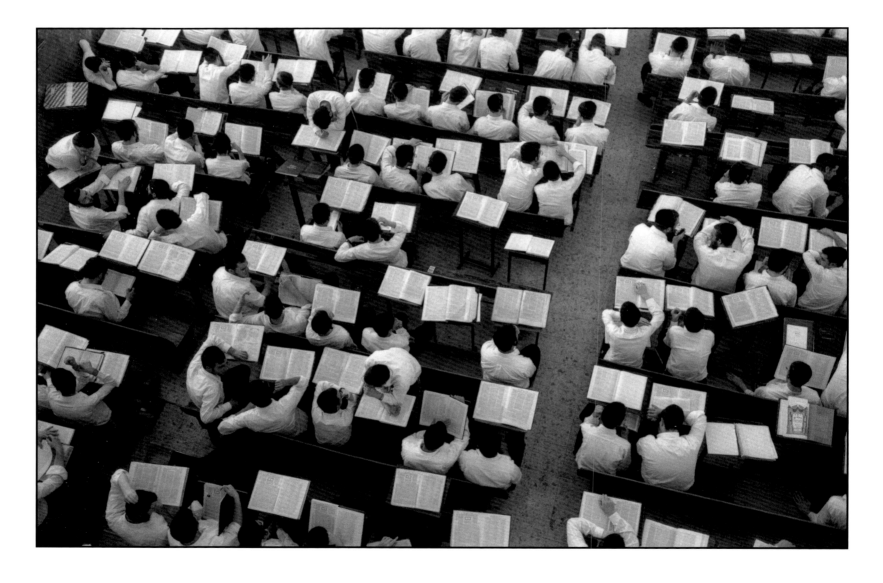

Bnei Brak  1998

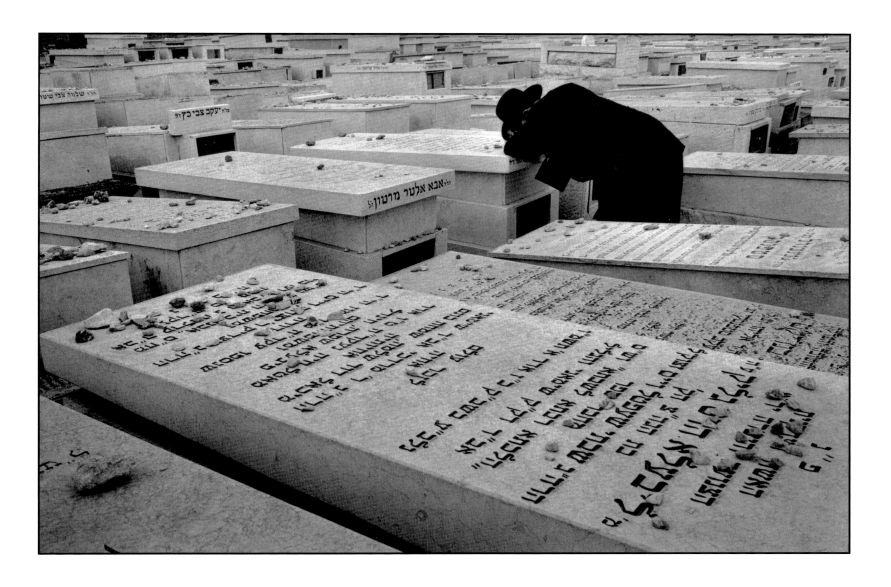

Bnei Brak  1998

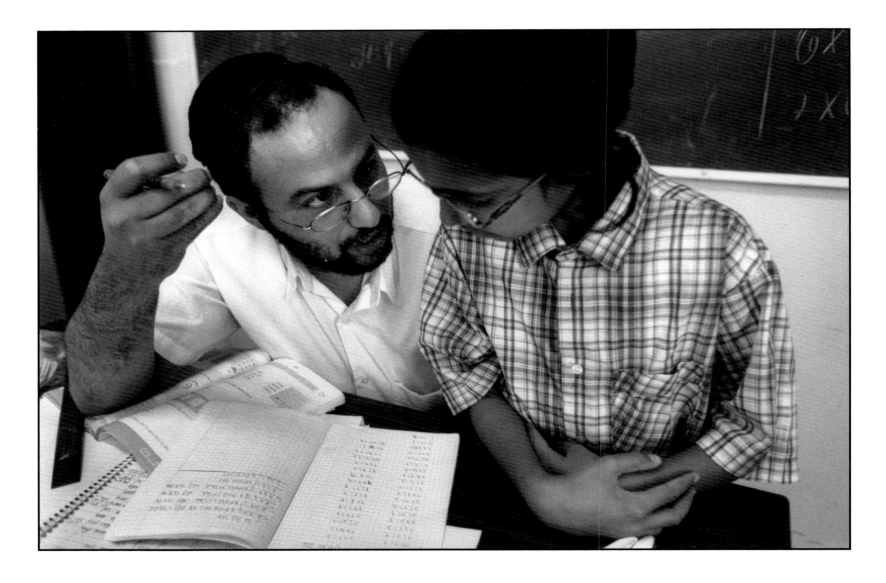

Tel Aviv  1998

Jericho 1993

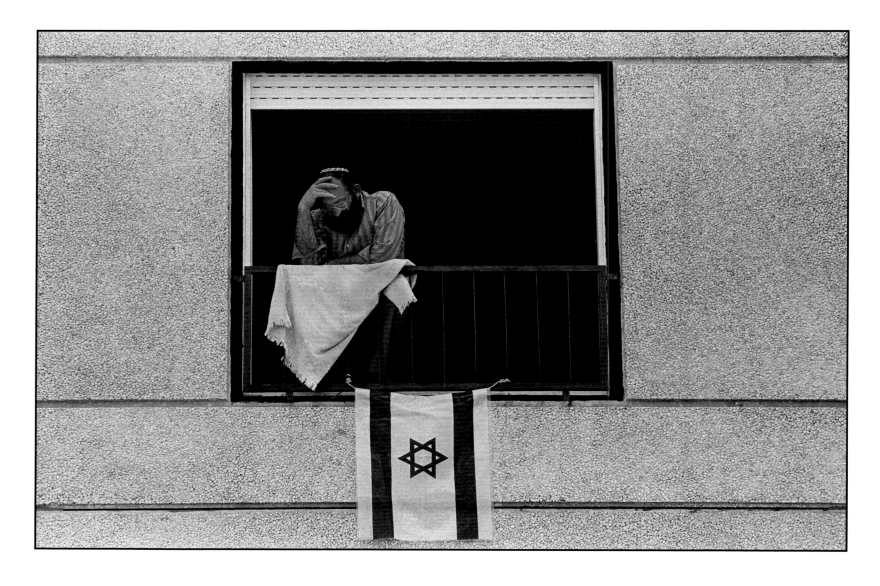

Yamit  1982

122

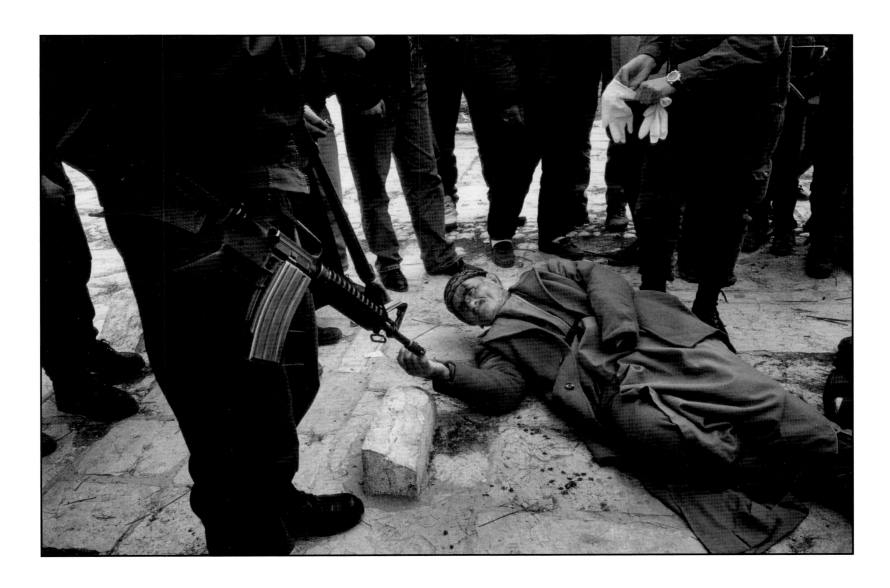

Hebron 1997

123

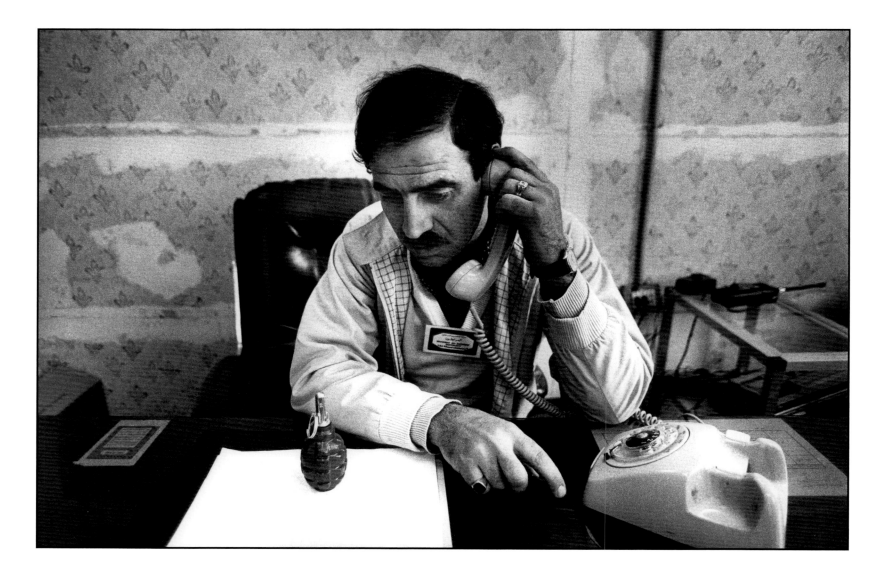

Beirut 1984

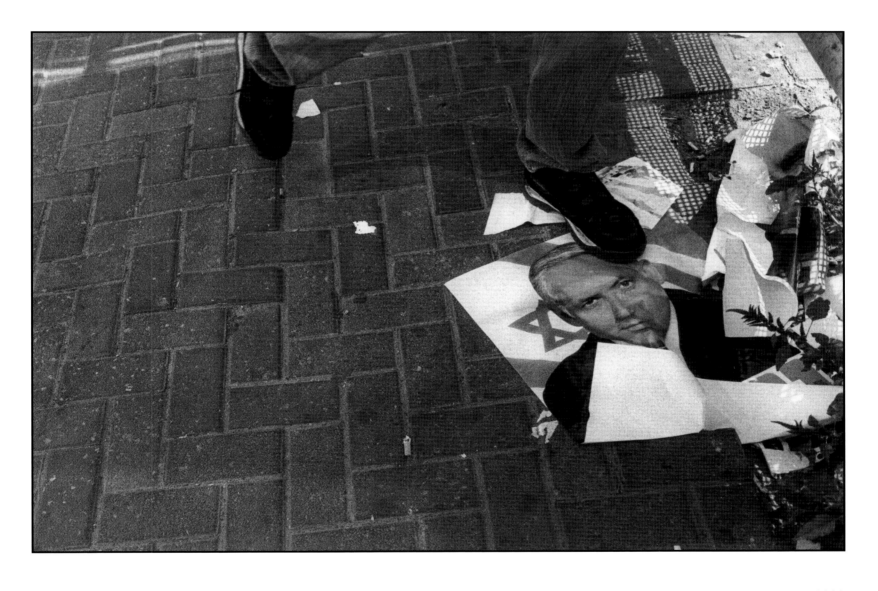

Tel Aviv  1999

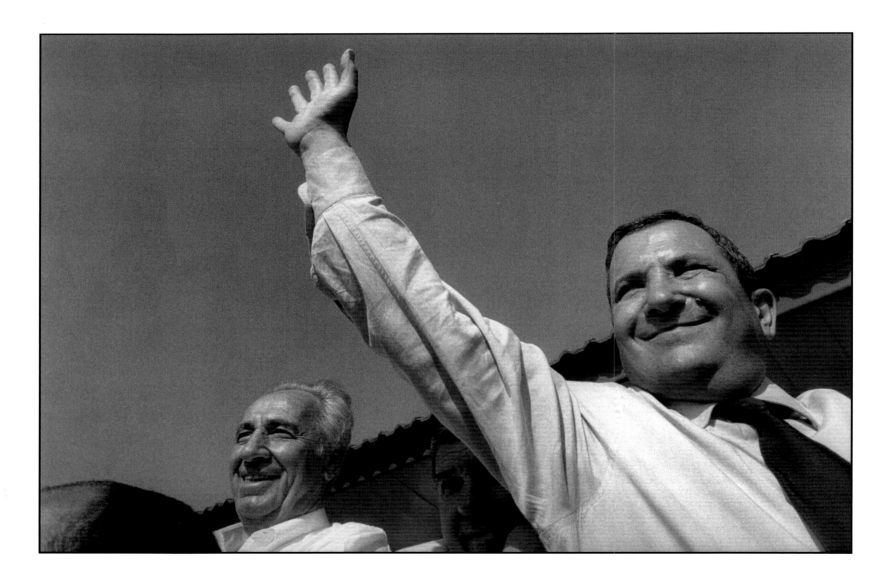

Herzliya  1999

126

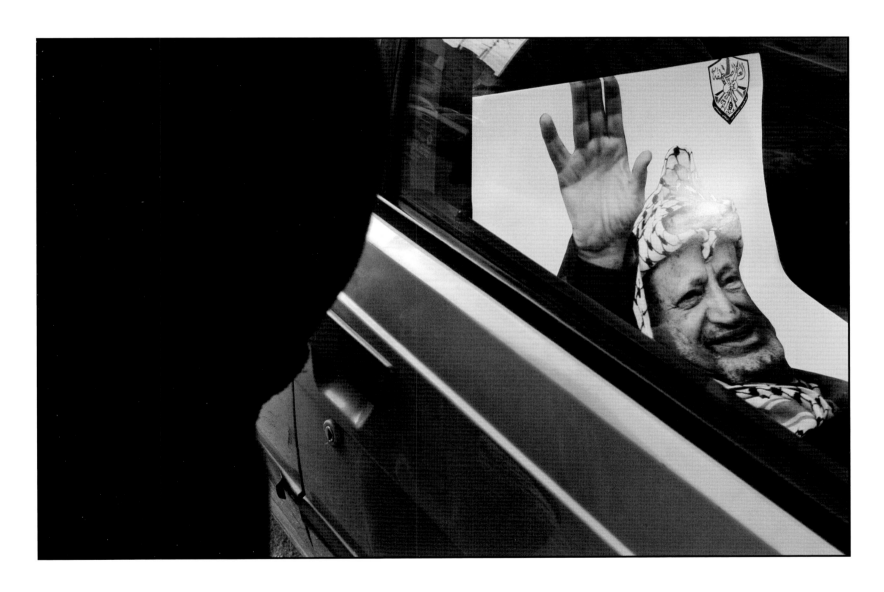

Ramallah  2004

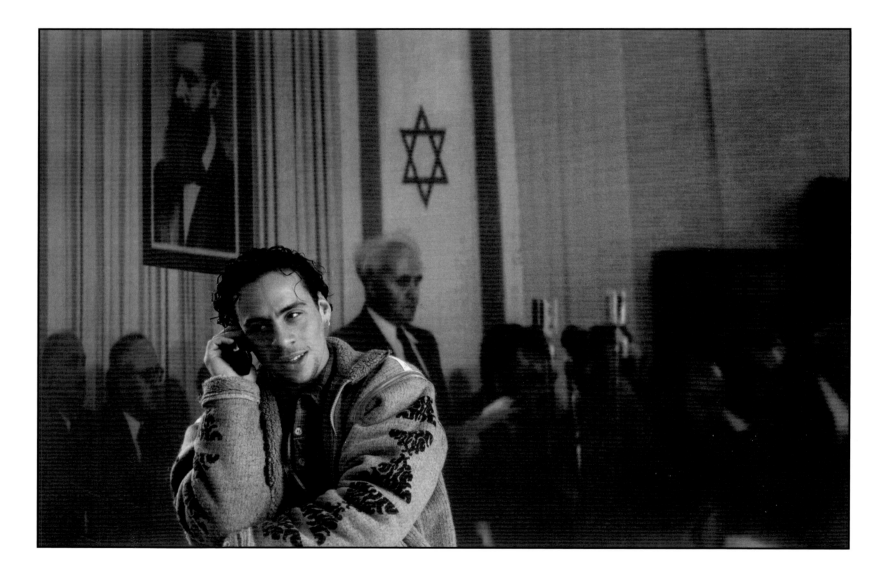

Tel Aviv  1998

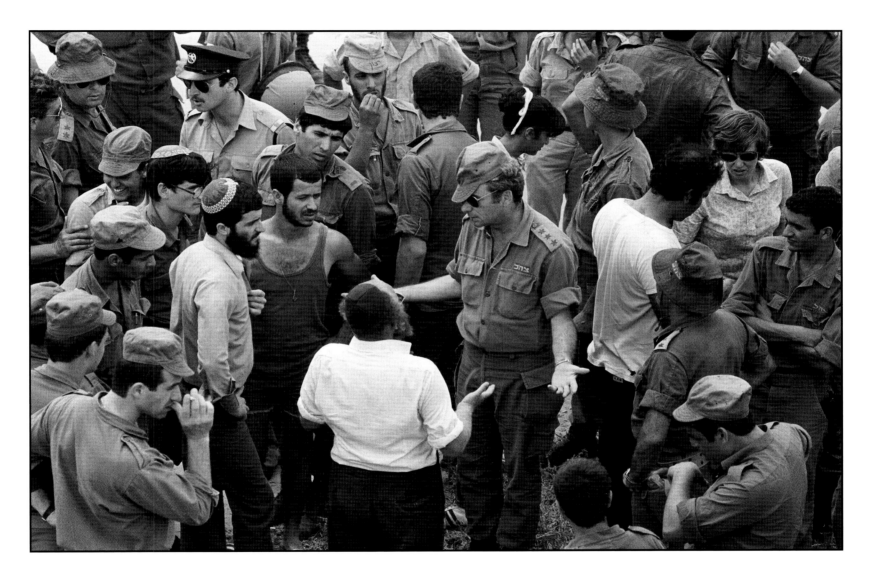

Yamit 1982

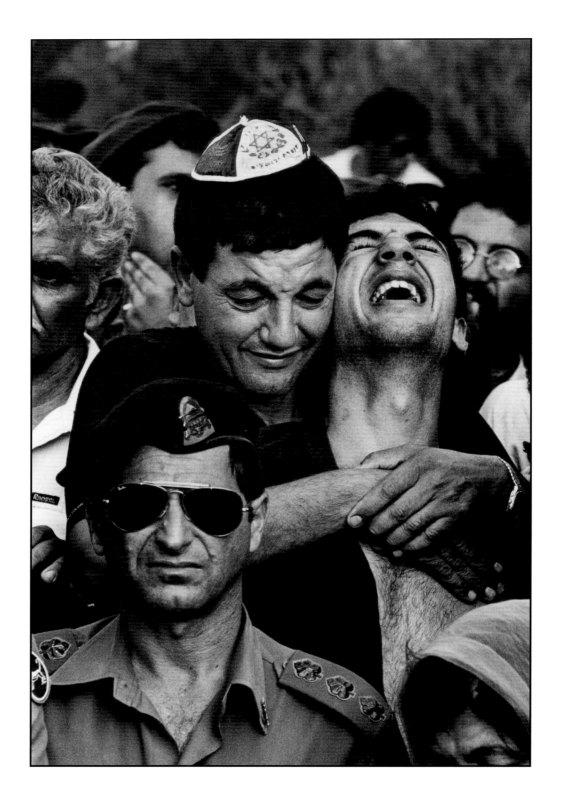

Tel Aviv  1998

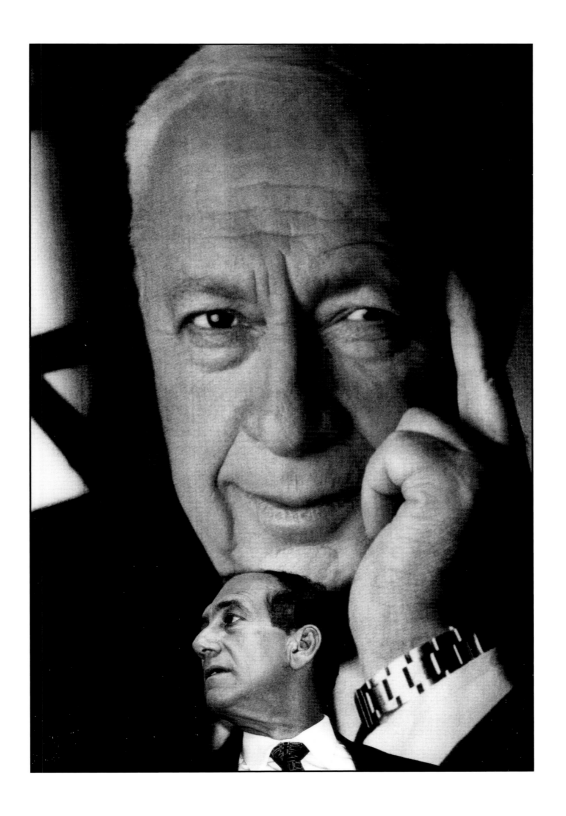

Tel Aviv  2001

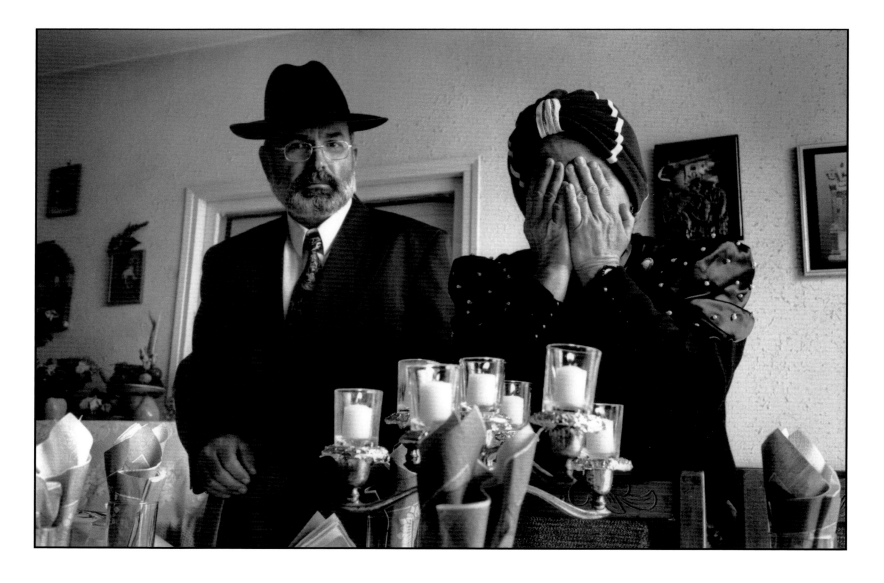

Bnei Brak 1998

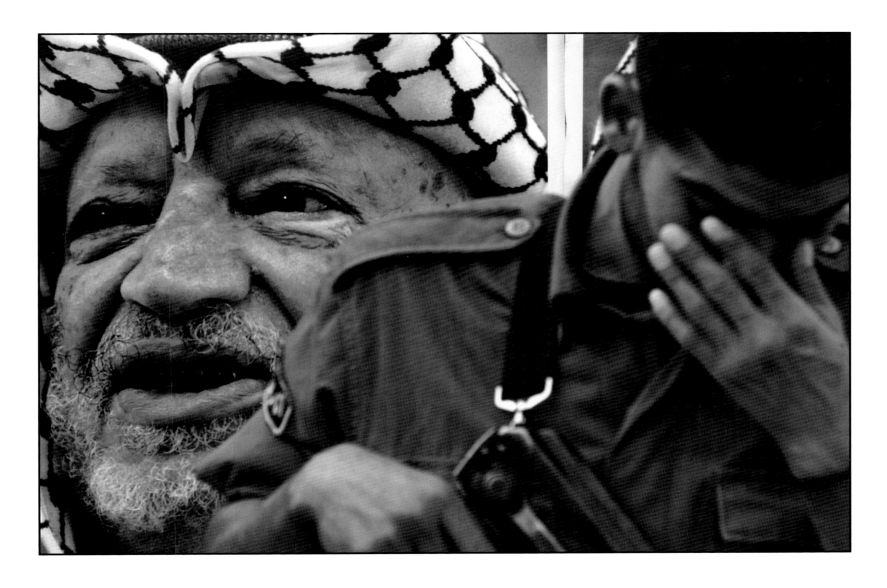

Ramallah 2004

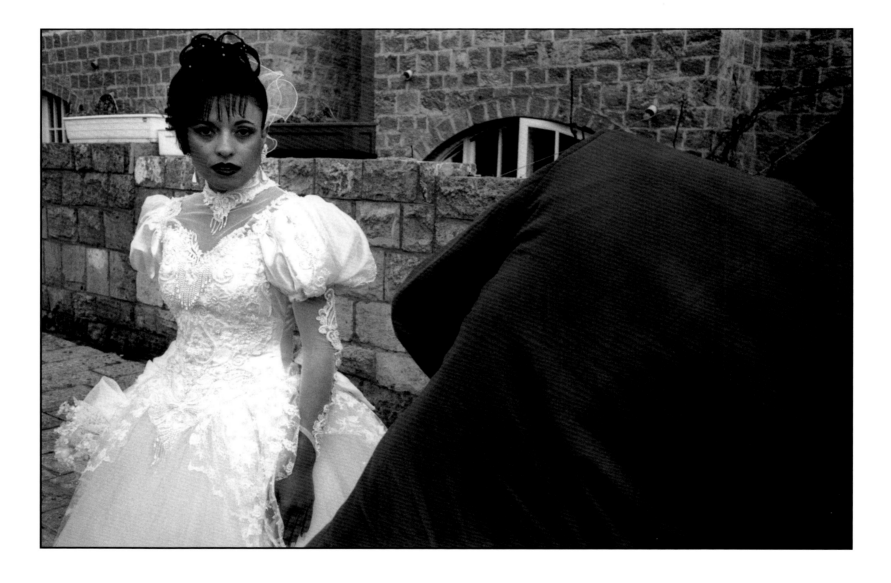

Jaffa 1994

134

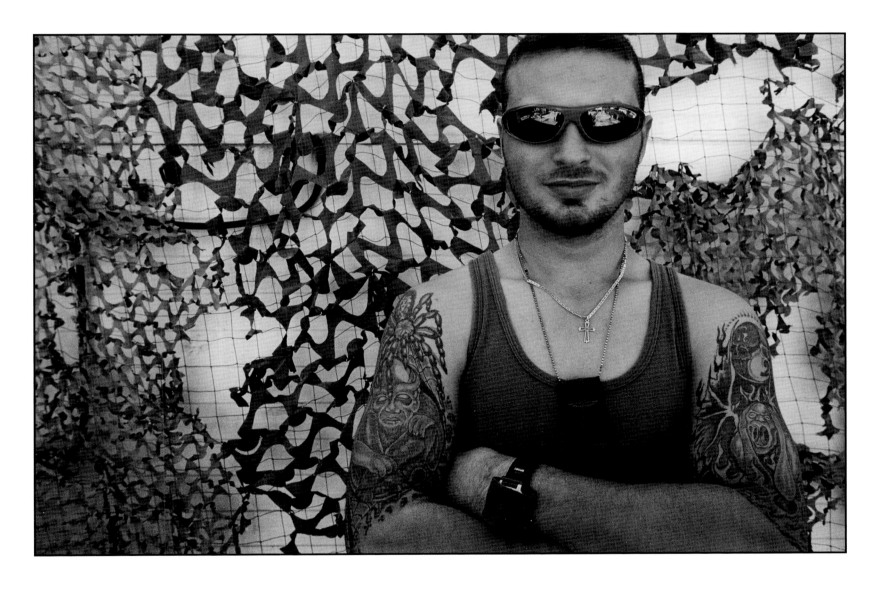

Kedumim 2003

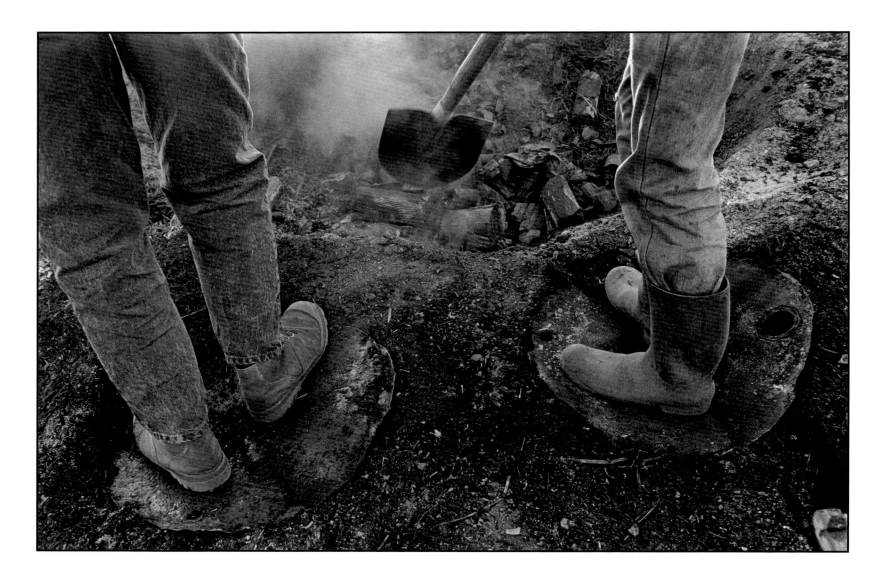

Um El Fahm  2002

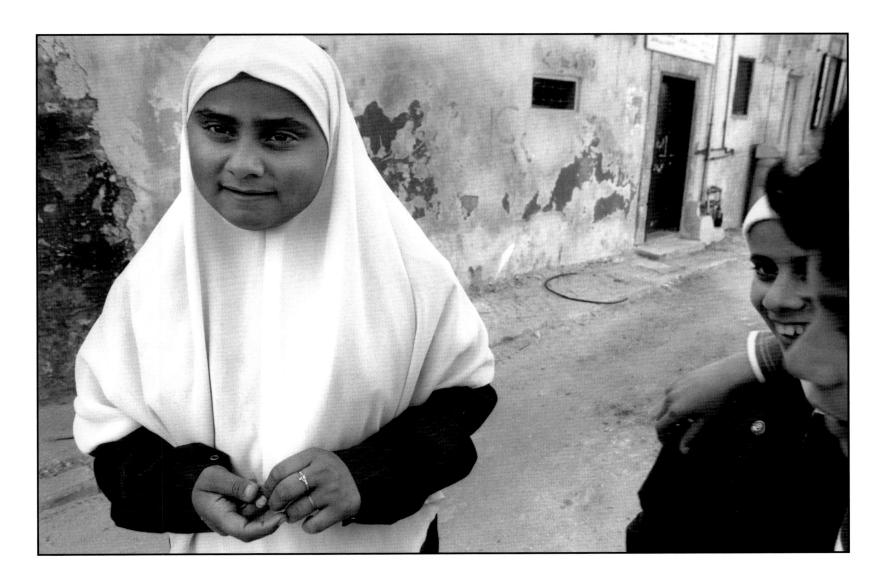

Jaffa 1994

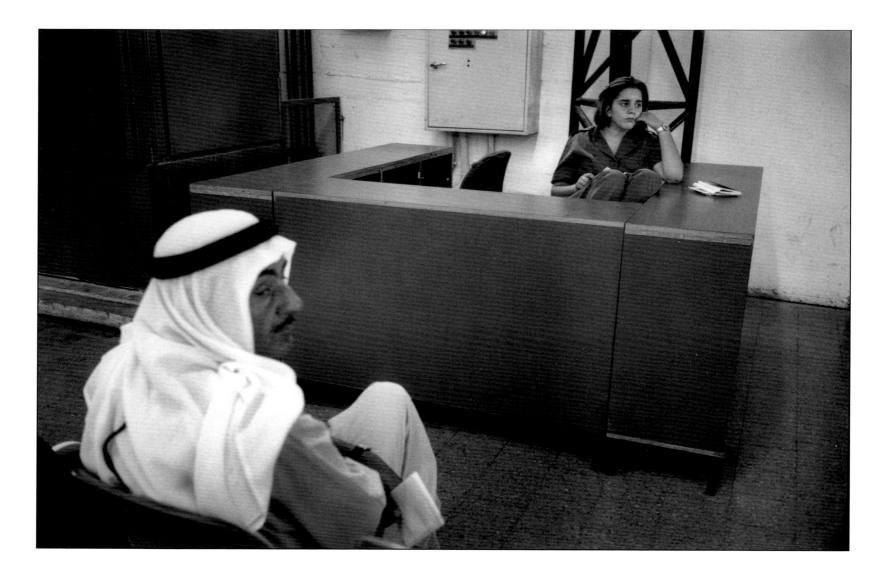

Jericho  1994

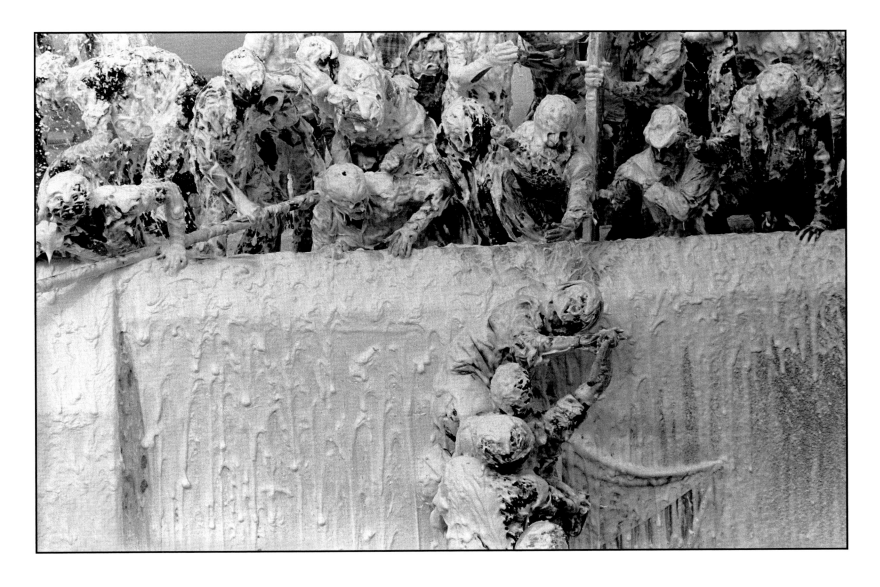

Yamit 1982

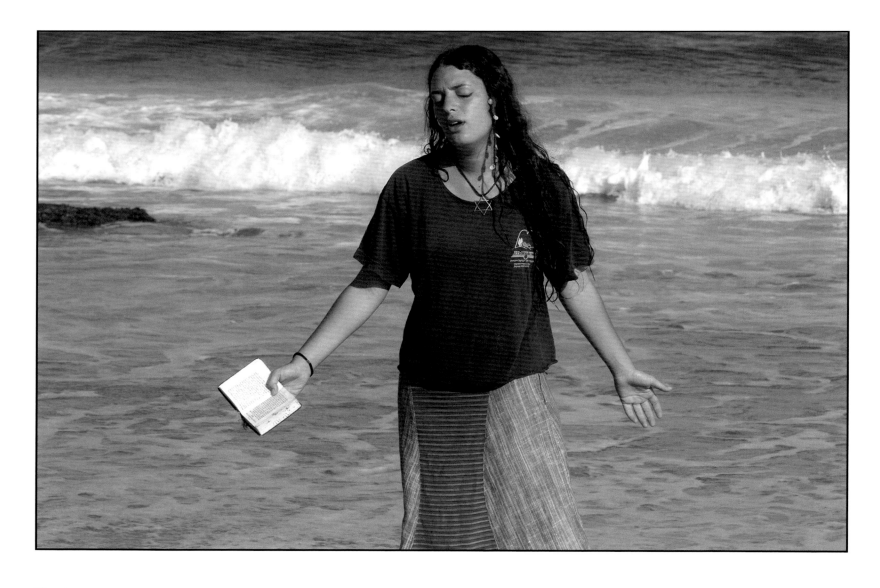

Kfar Yam  2005

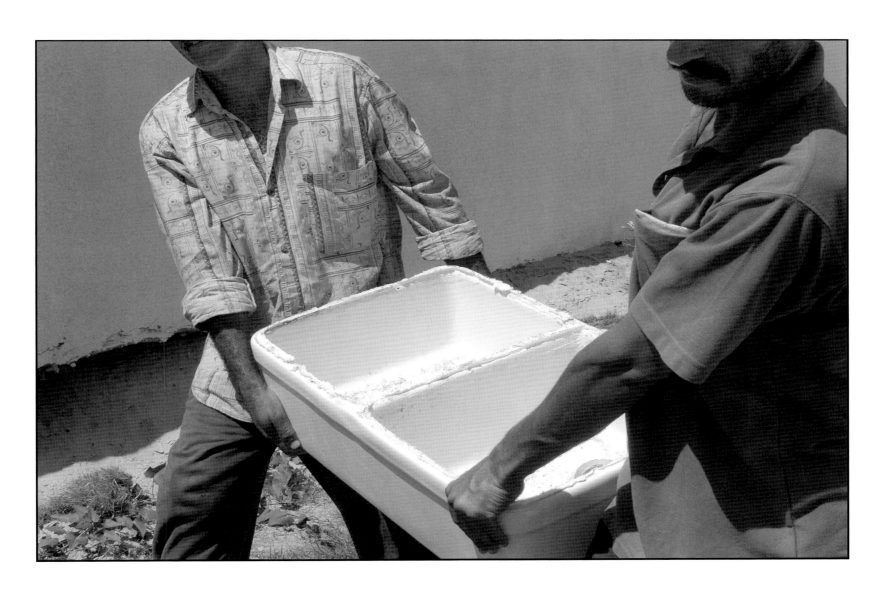

Pe'at Sadeh  2005

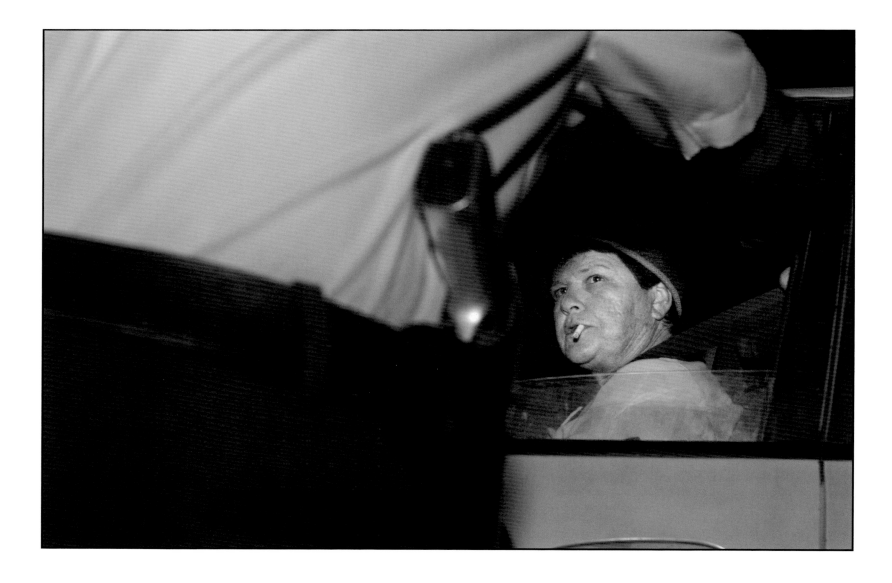

Kisufim 2005

142

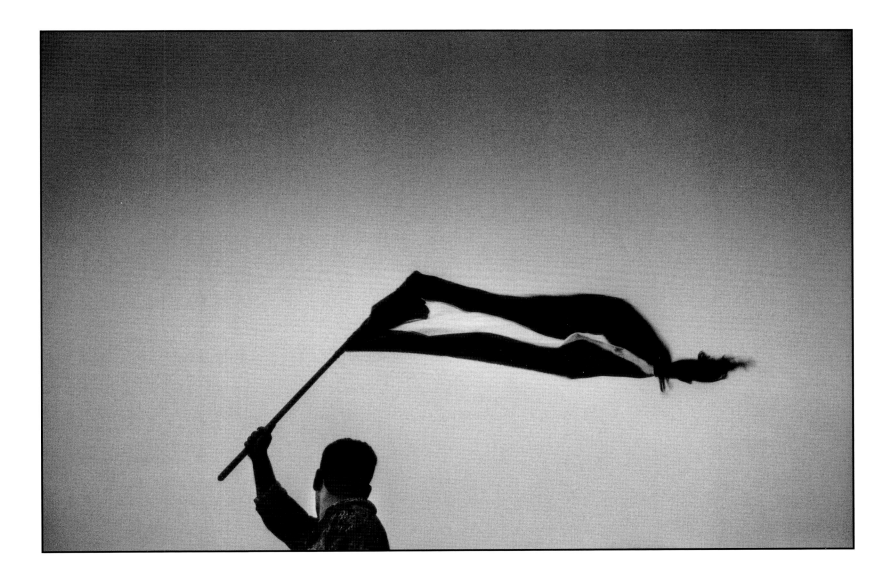

Jericho 1993

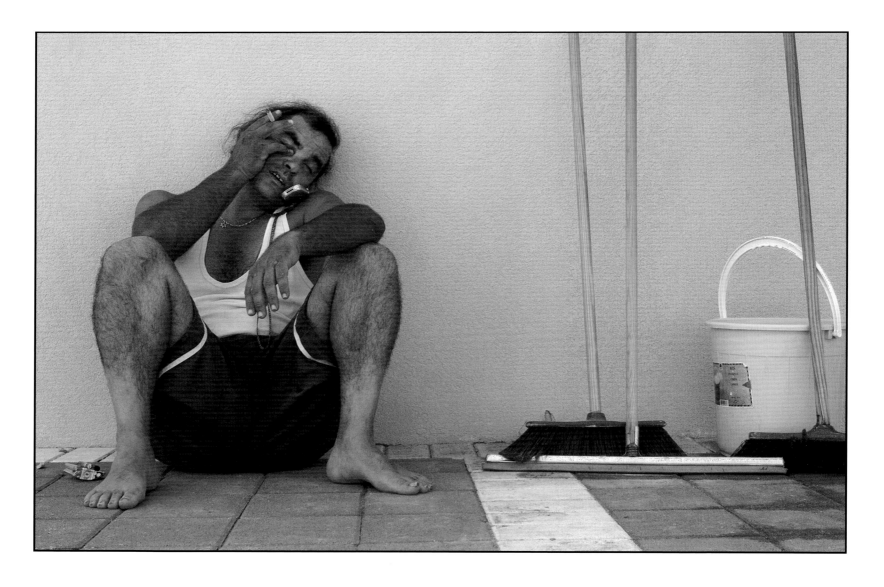

Nitsan 2005

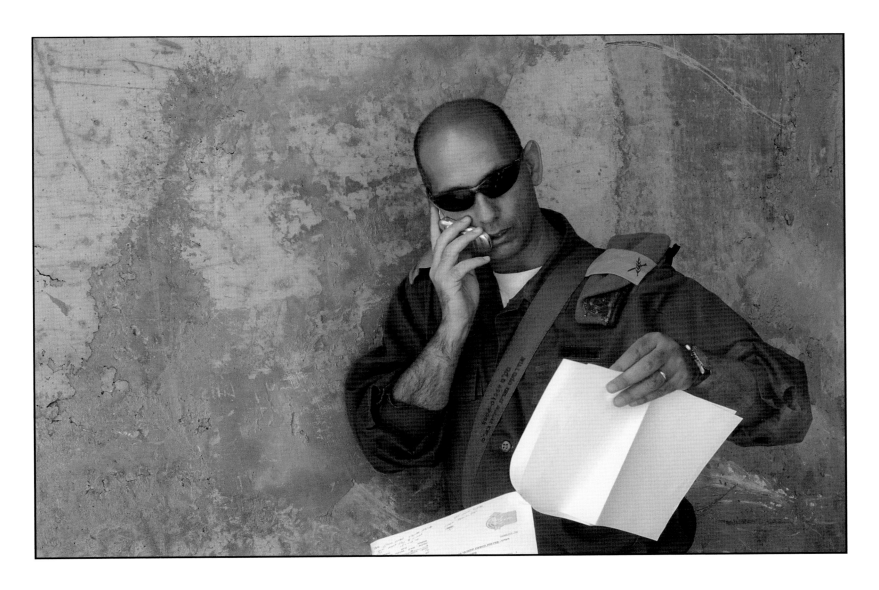

Tze'elim 2005

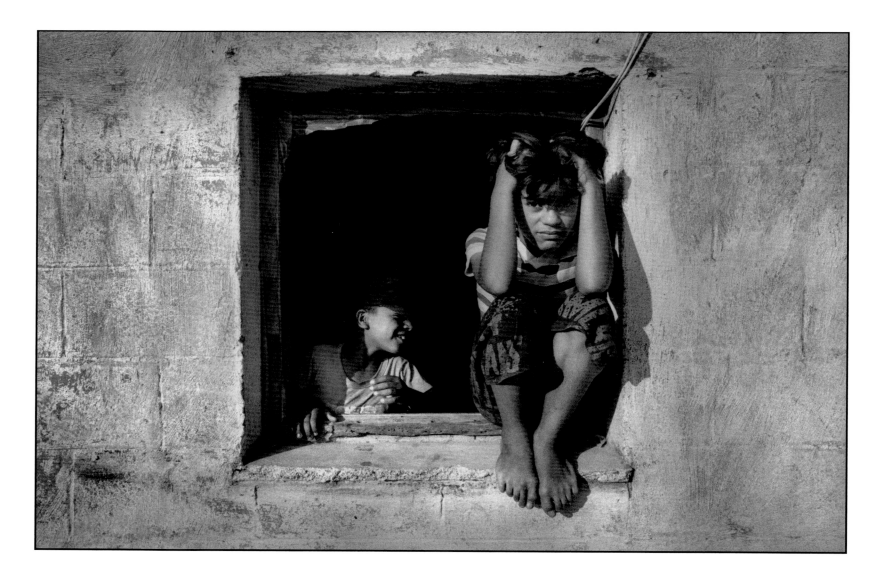

Fahme 1992

Pe'at Sadeh  2005

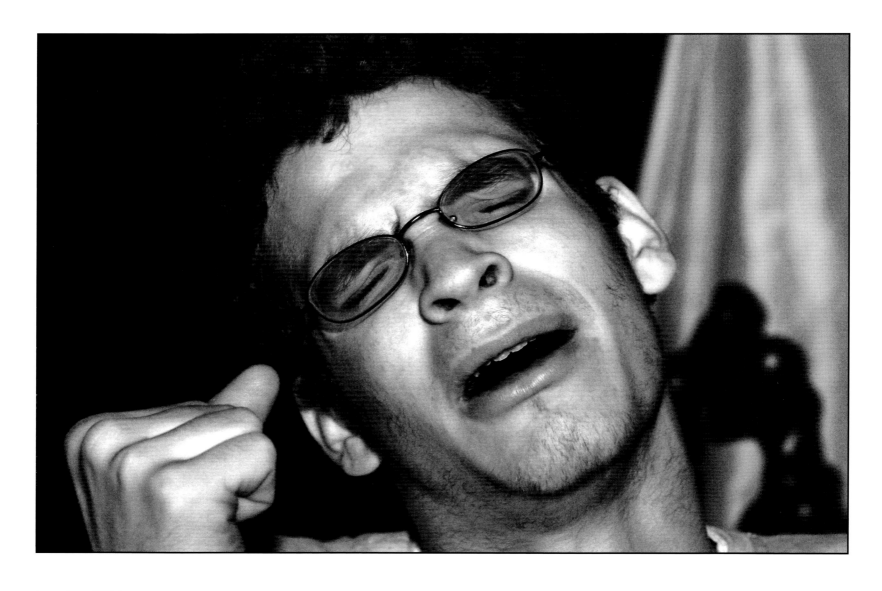

Jerusalem  2004

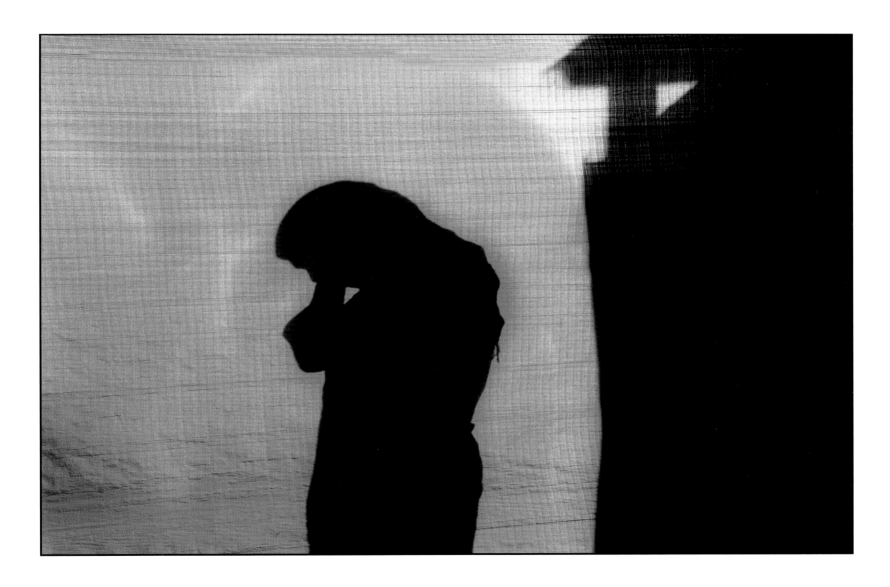

Kfar Yam  2005

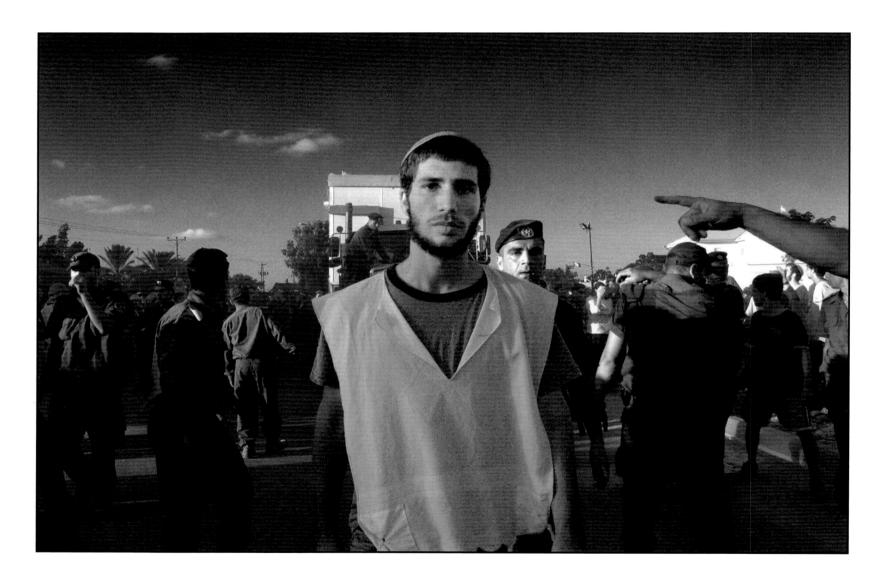

Kfar Darom  2005

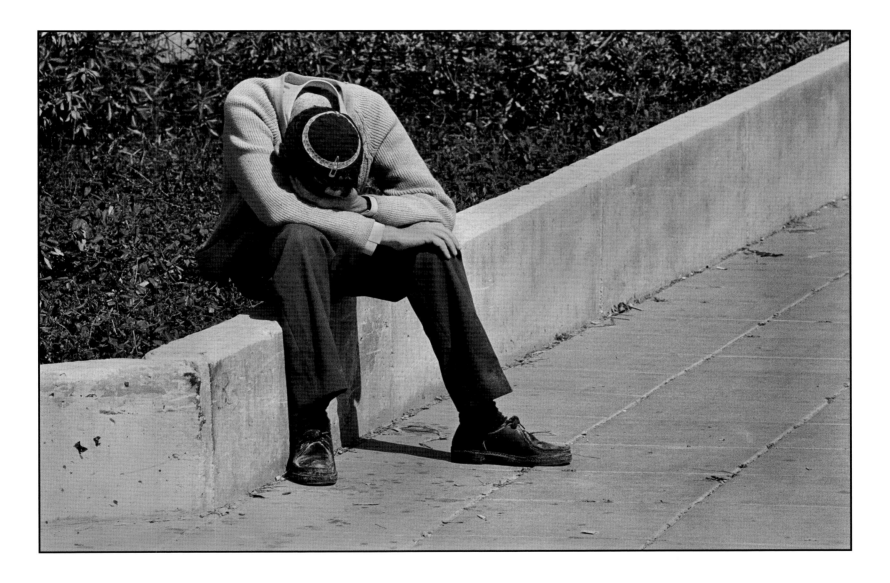

Yamit 1982

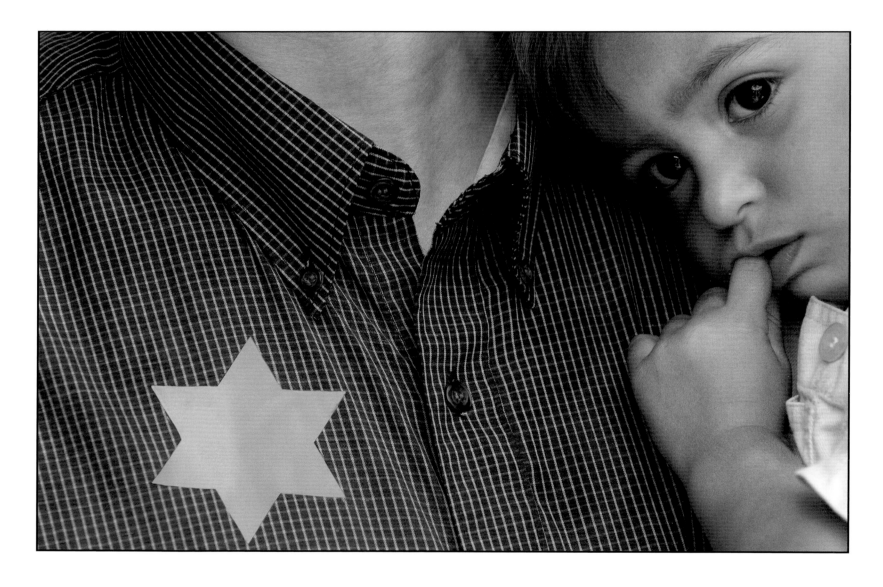

Neve Dekalim  2005

152

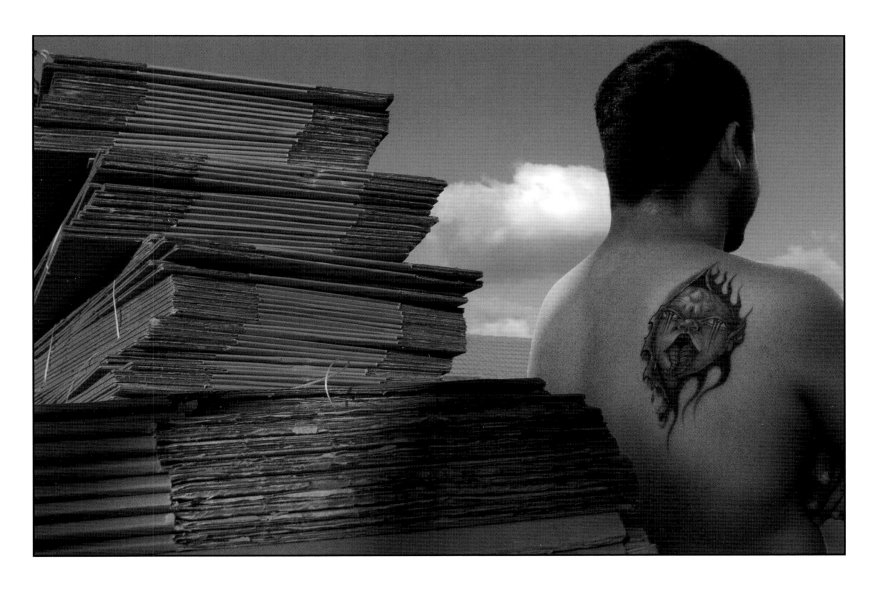

Pe'at Sadeh  2005

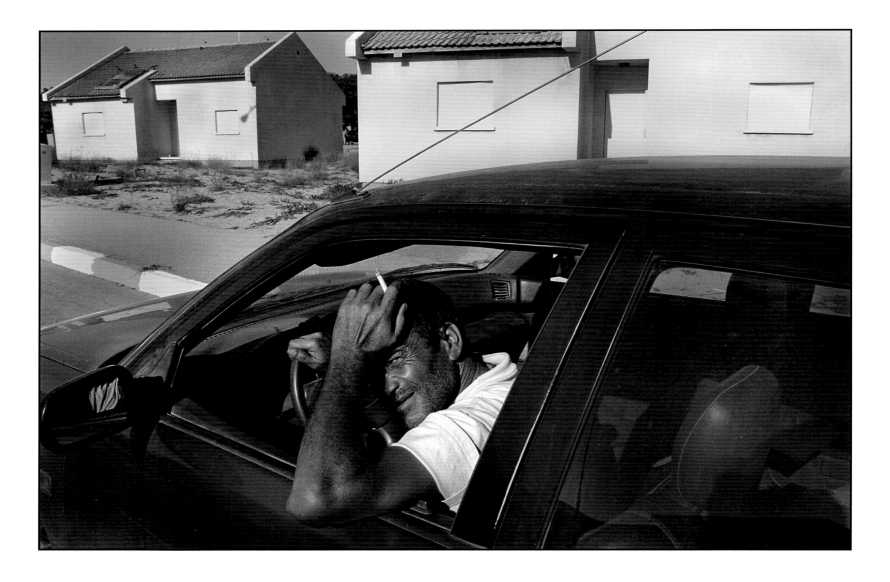

Pe'at Sadeh  2004

154

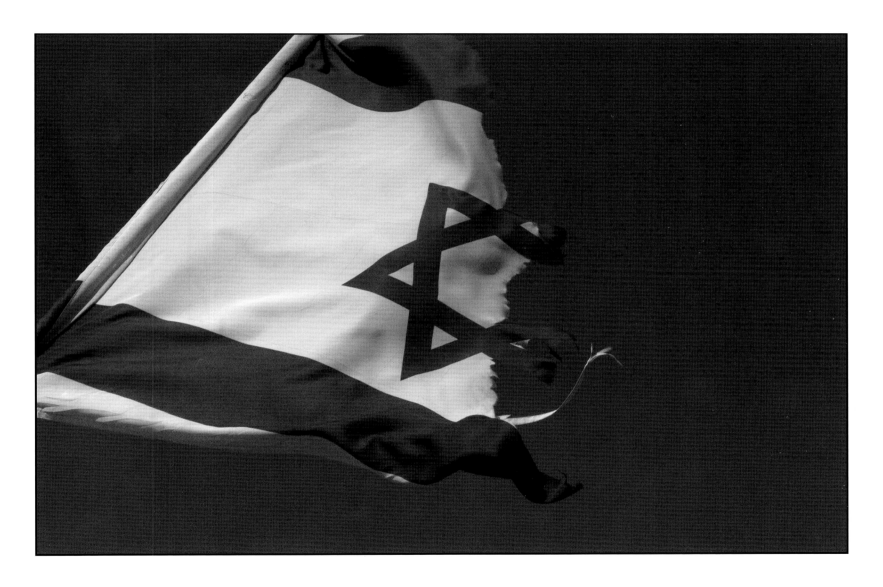

Neve Dekalim  2005

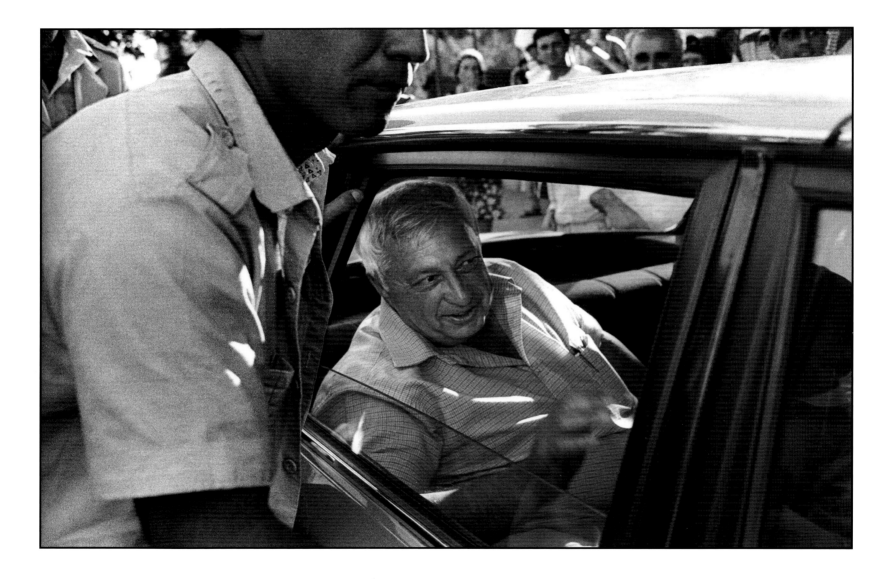

Jerusalem 1992

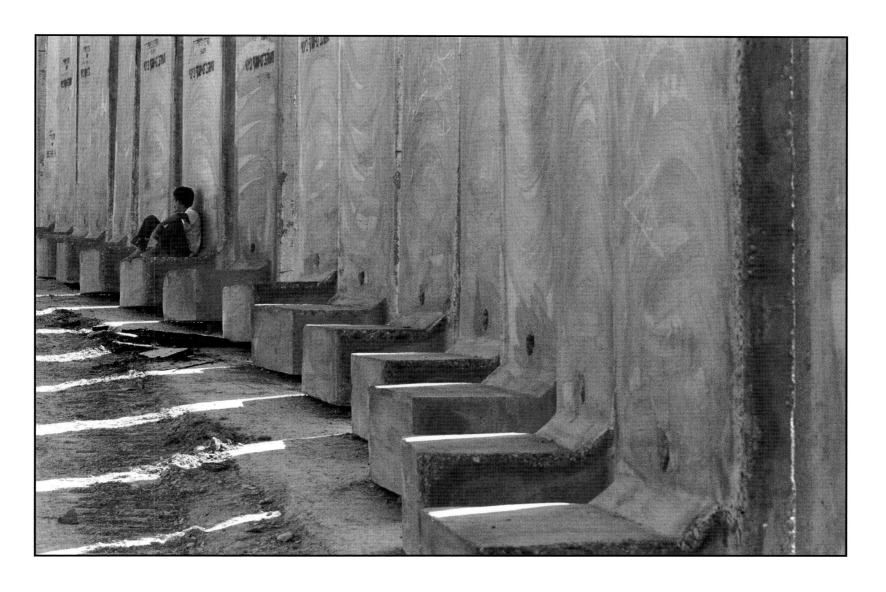

Kalkiliya   2004

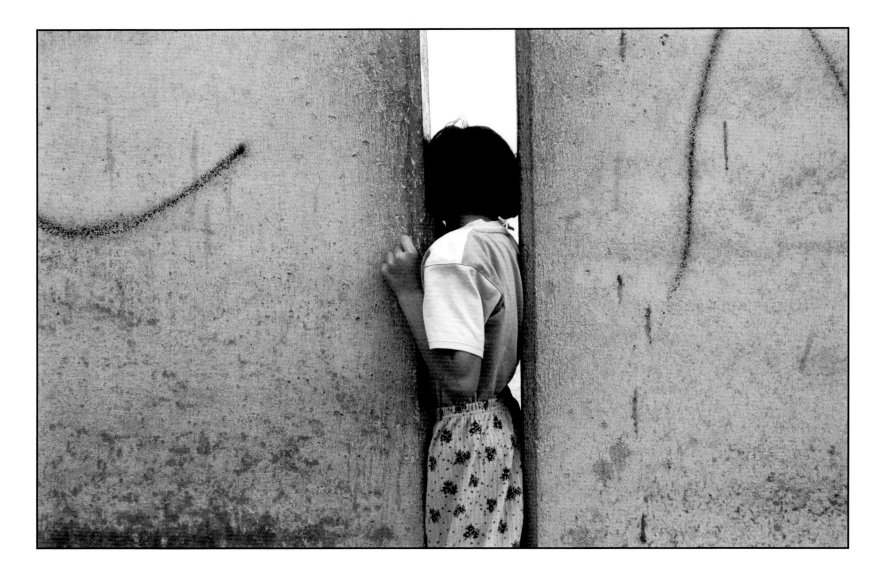

Abu Dis  2004

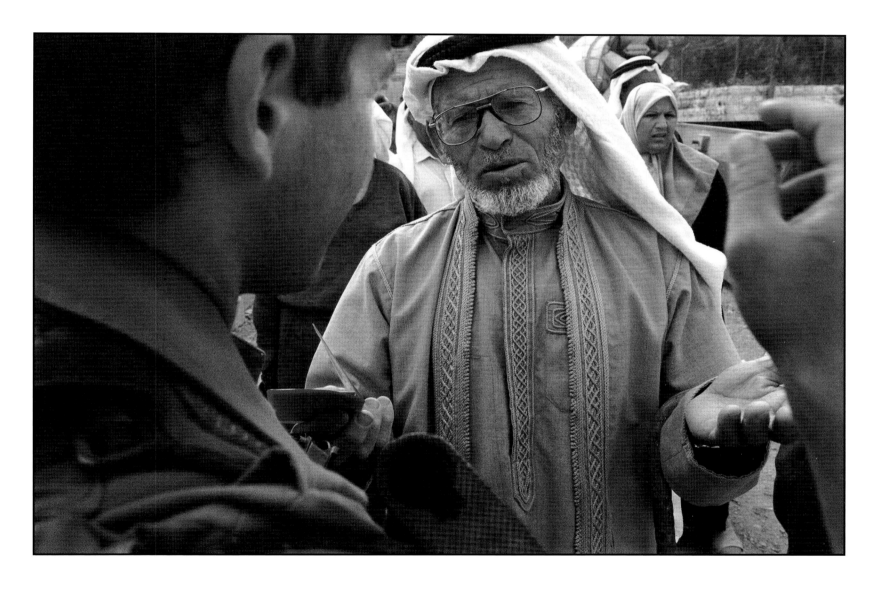

Abu Dis  2004

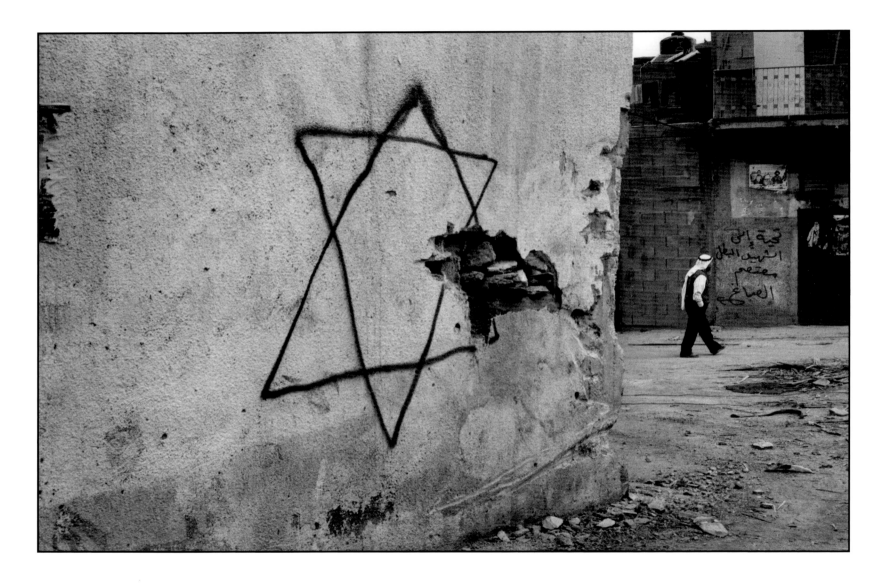

Jenin  2002

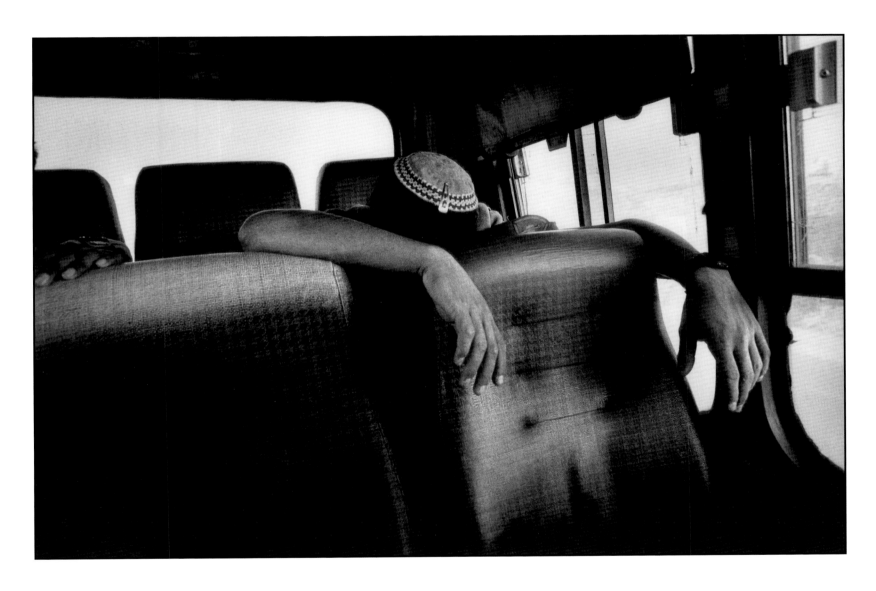

Ramallah  1989

Captions

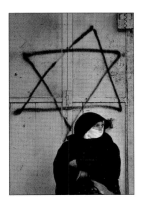

Hebron 1997 *page 16*

A Palestiniain woman sitting
in front of a store in Hebron's
central market on which
Israeli settlers in this West Bank
city have painted a Star of David
to claim ownership.

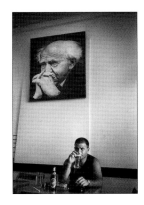

Tel Aviv 1992 *page 17*

A portrait of David Ben-Gurion,
Israel's first Prime Minister,
hanging on the wall in the bar
next door to Labour Party
headquarters.

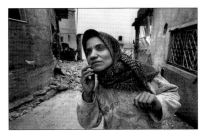

Jenin 2002 *page 18*

A Palestinian woman in the
Jenin refugee camp on the
West Bank watches nervously
as gunfire erupts down the
street between Israeli soldiers
and Palestinian miltants.

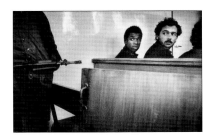

Nablus 1989 *page 19*

Palestinian men on trial at
Israeli military headquarters
on the West Bank.

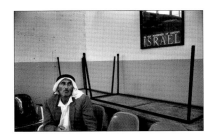

Jericho 1994 *page 20*

A Palestinian waits to have
his passport checked by Israeli
police at the Allenby Bridge
border crossing between
Jordan and Israel.

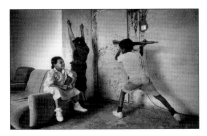

Fahme 1997 *page 21*

The children of a Palestinian
collaborator playing
'Intifada' in their home
on the West Bank.

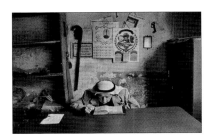

Hebron 1986 *page 22*

A devout Muslim shopkeeper
reading his Koran in the West
Bank city of Hebron.

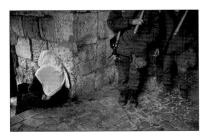

Jerusalem 1988 *page 23*

Israeli border police at the
Damascus Gate entrance
to the Old City of Jerusalem.

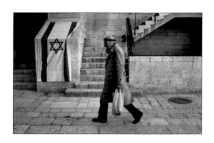

Jerusalem 2003 *page 24*

The Jewish quarter inside the Old City of Jerusalem.

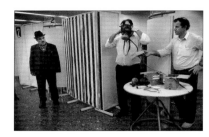

Tel Aviv 1991 *page 25*

Israeli civil defence officials demonstrating the use of gas masks to Russian immigrants arriving at Ben-Gurion airport during the first Gulf War.

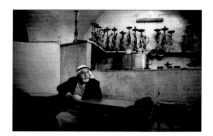

Jerusalem 1993 *page 26*

A coffee shop near Damascus Gate in the Muslim quarter of the Old City.

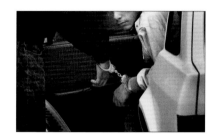

Nablus 1989 *page 27*

Israeli security service agent brings a Palestinian teenager to West Bank military headquarters in Nablus for questioning.

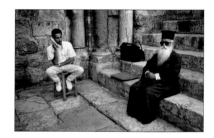

Jerusalem 1993 *page 28*

Patriarch of the Greek Orthodox Church and his Palestinian aide outside the Church of The Holy Sepulchre in the Old City.

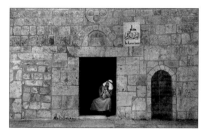

Jerusalem 1993 *page 29*

Inside the Haram al-Sharif, facing the Dome of the Rock in the Old City.

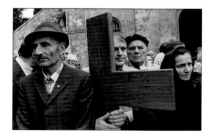

Jerusalem 1993 *page 30*

Catholic pilgrims retracing the twelve stations of the cross during Easter week in the Old City.

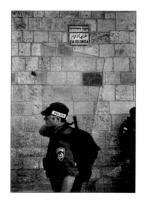

Jerusalem 2003 *page 31*

Israeli riot police deploying in the Old City on a Friday morning before Muslim prayers begin in the Al-Aqsa Mosque.

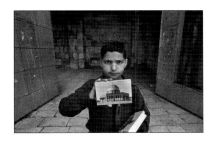

Jerusalem 1992 *page 32*

A young Palestinian street vendor selling post cards of the Dome of the Rock at the Jaffa Gate entrance to the Old City.

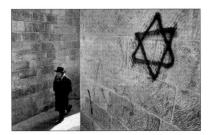

Jerusalem 2003 *page 33*

An Orthodox Jew returns from praying at the Western Wall in the Old City.

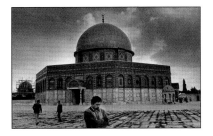

Jerusalem 1988 *page 34*

The Dome of the Rock on the Haram al-Sharif in the Old City. Inside the mosque is a huge rock which is believed by Muslims to be the point from which Mohammed was carried up to heaven on his fiery horse.

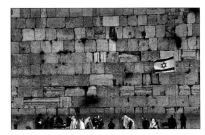

Jerusalem 2003 *page 35*

The Western Wall in the Old City.

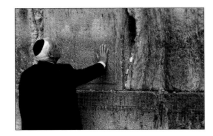

Jerusalem 2003 *page 36*

Prime Minister Ariel Sharon visiting the Western Wall in the Old City, the morning after defeating Ehud Barak in the Israeli elections.

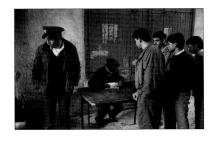

Jerusalem 2003 *page 37*

Israeli policemen check the identity papers of young Palestinians at the entrance to the Al-Aqsa Mosque inside the Old City before the start of Friday midday prayers.

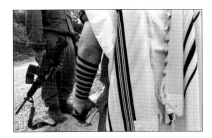

Kedumim 2003 *page 38*

A religious Israeli paratrooper just finishing his morning prayers (right, wearing prayer shawl) talks to a soldier from his platoon who has just returned from a dawn patrol near the West Bank town of Nablus.

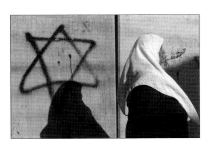

Abu Dis 2003 *page 39*

A Palestinian woman from the West Bank town of Abu Dis walking along the Israeli-built security wall which cuts the town in two, leaving half of it on the West Bank, and half of it annexed to municipal Jerusalem.

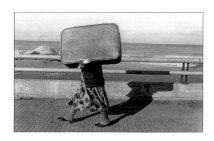

Sidon 1983 *page 40*

A Palestinian woman fleeing the fighting in Beirut crosses the Awali River bridge into Sidon in southern Lebanon.

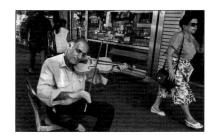

Tel Aviv 1993 *page 41*

A Russian immigrant, unable to find work as an orchestra violinist, playing for loose change from passers-by on a pavement in Tel Aviv.

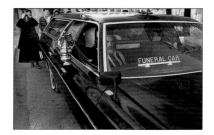

Jerusalem 1993 *page 42*

A funeral procession leaving the Armenian quarter of the Old City.

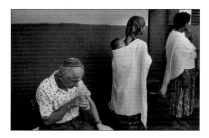

Tel Aviv 1992 *page 43*

Ethiopian immigrants waiting for a bus at Tel Aviv's Central Station.

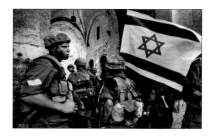

Jerusalem 1982 *page 44*

Israeli paratroopers entering the Old City on their way to the Western Wall for a ceremony honouring soldiers from the brigade killed in the battle to capture the Old City during the 1967 Six Day War.

Beirut 1984 *page 45*

A Lebanese Shiite woman in the Hezbollah-controlled southern suburb of Beirut. The writing on the wall says 'The resistance will never falter as long as there is a baby at its mother's breast'.

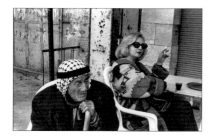

Hebron 1997 *page 46*

An Israeli woman and a Palestinian man sitting at a cafe across the street from the Tomb of the Patriarchs in the West Bank city of Hebron.

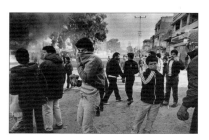

Gaza 1988 *page 47*

Palestinian demonstrators confronting Israeli troops on the street in Gaza City.

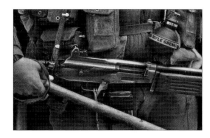

Gaza 1988 *page 48*

Israeli soldier confronting
Palestinian demonstrators
in Gaza City.

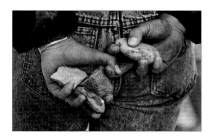

Gaza 1988 *page 49*

Palestinian demonstrator
confronting Israeli troops
in Gaza City.

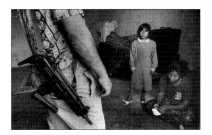

Fahme 1992 *page 50*

A Palestinian collaborator
with the Israeli security
services leaving home in
the morning in the West Bank
village of Fahme.

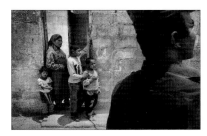

Fahme 1992 *page 51*

A Palestinian collaborator with
the Israeli security services
watches with his family as fellow
collaborators leave their West Bank
village of Fahme to meet with
their Israeli controllers.

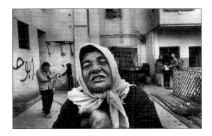

Beirut 1984 *page 52*

A Shiite woman enraged by the
constant shooting around her
house on the Green Line
dividing East and West Beirut.

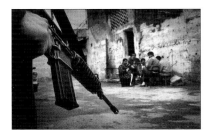

Gaza 1989 *page 53*

Israeli troops arrive to search
the house of a Fatah activist
in Gaza City.

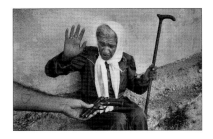

Fahme 1992 *page 54*

Palestinian woman refusing to
handle a pistol offered by her son
who works as an informer for the
Israeli security services on the West
Bank.

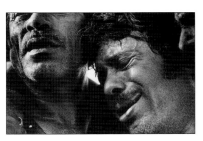

Jerusalem 1989 *page 55*

A father at the funeral for his
son, an Israeli soldier killed in
a clash with Palestinian militants
on the West Bank.

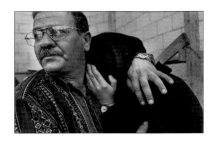

Jenin 2002 *page 56*

A Palestinian man comforts his wife as she grieves at a funeral for those killed in the Jenin refugee camp on the West Bank during the Israeli assault on the town.

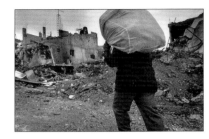

Jenin 2002 *page 57*

A Palestinian man carries what he could salvage from the rubble of his demolished house in the centre of the Jenin refugee camp on the West Bank.

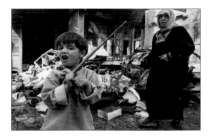

Bethlehem 2002 *page 58*

Inside the West Bank town, as an Israeli army operation flushes out Palestinian militants.

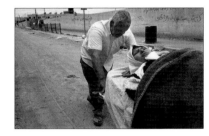

Jenin 2002 *page 59*

A Palestinian Red Crescent worker brings a woman injured during the Israeli assault on the Jenin refugee camp to the West Bank town's main hospital.

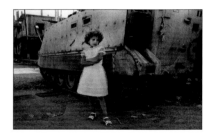

Beirut 1983 *page 60*

A Palestinian girl in the Sabra refugee camp waits outside her home for the rest of her family, who are on their way to a wedding.

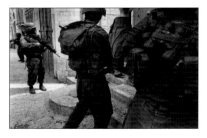

Bethlehem 2002 *page 61*

An Israeli army patrol moves through a street in Bethlehem during a 24-hour curfew in the West Bank town.

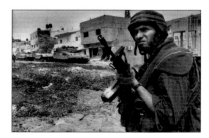

Jenin 2002 *page 62*

Israeli infantry and armour operating inside the Jenin refugee camp.

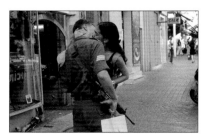

Tel Aviv 2003 *page 63*

An Israeli soldier on week-end leave meeting his girlfriend in Tel Aviv.

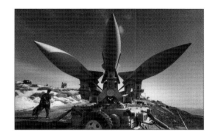

Judean Hills 1991 *page 64*

A Hawk missile battery stationed in the Jordan Valley on the West Bank during the first Gulf War, in an effort to shoot down Iraqi Scud missiles before they hit Israeli cities.

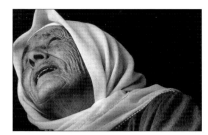

Araba 2000 *page 65*

An Israeli Arab woman stares out of the window of her home in this Northern Galilee village at a flight of Israeli Air Force helicopters heading towards the West Bank.

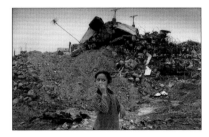

Tel Aviv 1991 *page 66*

A huge Israeli flag draped over the facade of the National Theatre building in Tel Aviv, designed to inspire courage in the city's residents in the face of Iraqi Scud missile attacks.

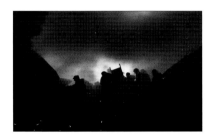

Ramat Gan 1991 *page 67*

Rescue workers climb through the rubble of a house in this Tel Aviv suburb moments after the building took a direct hit from an Iraqi Scud missile.

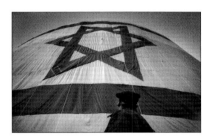

Jenin 2002 *page 68*

A young Palestinian girl stares at the wreckage of her neighbourhood in the centre of the Jenin refugee camp.

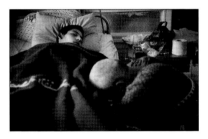

Nablus 2002 *page 69*

A Palestinian father keeps a vigil over his son at the central hospital in the West Bank town of Nablus. The son was injured during the Israeli army assault on the town.

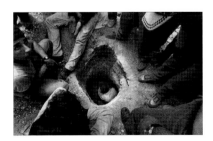

Jenin 2002 *page 70*

Palestinian residents of the Jenin refugee camp dig through the rubble of their home following the Israeli assault which levelled the centre of the camp.

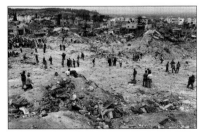

Jenin 2002 *page 71*

The centre of the Palestinian refugee camp in Jenin, the day after it was destroyed by the Israeli Army.

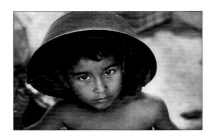

Beirut 1982 *page 72*

Palestinian boy wearing a
helmet during the Israeli army
shelling of West Beirut.

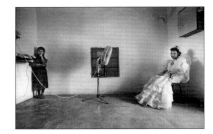

Jericho 1993 *page 73*

A Palestinian bride waits for her
wedding to begin at her home
in a refugee camp in the West Bank
town of Jericho.

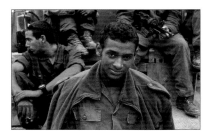

Kedumim 2003 *page 74*

Israeli army paratroopers at their
base on the West Bank.

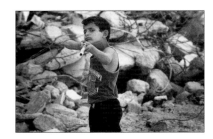

Jenin 2002 *page 75*

A young Palestinian boy
defending the rubble of his
home in the Jenin refugee
camp, after it was razed
by the Israeli Army.

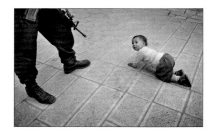

Hebron 1997 *page 76*

An Israeli soldier guarding
Jewish settlers in the
Avraham Avinu quarter of
Hebron on the West Bank.

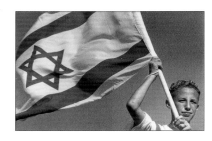

Tel Aviv 1999 *page 77*

A young Labour Party supporter
at an election rally in Tel Aviv.

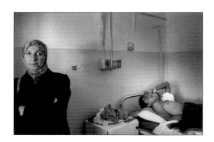

Nablus 2002 *page 78*

A Palestinian mother with her son in
the central hospital in Nablus on the
West Bank. The boy was shot during
the Israeli assault on the town.

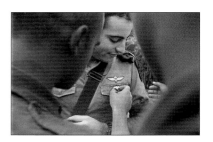

Kedumim 2003 *page 79*

Israeli army paratroopers at their
base on the West Bank prepare
for an inspection by their
platoon commander before
going on week-end leave.

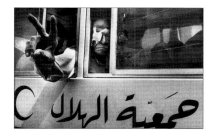

Beirut 1982 *page 80*

PLO fighters leaving Beirut following an American-brokered cease-fire between Israeli and Palestinian forces.

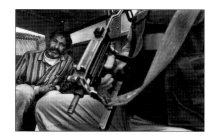

Bethlehem 2002 *page 81*

A Palestinian gunman, who surrendered to Israeli troops during a siege at the Church of the Nativity in Bethlehem, being guarded by soldiers moments after emerging from the Church.

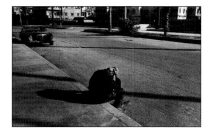

Beirut 1984 *page 82*

An elderly man on the edge of despair as fighting between several Palestinian militias makes life in the city intolerable.

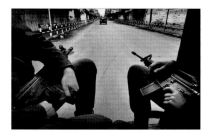

Gaza 1989 *page 83*

Israeli army jeep patrol enforcing a 24-hour curfew following several days of rioting in Gaza City.

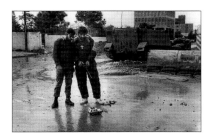

Sidon 1983 *page 84*

Christian militiamen guarding the entrance to Israeli army headquarters in Sidon, Southern Lebanon.

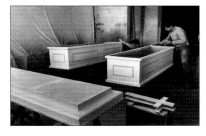

Jounieh 1984 *page 85*

Carpenter's shop in Jounieh, north of Beirut.

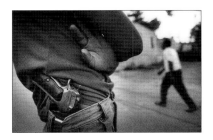

Fahme 1992 *page 86*

A Palestinian working as an informer for the Israeli security services on the West Bank.

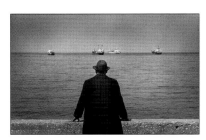

Jounieh 1984 *page 87*

A Lebanese man stares out to sea from the port of Jounieh. The fighting in Beirut had closed the city to both air and sea traffic, leaving Jounieh the only way out of the country for those who could afford it.

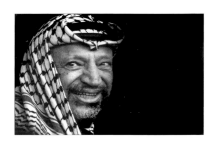

Jericho  1996  *page 88*

Palestinian Authority President
Yasser Arafat at his office in Jericho
on the West Bank.

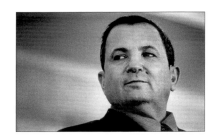

Tel Aviv  1999  *page 89*

Ehud Barak waits to be called
to deliver a campaign speech
in the run-up to the Israeli
general elections.

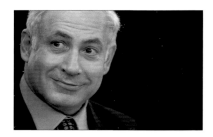

Tel Aviv   1993  *page 90*

Prime Minister Yitzhak Rabin
listening to a discussion about the
draft agreement of the Oslo Accords
at Labour Party headquarters, before
leaving for Washington to sign them
on the White House lawn.

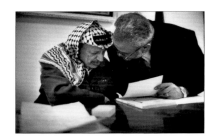

Jericho   1996  *page 91*

Palestinian Authority President
Yasser Arafat and chief Palestinian
negotiator Dr Saeb Erekat at the
President's office in Jericho.

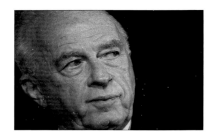

Tel Aviv  2003  *page 92*

Binyamin Netanyahu waits
to deliver a speech endorsing
Ariel Sharon's campaign for
Prime Minister at a Likud rally
on the eve of the 2003 Israeli
general elections.

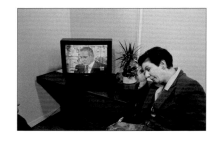

Madrid  1991  *page 93*

Hanan Ashrawi, a member
of the Palestinian delegation
to the Madrid peace talks,
listening to a televised
speech by Israeli delegate
Binyamin Netanyahu.

Tel Aviv  2003  *page 94*

A Sharon campaign strategist
watching the vote count at
Likud Party headquarters in
Tel Aviv after the polls closed
in the 2003 general elections.

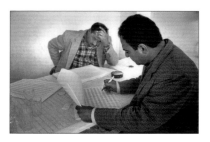

Jericho  1996  *page 95*

Campaign strategists for
Fatah Party candidate
Dr Saeb Erekat pore over
lists of voters in Jericho
on the last day of
campaigning before the
Palestinian general elections.

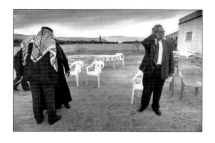

Jericho 1996 *page 96*

Dr Saeb Erekat, the chief
Palestinian negotiator and
Fatah representative for Jericho
on the Palestinian Legislative
Council, waits for voters to turn
up at an election rally in his
West Bank constituency.

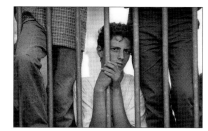

Nazareth 1999 *page 97*

Israeli Arabs in the Northern
Galilee listen as Prime Minister
Ehud Barak outlines his plans
for increased government
spending on housing,
education and health care
in the country's Arab sector.

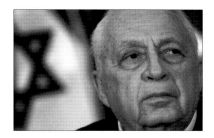

Jerusalem 1999 *page 98*

Voting at a polling station
in the ultra-orthodox
Mea Shearim district
of Jerusalem.

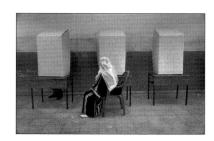

Jericho 1996 *page 99*

Palestinians voting in their
first general election at
a polling station in Jericho
on the West Bank.

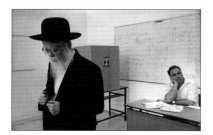

Jerusalem 2003 *page 100*

Ariel Sharon during his
campaign for re-election
as Prime Minister.

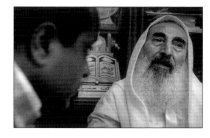

Gaza 2002 *page 101*

Sheikh Ahmed Yassin,
spiritual leader of Hamas,
in his home in Gaza.

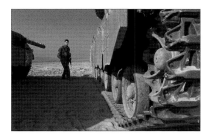

Gush Katif 2005 *page 102*

Tanks guarding Israeli
settlements in Gaza shortly
before they were evacuated.

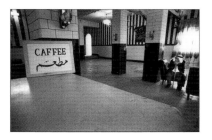

Jericho 1993 *page 103*

Lobby of a hotel in Jericho
on the day the Oslo Accords
were being signed between
the Israelis and Palestinians
at the White House
in Washington.

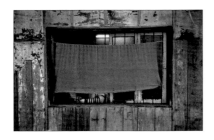

Bnei Brak 1998 *page 104*

Window of a small synagogue in Bnei Brak, the ultra-orthodox suburb of Tel Aviv.

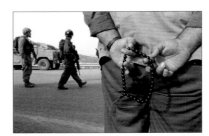

Kedumim 2003 *page 105*

Israeli paratroopers at a checkpoint on the highway between Kalkiliya and Nablus on the West Bank.

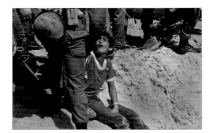

Yamit 1982 *page 106*

Israeli troops forcibly removing settlers from Yamit in the Sinai after the deadline for their voluntary evacuation had expired. Yamit was in territory returned to Egypt under the Camp David agreement.

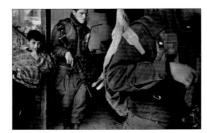

Hebron 1997 *page 107*

An Israeli army patrol leaving a Palestinian shop in the West Bank city of Hebron after searching the premises for illegal weapons.

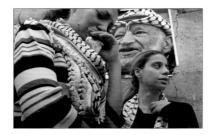

Ramallah 2004 *page 108*

Mourners at the funeral for Palestinian Authority President Yasser Arafat outside his headquarters in the West Bank city of Ramallah.

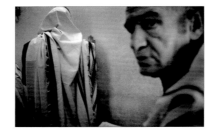

Bnei Brak 1998 *page 109*

Morning prayers inside a small synagogue in Bnei Brak, the ultra-orthodox suburb of Tel Aviv.

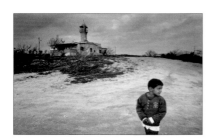

Jaffa 1994 *page 110*

The Ajami quarter of Jaffa, a city next door to Tel Aviv with a largely Israeli Arab population.

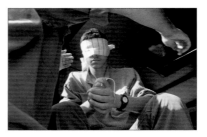

Kedumim 2003 *page 111*

A Palestinian wanted by the Israeli security services, shortly after his arrest by the army at a road block near the West Bank town of Nablus.

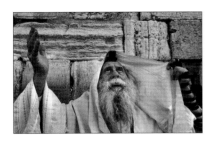

Jerusalem 1998 *page 112*

An elderly man praying at the Western Wall in the Old City.

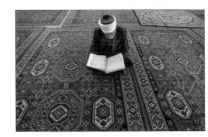

Araba 2000 *page 113*

The Imam of the mosque in Araba, an Israeli Arab town in the Galilee, reading his Koran between prayer sessions.

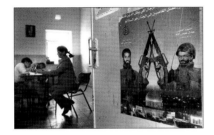

Ramallah 2001 *page 114*

A Palestinian high school in the West Bank city of Ramallah, with a poster displaying photographs of two Hamas-linked suicide bombers taped to a classroom door.

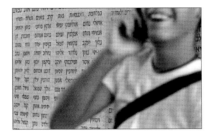

Tel Aviv 2001 *page 115*

The main entrance to a high school in Tel Aviv, with a wall inscribed with the names of graduates who have died in combat since Israel's War of Independence in 1948.

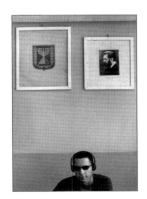

Tel Aviv 2001 *page 116*

A high school classroom in Tel Aviv, with a photograph of Theodor Herzl and the seal of the State of Israel on the wall.

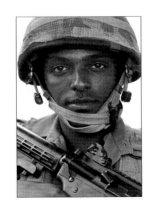

Kedumim 2003 *page 117*

An Ethiopian immigrant serving with the paratroopers in the Israeli Army, on patrol in the West Bank.

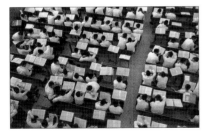

Bnei Brak 1998 *page 118*

Students studying at a yeshiva (a religious academy) in the ultra-orthodox Tel Aviv suburb of Bnei Brak.

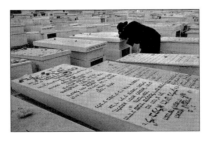

Bnei Brak 1998 *page 119*

A man visiting his father's grave in the Bnei Brak cemetery.

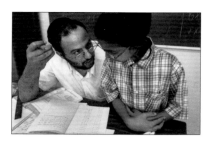

Tel Aviv 1998 *page 120*

A teacher working with one of his pupils in a religious elementary school in Tel Aviv.

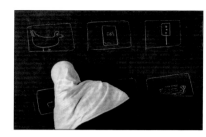

Jericho 1993 *page 121*

A teacher in a Palestinian elementary school working at the classroom blackboard.

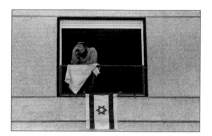

Yamit 1982 *page 122*

A Yamit settler in a moment of anguish as Israeli troops arrive at the Sinai settlement to make preparations for its forced evacuation.

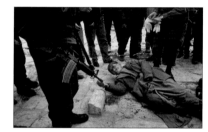

Hebron 1997 *page 123*

An elderly Palestinian pleads for help from a group of Israeli soldiers after falling and injuring himself as he came out from afternoon prayers at Hebron's Tomb of The Patriarchs on the West Bank.

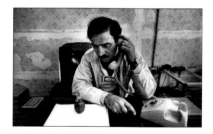

Beirut 1984 *page 124*

A live hand grenade being used as a paperweight inside the headquarters of the Lebanese Mourabitoun militia in West Beirut.

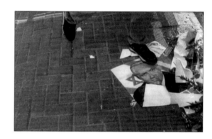

Tel Aviv 1999 *page 125*

A poster with a portrait of Israeli Prime Minister Binyamin Netanyahu lies torn on a Tel Aviv pavement the morning after the general elections in which he lost to Labour party challenger Ehud Barak.

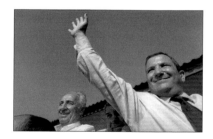

Herzliya 1999 *page 126*

Israeli Labour Party leader Ehud Barak and former Prime Minister Shimon Peres campaigning in the run-up to the general elections.

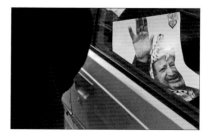

Ramallah 2004 *page 127*

A poster of Palestinian Authority President Yasser Arafat in the passenger seat of a car at his funeral in Ramallah.

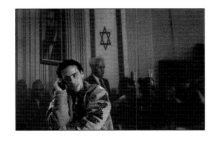

Tel Aviv 1998 *page 128*

A young resident of Tel Aviv talking on his mobile phone against a mural of an historic 1948 photograph showing David Ben-Gurion, Israel's first Prime Minister, declaring the founding of the State of Israel.

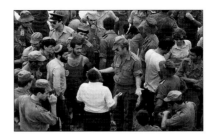

Yamit 1982 *page 129*

Israeli soldiers trying to convince residents in the Sinai settlement of Yamit to evacuate voluntarily. Their resistance was eventually crushed by troops brought in to remove them forcibly.

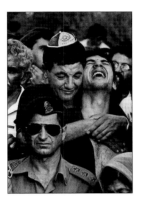

Tel Aviv 1988 *page 130*

Two Israeli men at the funeral for their younger brother, a soldier killed in Gaza.

Tel Aviv 2001 *page 131*

Ehud Olmert, a political disciple of Ariel Sharon, watches the vote count at Likud Party headquarters in Tel Aviv on the eve of the 2001 Israeli general elections which swept his mentor into office.

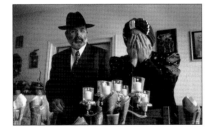

Bnei Brak 1998 *page 132*

An orthodox woman recites the prayer for lighting candles as she and her family celebrate the beginning of the Jewish Sabbath in Bnei Brak.

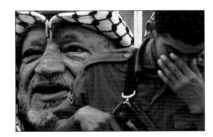

Ramallah 2004 *page 133*

A Palestinian soldier overcome with emotion at Yasser Arafat's funeral in Ramallah.

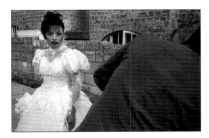

Jaffa 1994 *page 134*

An Israeli Arab bride waits for her groom to emerge from the car taking them to their wedding in Jaffa.

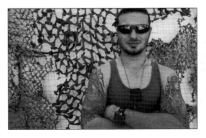

Kedumim 2003 *page 135*

A Christian Russian immigrant serving with an Israeli paratroop unit near Nablus on the West Bank.

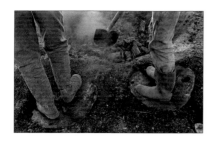

Um El Fahm 2002 *page 136*

Palestinians tend the fires of an open-air charcoal factory in the hills surrounding the village of Um El Fahm on the West Bank. Charcoal is a vital commodity in the Palestinian economy, used for heating and cooking.

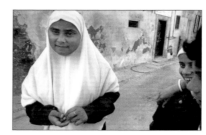

Jaffa 1994 *page 137*

Children on their way home from school in the Ajami quarter of Jaffa.

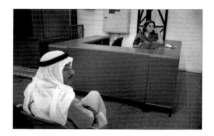

Jericho 1994 *page 138*

A Palestinian resident of the West Bank returning from a visit to Jordan waits for an Israeli soldier to examine his passport at the Allenby Bridge border crossing outside Jericho.

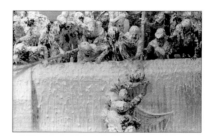

Yamit 1982 *page 139*

Israeli soldiers storm the roof of a house in Yamit, an Israeli settlement in the Sinai. When the settlers refused orders to leave, the Army sprayed them with immobilising foam, taking them off the roof one at a time.

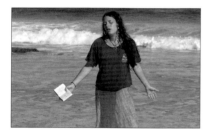

Kfar Yam 2005 *page 140*

A settler from Kfar Yam in Gaza praying by the sea for divine intervention in the Israeli government's plan to evacuate the settlements forcibly.

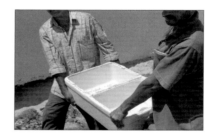

Pe'at Sadeh 2005 *page 141*

Palestinian workers carry a kitchen sink dismantled from a house evacuated by Israeli settlers in Gaza.

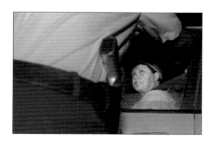

Kisufim 2005 *page 142*

A policeman stops a settler on the Israeli side of the Gaza border from returning to her home after the deadline for evacuating the settlements.

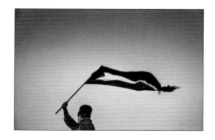

Jericho 1993 *page 143*

A resident of Jericho waves a Palestinian flag at the moment Israeli and Palestinian leaders sign the Oslo Agreement at the White House in Washington.

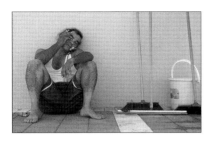

Nitsan 2005 *page 144*

A settler from Gaza sits exhausted outside his new home on Israel's southern coast, after moving his family out of their settlement a day before the Army arrived to forcibly remove evacuation opponents.

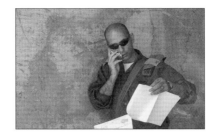

Tze'elim 2005 *page 145*

An Israeli army officer checking details of the military plan for evacuating settlers from Gaza at a rehearsal of the operation in southern Israel, several days before the troops were sent in.

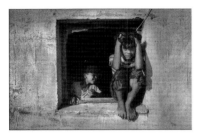

Fahme 1992 *page 146*

The children of a Palestinian collaborator with the Israeli security services at their home in the West Bank village of Fahme. Ostracised by other Palestinians, the children don't go to school and rarely leave the village.

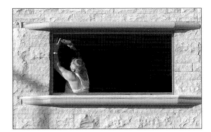

Pe'at Sadeh 2005 *page 147*

A Gaza settler dismantles the window frame in his home as he prepares to move to a new house inside Israel before the Army arrives to remove opponents to the evacuation.

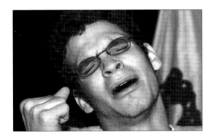

Jerusalem 2004 *page 148*

A Gaza settler, demonstrating outside the Israeli Parliament in Jerusalem, shows his anguish at hearing the result of a vote in which the government won approval for its evacuation plan of the Gaza settlements.

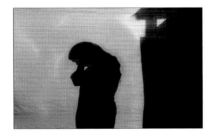

Kfar Yam 2005 *page 149*

A woman settler in Gaza praying for divine intervention in the Israeli government's plan to evacuate the settlements forcibly.

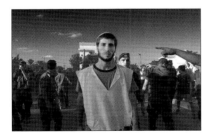

Kfar Darom 2005 *page 150*

Gaza settlers in a confrontation with Israeli troops sent in to begin dismantling their settlement.

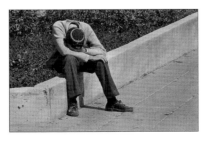

Yamit 1982 *page 151*

A Yamit settler in a moment of anguish as Israeli troops arrive at the Sinai settlement to make preparations for its forced evacuation.

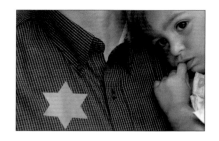

Neve Dekalim 2005 *page 152*

A Gaza settler and his daughter. The Star of David on his shirt is a reference to the Nazi treatment of Jews in Europe.

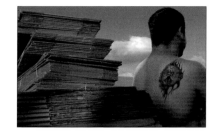

Pe'at Sadeh 2005 *page 153*

A Gaza settler with cardboard boxes supplied by the Israeli Army to encourage him to pack the contents of his home and leave ahead of the deadline for being forcibly removed.

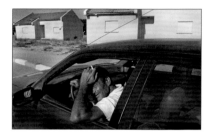

Pe'at Sadeh 2004 *page 154*

A Gaza settler drives through a section of his settlement full of empty homes. The Israeli government's plan to withdraw from Gaza has undermined the property market in the settlements.

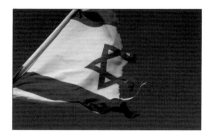

Neve Dekalim 2005 *page 155*

An Israeli flag torn in half hangs from a lamp post in a Gaza settlement. Opponents of the Gaza evacuation plan warned of a civil war that would rip the country apart should it go ahead.

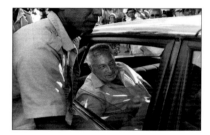

Jerusalem 1992 *page 156*

Ariel Sharon campaigning for Likud leader Yitzhak Shamir in the 1992 general elections.

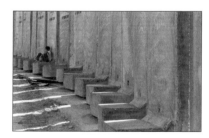

Kalkiliya 2004 *page 157*

The Israeli-built security wall surrounding the Palestinian town of Kalkiliya on the West Bank.

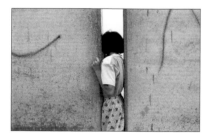

Abu Dis 2004 *page 158*

A young Palestinian girl squeezes through a gap in the Israeli-built security wall which cuts through the centre of the village of Abu Dis on the outskirts of Jerusalem.

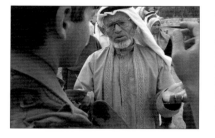

Abu Dis 2004 *page 159*

A Palestinian man pleads with an Israeli border policeman for permission to cross over the security wall running through the centre of the Palestinian village of Abu Dis.

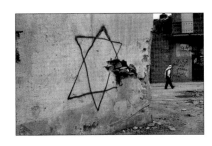

Jenin 2002 *page 160*

A Palestinian in the Jenin
refugee camp walking past a wall on
which Israeli soldiers
have painted a Star of David.

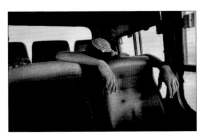

Ramallah 1989 *page 161*

An Israeli soldier returning
to Jerusalem exhausted
by his tour of duty on
the West Bank.

**The Photographer**

Judah Passow has been working on assignments for American and European magazines and newspapers since 1978.

Based in London, his work has been published extensively by all leading English newspapers and their associated magazines, including the *Guardian*, the *Observer*, *The Times* and *Sunday Times*, the *Daily Telegraph*, the *Sunday Telegraph* and the *Independent*. Abroad, he has contributed to *Time*, *Newsweek* and the *New York Times* in America, *Der Spiegel* and *Die Zeit* in Germany, *Elsevier* magazine and *De Volkskraant* in Holland, *Das* magazine in Switzerland and *L'Express* in France.

A winner of four World Press Photo awards for his coverage of conflict in the Middle East, his photographs have been exhibited in London, York, Leeds, Glasgow, Amsterdam, Paris, Arles, Perpignan, New York, and Washington D.C.

In 1995 Passow formed Further Vision, a new media production company, to explore the possibilities for combining traditional photojournalism with digital technology. His CD-ROM, *Days Of Rage*, based on his work in Beirut from 1982 to 1985, received critical acclaim in the British press for its journalistic integrity and technological innovation.

He was an Artist In Residence at the Institute of Contemporary Arts in London in 1998, where he directed the New Media Centre's Digital Photojournalism Laboratory, and has served as a consultant to the Soros Foundation's Open Society Institute training photojournalists at newspapers in Eastern Europe. Judah is a frequent lecturer and tutor on photojournalism at English universities.

## Acknowledgements

This book would not have been possible without the support and collaboration of some extraordinary people.

Marion Schut-Koelemij refuses to allow the flame in the torch she carries for photojournalism to go out. Her wisdom and insight guided this project from its very beginning around the dining room table at her home in Amsterdam, and is the reason it succeeded.

In Israel, Jim Hollander and Rina Castelnuovo were an invaluable source of objective criticism from the outset of the book's preparation. Our friendship goes back so far that each of us has a different recollection of how we first met. Many of the photographs on these pages are the result of their unstinting willingness over many years to share their extensive contacts and reliable information in a region where a shortage of both makes a photographer's life very difficult.

In London, Mike Goldwater and Wendy Wallace brought the warmth of another long friendship to provide a steady stream of perceptive ideas for improving the book through its various stages of development.

Linda Grant introduced me to Samir El-Youssef and Etgar Keret. I owe all three a debt of gratitude for their wholehearted enthusiasm for the project and their participation in it.

If an author were to compile a wish list of what he was looking for in a publisher, he would wind up describing Peter and Martine Halban. Their belief in this book and determination to publish it, their creative thinking and constant encouragement, all done with grace and wit, made our association a rare pleasure.

Alene Strausberg has tolerated my prolonged absences on assignment for many years. It has been her insistence that my work must have a life beyond the pages of a newspaper or magazine to have any lasting meaning, that has been the principal inspiration for this book. Our son Ben, who has grown up surrounded by these photographs and their unsettling messages, has always been a source of astute and sobering observations about my work that can only come from a generation that is puzzled by the world they are inheriting.

This book was made possible by the generous support of Trevor Pears, Gabrielle Rifkind and Jonathan Levy, and the European Jewish Publication Society.

First Published in Great Britain by
Halban Publishers Ltd
22 Golden Square
London W1F 9JW
2008
www.halbanpublishers.com

In association with
The European Jewish Publication Society
P O Box 19948
London N3 3ZL
www.ejps.org.uk

The European Jewish Publication Society gives
grants to support the publication of books relevant
to Jewish literature, history, religion, philosophy,
politics and culture.

A catalogue record for this book is available from the British Library.

ISBN 978 1 905559 06 0

Design by Patrick Roberts

Print consultant: Adrian Sleeman

Printed in Italy by
Arti Grafiche Amilcare Pizzi S.p.A.

HALBAN
LONDON

In association with

European Jewish Publication Society

To my parents

David and Aviva

who had the courage to dream